NIKON D90

THE EXPANDED GUIDE

NIKON D90

THE EXPANDED GUIDE

Jon Sparks

AMMONITE
PRESS

First published 2009 by
Ammonite Press
an imprint of AE Publications Ltd
166 High Street, Lewes, East Sussex, BN7 1XU

Reprinted 2010

Text © AE Publications Ltd
Product photography © Nikon
Illustrative photography © Jon Sparks
© Copyright in the Work AE Publications Ltd, 2009

ISBN 978-1-906672-40-9

A catalogue record for this book is available from the British Library.

Editor: Tom Mugridge
Design: Fineline Studios

Set in Frutiger and Palatino
Colour origination by GMC Reprographics
Printed and bound in China by Hing Yip Printing Co. Ltd.

Contents

Chapter **1**

Overview

The Nikon D90 stands at the top of the company's 'consumer' digital SLR (DSLR) line-up. Although the camera is marketed primarily at keen amateur and enthusiast photographers, its combination of powerful features and relatively light weight will make it worth more than a passing look by many professional photographers too. While the D90 incorporates a raft of innovations, its headline feature is undoubtedly its status as the first DSLR from any manufacturer to offer the ability to shoot movies.

Evolution of the Nikon D90

Nikon, more than any other major manufacturer, has always been noted for continuity as well as innovation. When the main manufacturers introduced their first viable autofocus 35mm cameras in the 1980s, most of them jettisoned their existing lens mounts, but Nikon stayed true to its tried and tested F-mount system. It's still possible to use the vast majority of classic Nikon lenses with the D90, though some functions may be lost. For this and other reasons, the term 'evolution' accurately describes the development of Nikon's DSLRs.

Nikon's first digital SLR was the E2s. Sporting a then impressive 1.3-megapixel (Mp) sensor, its body design was based on the F-801 35mm SLR. However, the D90's true line of descent begins with the 2.7-megapixel D1, in 1999. Its sensor adopted the DX format, which has been a constant with every Nikon DSLR until the introduction of the 'full-frame' D3 in early 2008.

The D90's first direct antecedent arrived in 2004 with the introduction of the 6-megapixel D70, which is usually recognized as Nikon's first 'enthusiast' DSLR. After an interim, incremental upgrade with the D70s in 2005, 2006 saw the launch of the 10-megapixel D80. Two years later, the D90 increased the megapixel count to 12, combining it with many less obvious but arguably more important features: Live View; dust removal; a new CMOS sensor; better low-light performance; and, of course, the innovative movie mode.

The Nikon DX format sensor

The DX format sensor, measuring approximately 23.6 × 15.8mm, has been used in the vast majority of Nikon DSLRs since the D1, but the number of pixels squeezed into that tiny area has risen from 2.7 million to 12.3 million in the D90 and the semi-professional D300. The DX format dictates a 1.5× magnification factor relative to the same lenses used on 35mm or 'full-frame' cameras.

A significant change has been the move from CCD (Charge-coupled Device) to CMOS (Complementary Metal Oxide Semiconductor) sensors in these cameras. Although they are significantly cheaper to manufacture and less power-hungry, CMOS sensors were initially considered inferior in terms of the image quality they could produce, and a great deal of research and development has gone into making them suitable for critical use.

The Nikon D90's CMOS sensor, with 12.3 million effective pixels, produces images at a native size of 4288 × 2848 pixels, making them suitable for large prints and book and magazine reproduction.

2008 – NIKON D300
The semi-professional D300 debuted many features which have since trickled down to the D90, including a 12.3-megapixel CMOS sensor, Live View, dust removal, and a superb 3in (7.6cm) rear LCD screen.

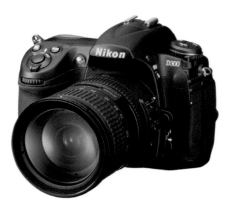

About the D90

The Nikon D90 is much more than just an upgrade of the D80. The most obvious difference is the 3in (7.6cm) rear LCD panel, which is larger, brighter and crisper than the D80's, making it far more useful for critical assessment of images in the field.

Under the hood, the most significant features include a 12.3-megapixel CMOS sensor with self-cleaning function, Expeed image processing, and a maximum shooting rate of 4.5 frames per second. Another notable advance over the D80 is the addition of Live View mode, from which the D90 derives its 'world-first' movie mode.

Like all Nikon SLRs, the D90 is part of a vast system of lenses, accessories and software. This book will guide you through all aspects of the camera's operation, and its relation to the system as a whole.

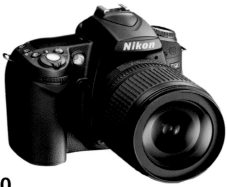

Main features

Sensor 12.3 effective Mp, DX format, RGB CMOS sensor measuring 23.6 × 15.8mm and producing maximum image size of 4288 × 2848 pixels; self-cleaning function.

Image processor EXPEED image processing system featuring 12-bit analogue-to-digital (A/D) conversion.

Focus 11-point autofocus system, supported by Nikon Scene Recognition System, which tracks subjects by shape, position and colour. Three focus modes: (S) Single-servo AF; (C) Continuous-servo AF and (M) Manual focus. Three AF-area modes: Single-point AF; Dynamic-area AF with option of 3D tracking and Auto-area AF. Rapid focus point selection and focus lock.

Exposure Three metering modes: matrix metering; centre-weighted metering; spot metering. 3D Colour Matrix Metering II uses a 420-pixel colour sensor to analyze data on brightness, colour, contrast and subject distance from all areas of the frame. With non-G/D type lenses, Standard Colour Matrix Metering II is employed. Two fully auto modes: Auto; Auto (flash off). Four user-controlled modes: (P) Programmed auto with Flexible program; (A) Aperture-priority auto; (S) Shutter-priority auto; (M) Manual. Five advanced Scene modes: Portrait; Landscape; Close-up;

Sports; Night portrait. ISO range between 200 and 3200, with extensions to 100 and 6400. Exposure compensation between -5 Ev and +5 Ev; exposure bracketing facility.

Shutter Shutter speeds range from 1/4000 sec to 30 sec, plus B. Max frame advance 4.5 fps.

Viewfinder and Live View Bright viewfinder with 96% coverage and 0.94× magnification. Live View available on rear LCD monitor.

Movie mode Continuous feed in Live View mode allows movie capture in .AVI format (Motion-JPEG compression) with image size (pixels) of: 640 × 424; 320 × 216; 1280 × 720.

Buffer Buffer capacity allows up to 100 frames (JPEG fine, large) to be captured in a continuous burst at 4.5fps, or approximately 11 NEF (RAW) files.

Built-in flash Pop-up flash (manually activated) with Guide Number of 17 (m) or 56 (ft) at ISO 200 supports i-TTL balanced fill-flash for DSLR (when matrix or centre-weighted metering is selected) and Standard i-TTL flash for DSLR (when spot metering is selected). Up to eight

flash-sync modes (dependent on exposure mode in use): Fill-flash; Front-curtain sync; Slow sync; Rear-curtain sync; Red-eye reduction; Auto slow sync; Slow sync with red-eye reduction. Flash compensation to +/-3 Ev; FV lock.

LCD monitor High definition 3in (7.6cm), 920,000 pixel (VGA) TFT LCD display with 100% frame coverage.

Custom functions Over 40 parameters and elements of the camera's operations can be customized through the Custom Setting menu.

File formats The D90 supports NEF (RAW) (12-bit); TIFF and JPEG (Fine/Normal/Basic) file formats plus .AVI movie format.

System backup Compatible with over 60 current and many more non-current Nikkor lenses (functionality varies with older lenses); SB-series flashguns; Multi-Power Battery Pack MB-D80; Wireless Remote Control ML-L3; GPS Unit GP-1 and many more Nikon accessories.

Software Supplied with Nikon Transfer and Nikon View NX; compatible with Nikon Capture NX and many third-party imaging applications.

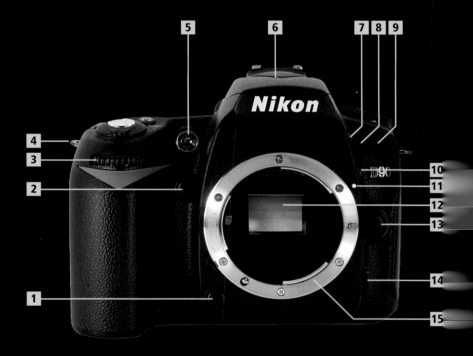

FRONT OF CAMERA

1 Depth-of-field preview button
2 Function button
3 Sub-command dial
4 Camera strap eyelet
5 AF-assist/Self-timer/Red-eye reduction lamp
6 Built-in flash
7 Flash mode/Flash compensation button

8 Microphone
9 Infra-red receiver
10 Bracketing button
11 Lens mount index
12 Reflex mirror
13 Lens-release button
14 Focus mode selector
15 Lens mount

OVERVIEW

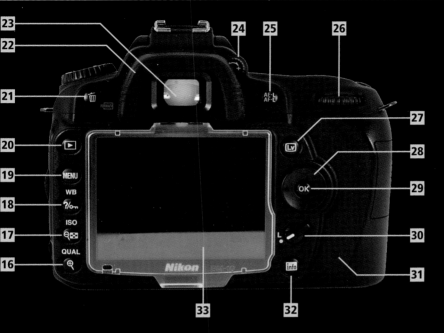

BACK OF CAMERA

16 Playback zoom in/QUAL button

17 Thumbnail/playback zoom out/
ISO button

18 Protect button/Help/WB button

19 Menu button

20 Playback button

21 Delete/Format button

22 Viewfinder eyepiece

23 Viewfinder

24 Dioptre adjustment control

25 AE/AF-lock button

26 Main command dial

27 Live view button

28 Multi selector

29 OK button

30 Focus selector lock

31 Memory card access lamp

32 INFO display/Quick settings
display button

33 Playback and menu monitor

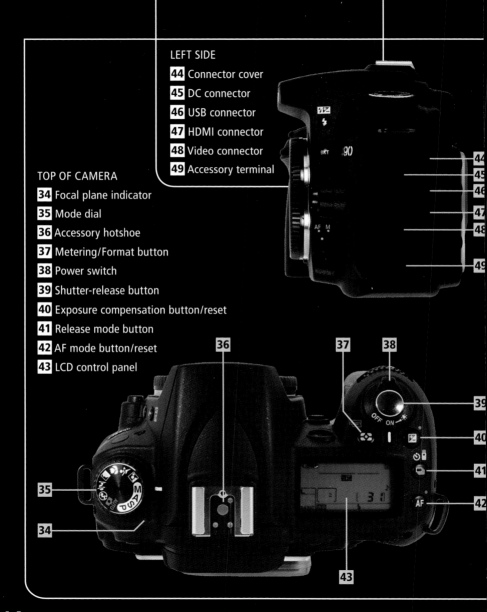

LEFT SIDE

44 Connector cover

45 DC connector

46 USB connector

47 HDMI connector

48 Video connector

49 Accessory terminal

TOP OF CAMERA

34 Focal plane indicator

35 Mode dial

36 Accessory hotshoe

37 Metering/Format button

38 Power switch

39 Shutter-release button

40 Exposure compensation button/reset

41 Release mode button

42 AF mode button/reset

43 LCD control panel

14

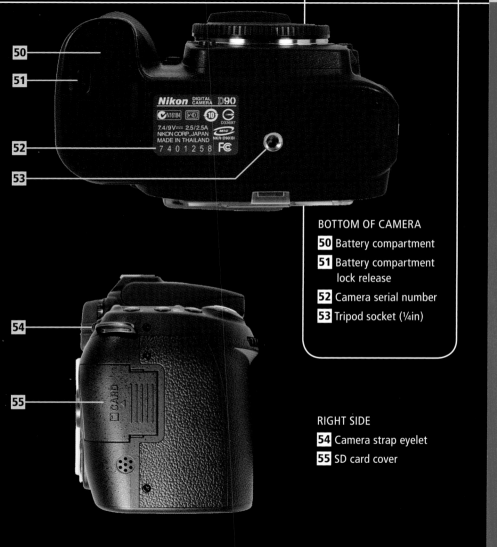

BOTTOM OF CAMERA
50 Battery compartment
51 Battery compartment lock release
52 Camera serial number
53 Tripod socket (¼in)

RIGHT SIDE
54 Camera strap eyelet
55 SD card cover

Viewfinder display

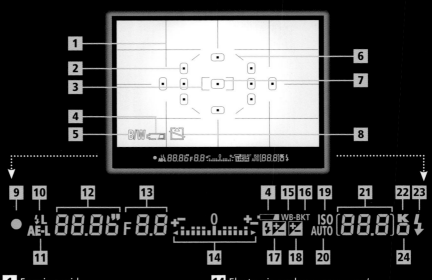

1 Framing grid

2 Focus points

3 Centre focus point (wide frame)

4 Battery indicator

5 Black-and-white indicator

6 Reference circle for centre-weighted metering

7 Centre focus point (normal frame)

8 No memory card warning

9 Focus indicator

10 Flash value lock indicator

11 Auto-exposure (AE) lock indicator

12 Shutter-speed lock icon

13 Aperture

14 Electronic analogue exposure/ Exposure compensation display

15 WB bracketing indicator

16 Bracketing indicator

17 Flash compensation indicator

18 Exposure compensation indicator

19 ISO sensitivity indicator

20 Auto ISO sensitivity indicator

21 Number of exposures remaining/Number of shots remaining in buffer/White-balance recording indicator/Exposure compensation value/Flash compensation value/ISO sensitivity

22 K (when over 1,000 exposures remain)

23 Flash-ready indicator

24 ISO sensitivity compensation indicator

16

LCD control panel

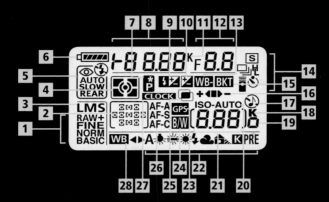

1 Image quality

2 Focus points/
AF area mode

3 Image size

4 Metering

5 Flash mode

6 Battery indicator

7 Flexible program indicator

8 Shutter speed/Exposure
compensation value/Flash
compensation value/WB
fine-tuning/WB colour
temperature/WB balance
preset number/No. of
shots in bracketing
sequence

9 Flash compensation
indicator

10 Exposure compensation
indicator

11 Colour temperature
indicator

12 Aperture/Bracketing
increment

13 White-balance
bracketing indicator

14 Release mode

15 Bracketing indicator

16 Bracketing progress
indicator

17 Beep indicator

18 K (when over 1,000
exposures remain)

19 ISO sensitivity
compensation indicator

20 ISO sensitivity indicator

21 No. of exposures
remaining/No. of shots
remaining in buffer/
Capture mode indicator/
Preset WB recording
indicator/ISO sensitivity

22 White balance

23 GPS connection indicator

24 Black-and-white
indicator

25 Multiple-exposure
indicator

26 Autofocus mode

27 Clock not set indicator

28 White balance
fine-tuning indicator

17

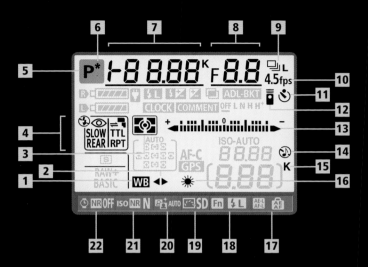

1 White balance

2 White balance fine-tuning indicator

3 Metering

4 Flash mode/Flash control for optional flash units

5 Shooting mode

6 Flexible program indicator

7 Shutter speed/Exposure compensation value/ Flash compensation value/ Colour temperature/ No. of shots in bracketing sequence

8 Aperture/Bracketing increment

9 Release mode

10 Continuous shooting speed

11 Self-timer mode indicator

12 Remote control indicator

13 Electronic analog exposure display/ Exposure compensation/ Bracketing progress indicator

14 Beep indicator

15 K (when over 1,000 exposures remain)

16 White-balance setting indicator

17 AE-L/AF-L button assignment

18 Fn button assignment

19 Picture control indicator

20 Active D-lighting indicator

21 High ISO noise reduction indicator

22 Long exposure noise-reduction indicator

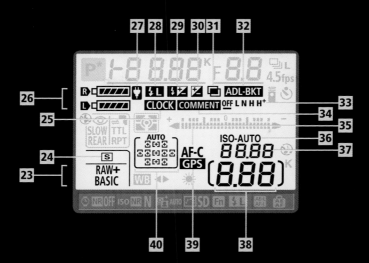

23 Image size

24 Image quality

25 Clock not set indicator

26 Battery indicator

27 AC adaptor indicator

28 Flash value lock indicator

29 Flash compensation indicator

30 Exposure compensation indicator

31 Multiple-exposure indicator

32 Bracketing indicator

33 Active D-lighting bracketing amount

34 Image comment indicator

35 Autofocus mode

36 ISO sensitivity/Auto ISO sensitivity indicator

37 ISO sensitivity

38 No. of exposures remaining

39 GPS connection indicator

40 Auto-area AF indicator/3D tracking indicator/Focus point/ AF-area mode indicator

Menu displays

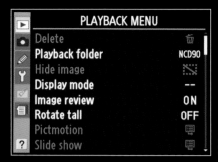

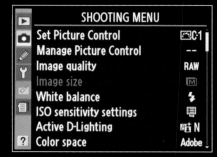

PLAYBACK MENU
Delete
Playback folder
Hide image
Display mode
Image review
Rotate tall
Pictmotion
Slide show
Print set (DPOF)

SHOOTING MENU
Set Picture Control
Manage Picture Control
Image quality
Image size
White balance
ISO sensitivity settings
Active D-Lighting
Colour space
Long exp. NR
High ISO NR
Active folder
Multiple exposure
Movie settings

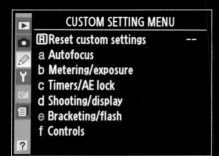

CUSTOM SETTING MENU
Reset custom settings

a: Autofocus
a1 AF-area mode
a2 Centre focus point
a3 Built-in AF-assist illuminator
a4 AF Point illumination
a5 Focus point wrap-around
a6 AE-L/AF-L for MB-D80
a7 Live View autofocus

b: Metering/Exposure
b1 EV steps for exposure control
b2 Easy exposure compensation
b3 Centre-weighted area
b4 Fine tune optimal exposure

c: Timers/AE Lock
c1 Shutter-release button AE-L
c2 Auto meter-off delay
c3 Self-timer delay
c4 Monitor-off delay
c5 Remote on duration

d: Shooting/display
d1 Beep
d2 Viewfinder grid display
d3 ISO display and adjustment
d4 Viewfinder warning display
d5 Screen tips
d6 CL mode shooting speed
d7 File number sequence
d8 Shooting info display
d9 LCD illumination
d10 Exposure delay mode
d11 Flash warning
d12 MB-D80 battery type

(Continued on next page)

Menu displays

```
           CUSTOM SETTING MENU
  [R]Reset custom settings        --
  a Autofocus
  b Metering/exposure
  c Timers/AE lock
  d Shooting/display
  e Bracketing/flash
  f Controls
```

```
                SETUP MENU
  Format memory card              --
  LCD brightness                   0
  Clean image sensor              --
  Lock mirror up for cleaning     --
  Video mode                    (PAL)
  HDMI                          AUTO
  World time                      --
  Language                        En
```

CUSTOM SETTING MENU (continued)

e: Bracketing/flash
e1 Flash shutter speed
e2 Flash control for built-in flash
e3 Modeling flash
e4 Auto bracketing set
e5 Auto FP
e6 Bracketing order

f: Controls
f1 <20> switch
f2 OK button (shooting mode)
f3 Assign FUNC button
f4 Assign AE-L/AF-L button
f5 Customize command dials
f6 No memory card?
f7 Reverse indicators

SETUP MENU
Format memory card
LCD brightness
Clean image sensor
Lock mirror up for cleaning
Video mode
HDMI
World time
Language
Image comment
Auto image rotation
Image Dust Off ref photo
Battery info
GPS
Firmware version

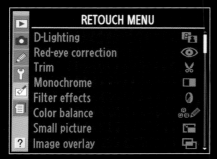

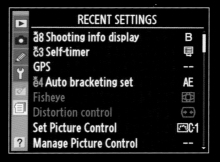

RETOUCH MENU
D-Lighting
Red-eye correction
Trim.
Monochrome
Filter effects
Colour balance
Small picture
Image overlay
NEF (RAW) processing
Quick retouch
Straighten
Distortion control
Fisheye

RECENT SETTINGS
Automatically stores up to 20 of the most recent settings selected from any of the other menus.

Chapter **2**

Functions

The Nikon D90, with its numerous buttons, dials and menus, may initially appear complex or even daunting to photographers graduating from digital compacts or 35mm SLRs. Complex it may be, but a better description would be 'powerful'.

If you need to ease yourself in gradually, the D90 has an Auto mode that makes almost all the shooting decisions for you. The camera will be set to this mode when you first unpack it, and you can reset it at any time by simultaneously pressing the and **AF** buttons (marked with green dots) on the top of the camera.

Of course, using the camera at these baseline settings exploits only a mere fraction of its immense potential. This chapter will provide a step-by-step introduction to the D90's most important features and functions. Such is the camera's power that it would be impossible, even in a book twice this length, to fully explore every last detail, so we will focus on the areas that are of prime interest to the majority of serious photographers.

Thanks to Nikon's evolutionary approach to camera design, users of earlier Nikon DSLRs may well be familiar with many of the D90's design features. However, for best results it is well worth exploring the D90's new features before diving in.

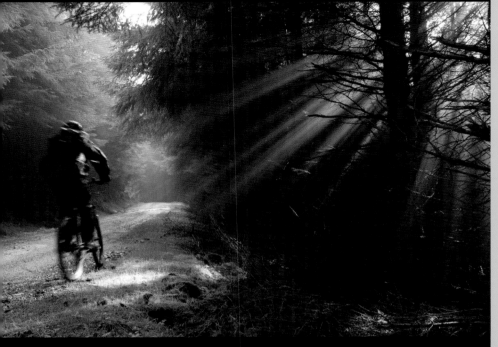

KIELDER FOREST, NORTHUMBERLAND, UK
When you buy a new camera, it's tempting to start taking pictures right away. However, if you do so, you will miss out on some of the camera's most creative capabilities. Read this guide first to familiarize yourself with the camera's functions and you will reap the benefits in the field.

Settings
ISO: 800
Focal length: 22mm
1/25 sec
f/5.6

Camera preparation

Operations such as changing lenses or memory cards may seem trivial, but the ability to perform them quickly and smoothly in awkward situations is not. Repetition and familiarity means these operations can be carried out safely and surely, even working by touch alone.

Attaching the strap

Unless your camera never leaves home, it needs the security of a strap. To attach the strap, ensure the padded side faces inwards (so the name faces out). Secure either end to the appropriate eyelets, located at the top left and right of the camera. Loosen the strap slightly where it runs through the buckle, then pass the end of the strap through the eyelet. Bring the end of the strap back through the buckle, under the length of strap already threaded. Repeat the operation on the other side. Adjust the length as required, but ensure a minimum of 2in (5cm) of strap extends beyond the buckle on each side to avoid any risk of it pulling through. When you're happy with the length, pull it firmly to fix it securely within the buckle.

Adjusting the dioptre

The D90 offers dioptric adjustment of between -3 and +1 m-1 to allow for individual variations in eyesight. Make sure this is optimized for your eyesight before using the camera. The dioptre adjustment control is located just to the right of the viewfinder. With the camera switched on, pull out the knob and rotate it until the viewfinder display appears sharpest. Push the knob back in. Most people will only ever need to do this once. Supplementary viewfinder lenses are available if the built-in adjustment proves to be insufficient.

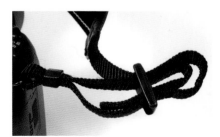

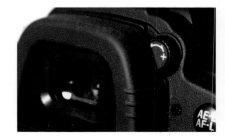

Mounting lenses

Switch the camera off before changing lenses. Remove the rear lens cap and the camera body cap (or the lens already mounted). To do this, press the lens release button and turn the cap or lens clockwise (as you face the front of the camera). Align the index mark on the lens with the one on the camera body (a white dot), insert the lens gently into the camera and turn it anti-clockwise until it clicks home. Do not use force; if the lens is correctly aligned it will mount smoothly.

Almost all Nikon F-mount lenses can be used on the Nikon D90; see the maker's manual for detailed information. If the lens has an aperture ring, rotate it to minimum aperture before shooting. The effective focal length of all lenses will be 1.5× the nominal figure (e.g. a 50mm lens will be an effective 75mm).

Common errors

Take care when changing lenses, especially in crowded surroundings or other awkward situations. Try to avoid dropping either the lens or the camera. Take extra care in dusty environments and beware of wind that could introduce dust or sand while the camera's interior is exposed. Point the camera downwards and stand with your back to the wind. In really bad conditions, it's best not to change lenses at all. Avoid touching the electrical contacts on the camera body and lens, and replace the lens- and body-caps as soon as possible.

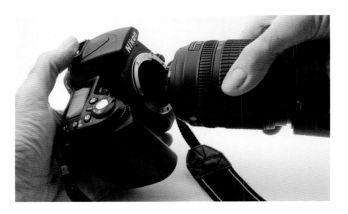

Inserting and removing a memory card

The D90 stores images on Secure Digital (SD) cards. High-capacity SDHC cards can also be used.

1) Ensure that the camera is switched off and that the green access lamp on the back of the camera (bottom right) is not lit.

2) Slide the card slot cover on the right side of the camera gently towards the rear. It will spring open.

3) Insert a card with its label side towards you and the terminals along the card edge facing into the slot. The 'cut-off' corner of the card will be at top left. Push the card firmly into the slot – but without excessive force – until it clicks home. The green access lamp will light briefly.

4) Close the card slot cover.

To remove a memory card, press it gently into the slot. It will spring out slightly. Pull the card gently from its slot.

Tips
Inserting a memory card incorrectly may damage the camera.

Do not open the card slot cover or remove the battery when the green access lamp is lit or blinking.

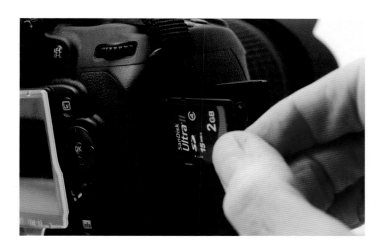

Formatting a memory card

It is always recommended to format a new memory card, or one that has been used in another camera, before using it with the D90. Formatting is also the quickest way to erase any existing images, but for this reason it needs to be done with caution – always make sure images have been saved elsewhere before formatting a card. The simplest way to format a card is to press

and hold the two FORMAT buttons (⊡ and 🗑) for about two seconds. A blinking **FOR** icon appears in the viewfinder and control panel. Release the two buttons and press them again to confirm. Press any other button to exit without formatting the card. You can also format the card through the Setup menu (see page 101).

Inserting the battery

The Nikon D90 is supplied with an EN-EL3e li-ion rechargeable battery. It is not compatible with the EN-EL3/EN-EL3a batteries supplied with some other Nikon DSLRs. The battery needs to be fully charged before first use (see page 32).

1) Turn the camera upside down and locate the battery compartment below the hand-grip. Release the latch to open the battery compartment.

2) Insert the battery, contacts first, with the flat face facing towards the lens. Press the battery gently down until it locks into position. Shut the battery compartment cover until it clicks home.

To remove the battery, ensure the camera is switched off, and open the compartment cover as above. Rotate the camera and the battery should slip out part of the way. Gently pull it the rest of the way out.

Warning!
Always ensure the camera is switched off before removing or replacing the battery.

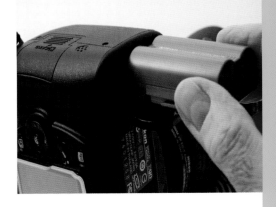

Battery charging

Use the Quick Charger MH-18a, supplied with the camera, to charge the battery. Connect the AC power cord to the charger and insert the plug into a mains outlet. Remove the terminal cover from the battery and place the battery flat side down with terminals facing the contacts on the charger. Slide the battery towards the contacts until it snaps home. The Charge lamp will blink while the battery is charging, changing to a steady illumination when charging is complete. A fully discharged battery will take around 2½ hours to recharge fully.

Tips
Even when not in use, your camera battery will gradually lose charge over a period of time. If the camera is to remain unused for a long period, it is suggested that you remove its battery. Storing the battery after it is fully recharged may lower the battery's performance.

The battery charger can be used abroad (100–240 v AC 50/60 Hz) with a commercially available travel plug adaptor. Do not attach any form of voltage transformer as this may damage the battery charger.

Battery life

The life of the battery is dependent on various factors. Working temperature can be critical and Nikon do not recommend use at temperatures below 0°C or above 40°C. Other factors that can reduce battery life include prolonged use of the LCD screen, especially for image review; use of the built-in flash; a long auto meter-off delay; and continuous use of autofocus (as when tracking a moving subject). Extensive use of Live View or movie shooting is particularly demanding.

Under standard (CIPA) conditions you can expect approximately 1000 shots from a fully-charged EN-EL3e battery. The Control panel gives an approximate indication of how much charge remains, but for more detail see **Battery Info** in the Shooting Menu. The Control panel icon blinks when the battery is exhausted, and a low-battery icon appears in the viewfinder when it is approaching exhaustion.

For more information on batteries and mains adaptors, see page 225.

Basic camera functions

While the Nikon D90 can be as simple to operate as any point-and-shoot camera, it has a great deal more power and flexibility just waiting to be unleashed. It makes sense to start exploring the most basic camera functions first. These are principally accessed through the Main command dial, the Sub-command dial and the Mode dial.

Switching the camera on

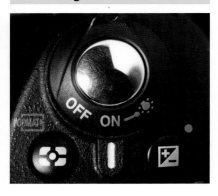

The power switch has three settings:
OFF The camera will not operate.
ON The camera operates normally.
☀ Move the power switch beyond the **ON** setting and release (it will not lock in this position). This illuminates the Control panel for approximately five seconds.

Custom Setting d9 enables you to keep the Control panel illuminated permanently, which may be useful for night shooting but will reduce battery life.

The Mode dial

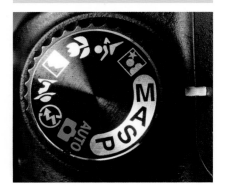

The Mode dial is probably the first port of call for any new user. It has 11 possible positions, so it is useful to divide these into three groups. For further information, see Exposure modes on page 38.

> **Tip**
> If the power switch is turned to **OFF** while the camera is recording image file(s), the camera will finish the process before turning off.

Operating the shutter

The shutter-release button operates in two stages. Pressing it lightly, until initial resistance is felt, activates the D90's metering and focus functions. If you maintain half-pressure on the button, in Single-servo AF, focus is locked (see page 58). Half-pressure also cancels image playback or camera menus, if active, making the D90 instantly ready to shoot.

Many cameras will lock exposure settings while you maintain half-pressure on the shutter-release button; this is referred to as exposure lock. By default, the D90 does not do this and you must use the **AE-L/AF-L** button instead. This can be changed in Custom Setting c1 (see page 92), so that exposure lock is activated by half-pressure on the shutter-release.

Release mode button

The Release mode is selected by holding down the Release mode button (not to be confused with the shutter-release button) and rotating the Main command dial. The chosen Release mode is displayed in the Control panel, close to the button, and in the Shooting information display (see pages 18–9) when it is active. Six possible Release modes can be selected in this way (see table opposite).

Note
There are several other Release mode options which are not accessed using the method described above. Live View mode can be activated at any time by pressing the **LV** button on the rear of the camera (see page 68). Movie mode is entered by pressing **OK** when the camera is in Live View mode (see page 186). Finally, the Exposure delay mode can only be activated via the Custom Setting menu (see page 96).

34

Release mode options

Setting		Description
S	Single Frame	The camera takes a single shot each time the shutter release is fully depressed.
C_L	Continuous Low-speed	The camera fires continuously as long as the shutter release is fully depressed. The default frame rate is 3 frames per second (fps) but this can be varied between 1 and 4 fps using Custom Setting d6.
C_H	Continuous High-speed	The camera fires continuously at the maximum possible frame rate as long as the shutter release is fully depressed. The maximum frame rate is approximately 4.5fps, but this slows by more than half when the buffer is full.
↺	Self-timer	The shutter is released at a set interval after the release button is depressed. Can be used to minimize camera shake and for self-portraits. The default interval is 10 sec but 2 sec, 5 sec or 20 sec can be set using Custom Setting c3.
▯↺	Delayed Remote	Requires the optional ML-L3 remote control; shutter fires approximately 2 sec after this is tripped.
▯	Quick Response	Requires the optional ML-L3 remote control; shutter fires immediately when this is tripped.

Operating the command dials

The Main command dial and Sub-command dial are fundamental to the operation of the Nikon D90. Their function is extremely flexible, varying according to the operating mode at the time. The plethora of different options may appear daunting, but in practice, operation turns out to be much more intuitive than a description in print might suggest.

By default, when used on their own, the dials operate as described below.

Main command dial

In Shutter priority or Manual mode, rotating the Main command dial selects the shutter speed. In Program mode, the Main command dial will engage Flexible program, changing the combination of shutter speed and aperture. In Aperture priority mode it has no effect.

Sub-command dial

In Aperture priority or Manual mode, rotating the Sub-command dial selects the aperture. In Shutter priority or Program mode it has no effect.

The Main command and Sub-command dials have a range of other functions when they are used in conjunction with other buttons. Hold down the appropriate button while rotating the dial to make a selection (see table opposite).

Main command dial

Sub-command dial

Principal uses of the command dials in conjunction with other buttons

Command dial	Other button	Function
Main	🖳	Select Release mode (see page 35)
Main	±	Select the level of Exposure compensation (see page 51)
Main	⚡	Select the Flash mode (see page 151)
Sub	⚡	Select the level of Flash compensation (see page 154)
Main	◉	Set Metering mode (see page 49)
Main	AF	Set AF mode (see page 55)
Main	QUAL	Set Image quality (see page 60)
Sub	QUAL	Set Image size (see page 62)
Main	ISO	Set ISO sensitivity (see page 66)
Main	WB	Select White-balance setting (see page 63)
Main	±	Set Exposure compensation (see page 51)

Multi selector

The Multi selector is another important part of the D90's control system. Its principal functions are navigating through the camera's menus (see page 78) and through images on playback (see page 71). The **OK** button at its centre is also used to confirm many of the camera's settings. Its operation is very similar to that used on mobile phones and other devices.

Exposure modes

The Nikon D90's exposure modes are divided into three groups, as shown below. See opposite for further detail on Full Auto modes; see pages 40–2 for Scene modes and pages 43–7 for User-control modes.

Although the D90's Full Auto modes and Scene modes should give good and predictable results, don't be afraid to experiment with the full range of exposure modes, perhaps when shooting casually and with a little time to spare. Try shooting the same subject using different Scene modes, to get a better idea of how these work. For instance, try using Landscape mode as well as Sports mode to shoot moving subjects.

Mode group	Exposure mode		
Full Auto modes	AUTO	Auto	Leave all decisions about shooting settings to the camera.
	⚡	Auto (flash off)	
Scene modes	👤	Portrait	Choose the appropriate mode to suit the subject and the camera will employ appropriate shooting settings.
	🏔	Landscape	
	🌷	Close-up	
	🏃	Sports	
	🌃	Night portrait	
User-control modes	P	Program	Allow much greater control over the full range of camera settings.
	S	Shutter priority	
	A	Aperture priority	
	M	Manual	

Full Auto modes

The two Full Auto modes are ideal when shots need to be grabbed quickly, but they can diminish the photographer's sense of control and creativity. In the D90 manual, Nikon calls them 'point-and-shoot' modes, which is a fair description of the kind of photography for which they're likely to be used.

In Full Auto modes, the camera determines not only basic exposure settings (aperture and shutter speed), but many other settings too. Left to its own devices, the camera is capable of getting acceptable shots under most conditions, but you may find that the results don't always match exactly what you had in mind.

There's really only one difference between the two Full Auto modes. In ▲ Auto mode, the built-in flash will pop up automatically if the camera determines that light levels are too low, and there's no way of turning it off (unless a separate accessory flashgun is attached and switched on, in which case this overrides the built-in unit).

In ⚡ Auto (flash off) mode, the reverse is true, and the flash always remains off. This can be very useful in situations where flash is banned, or would be intrusive – anything from weddings to Wimbledon – or when you want to discover just what the D90 can do in low light.

Taking the picture

Basic picture-taking with the Nikon D90 is essentially the same in all of the Full Auto and Scene modes (see page 40). The process is as follows:

1) Select the desired mode by rotating the Mode dial to the appropriate position.

2) Frame the picture.

3) Apply half-pressure to the release button to activate focusing and exposure. The focus point(s) will be displayed in the viewfinder image and shutter speed and aperture settings will appear at the bottom of the viewfinder.

4) Fully depress the shutter release to take the picture.

Scene modes

The Nikon manual refers to these as creative modes, but this may irritate some photographers, as the Scene modes still take many decisions out of the photographer's hands. But even experienced photographers may find they are sometimes handy as a quick way to prepare the camera for shooting a particular kind of image. Less experienced users will find Scene modes a great way to discover just how differently the camera can interpret the same scene. This makes them a great stepping-stone to fully exploiting the wide range of options that the D90 offers.

The Nikon manual gives a basic explanation of these modes, but doesn't go into much detail. It's clear, though, that the different modes don't just affect basic shooting decisions such as the way the camera focuses and how it sets shutter speed and aperture. They also have a bearing on how the image is processed subsequently by the camera, assuming you are shooting JPEG images. For example, you can't choose which Nikon Picture Control (see pages 76–7) will be applied, so it's fair to conclude that these are predetermined. In ▲ Portrait mode, for example, it's a safe bet that the camera is applying a Portrait Picture Control, which gives natural colour rendition and is particularly kind to skin tones.

♞ Portrait mode

In Portrait mode, the camera sets a relatively wide aperture to reduce depth of field (see pages 116–7), helping to make portrait subjects stand out from their background. The camera also selects the focus point automatically (presumably using face-detection technology), and this cannot be overridden, though you can switch to manual focus. The flash automatically pops up if the camera determines light levels are too low, and there's no way of turning it off.

40

⛰ Landscape mode

In Landscape mode, the camera sets a small aperture with the aim of maximizing depth of field (see pages 116–7). The camera also selects the focus point automatically, and its choice cannot be overridden. Results suggest that it uses the hyperfocal principle (see page 118) to maximize depth of field. Small apertures mean that shutter speeds can be on the low side and therefore a tripod or other solid camera support is often advisable. You can't choose to apply your own choice Picture Control in Scene modes, so presumably a Landscape Picture Control is applied

automatically in Landscape mode to give vibrant colours. The built-in flash remains off, even in low light, and there's no way to override this. However, if you'd like to add fill-in flash (see page 148), you can fit a separate flashgun and it will fire.

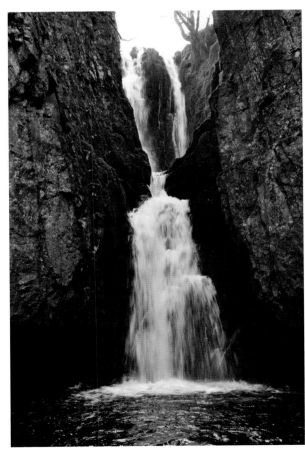

CATRIGG FORCE, NORTH YORKSHIRE, UK
Landscape mode set a shutter speed of 1/20 sec for this image, when I really wanted something much slower (see page 121).

❀ Close-up mode

Close-up mode is, of course, designed for shooting really close-up subjects. The camera sets a medium to small aperture to increase depth of field, so a tripod is recommended to avoid camera shake. The built-in flash will pop up automatically if the camera determines light levels are too low, and there's no way of turning it off. However, the built-in flash is far from ideal for close-up shots and in many cases the lens will throw a shadow on the subject. A separate accessory flashgun is often a better option and if one is attached and switched on, it will override the built-in unit. The camera automatically selects the central focus point, but in this mode this selection can be overridden using the Multi selector (see page 37).

⚹ Sports mode

Sports mode is suitable for shooting not only sports but other fast-moving subjects, such as many varieties of wildlife. The camera seeks to set a fast shutter speed to freeze the action, and this usually implies a wide aperture and therefore shallow depth of field. The camera initially selects the central focus point and, if it detects subject movement, will track it using the other 10 focus points. This initial selection can be overridden if desired. The flash remains off, even in low light, and there's no way to override this, so if you want to use fill-in flash or mixed lighting (see page 148), you'll have to use one of the user-control modes or fit a separate flashgun.

◪ Night portrait mode

In most respects, Night portrait mode is similar to the standard Portrait mode, but when the ambient light is low it permits the camera to set a long shutter speed to allow an image of the background to register. Because of the potential for long shutter speeds, it's recommended to use a tripod or other solid camera support to avoid camera shake.

Tip
Sports mode aims to set a fast shutter speed, but there's no law that says you always have to use fast shutter speeds for sports or other moving subjects. Using slower shutter speeds can often create striking and distinctive results (see page 120).

User-control modes

The D90's four User-control modes are the traditional modes that will be familiar to any experienced photographer. As well as allowing direct control over the basic settings of aperture and shutter speed – even in P mode, using Flexible program (see page 44) – these modes give full access to controls such as White balance (see pages 63–5), Active D-Lighting (see page 75) and Nikon Picture Controls (see pages 76–7), all of which give the photographer considerable influence over the look and feel of the image.

LAKE BLED, SLOVENIA
Programmed auto mode, one of the D90's four User-control modes, allows the photographer far greater creative freedom than Scene modes.

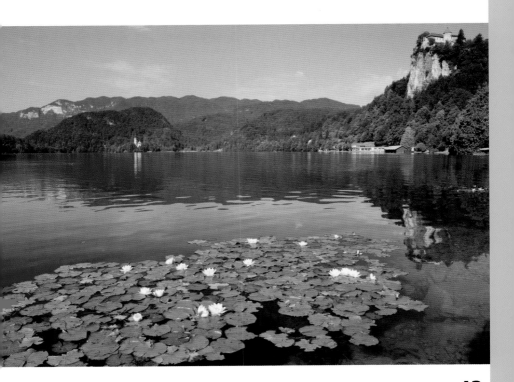

FUNCTIONS

(P) Programmed auto

In **P** mode, the camera sets a combination of shutter speed and aperture that will give correctly exposed results in most situations. Although the same is true of the Full Auto and Scene modes, **P** mode is different in a number of ways, with much more scope for creative freedom. Not only does **P** mode give you access to controls like White balance, Active D-Lighting and Nikon Picture Controls, but it also offers considerable room for user intervention via Flexible program (see below), exposure lock and exposure compensation, and possibly auto bracketing.

1) To use (**P**) Programmed auto mode, select it by rotating the Mode dial to **P**.

2) Frame the picture.

3) Apply half-pressure to the release button to activate focusing and exposure. The focus point or points will be displayed in the viewfinder image. Shutter speed and aperture settings will appear at the bottom of the viewfinder.

4) Fully depress the shutter release to take the picture.

Warning!

If predetermined exposure limits are exceeded, a warning will be displayed in the viewfinder and control panel. Hi = subject too bright; Lo = subject too dark. It's often possible to achieve an acceptable exposure by adjusting the ISO sensitivity (see page 66).

Flexible program

Without leaving **P** mode you can vary the combination of shutter speed and aperture by rotating the Main command dial to engage Flexible program. While Flexible program is in effect, the **P** indication in the Shooting Information display (see pages 18–9) changes to **P***. There's no such indication in the Control panel or viewfinder, but the shutter speed and aperture can be seen to change.

(A) Aperture priority auto

In Aperture priority (**A**) mode, you control the aperture while the camera sets an appropriate shutter speed that will give correctly exposed results in most situations. Control of aperture is particularly useful for controlling depth of field (see pages 116–7). The range of apertures that can be set is determined by the lens, not by the camera.

Fine-tuning of exposure is possible through exposure lock and exposure compensation, and possibly auto bracketing.

1) To use (**A**) Aperture priority auto mode, select it by rotating the Mode dial to position **A**.

2) Frame the picture.

3) Apply half-pressure to the release button to activate focusing and exposure. The focus point(s) will be displayed in the viewfinder. Shutter speed and aperture settings will appear at the bottom of the viewfinder. Rotate the Sub-command dial to alter the aperture; the shutter speed will be adjusted automatically.

4) Fully depress the shutter release to take the picture.

CHURCHYARD AT COVERHAM, NORTH YORKSHIRE, UK
Aperture-priority mode is ideal when control over depth of field is paramount.

(S) Shutter priority auto

In Shutter priority (**S**) mode, you control the shutter speed while the camera sets an aperture that will give correctly exposed results in most situations. Control of shutter speed is particularly useful when dealing with moving subjects (see pages 119–20). Shutter speeds between 30 sec and 1/4000 sec can be set. Fine-tuning of exposure is possible through exposure lock and exposure compensation, and possibly auto bracketing.

1) To use (**S**) Shutter priority auto, select it by rotating the Mode dial to position **S**.

2) Frame the picture.

3) Apply half-pressure to the release button to activate focusing and exposure. The focus point(s) will be displayed in the viewfinder image and shutter speed and aperture settings will appear at the bottom of the viewfinder. Rotate the Main command dial to alter the shutter speed; the aperture will adjust automatically.

4) Fully depress the shutter release to take the picture.

Warning!

If the shutter speed you've set requires an aperture that is not available with the lens, a warning will be displayed in the viewfinder and control panel: Hi = subject too bright; Lo = subject too dark. Adjust the shutter speed to achieve an acceptable aperture. Alternatively, fit a different lens with a wider maximum aperture, or adjust the ISO sensitivity (see page 66).

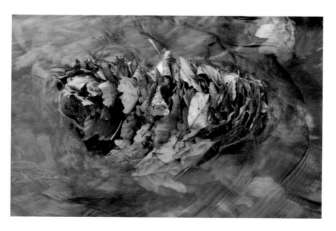

GRIZEDALE BECK, NEAR GARSTANG, LANCASHIRE, UK
After some trial and error, a shutter speed of 1/15 sec gave the desired result for the moving water.

46

(M) Manual mode

In **M** mode, you control both shutter speed and aperture, allowing maximum creative flexibility. Further fine-tuning of exposure is possible through exposure lock and possibly auto bracketing. Manual mode is perhaps best employed when shooting without pressure of time or in fairly constant light conditions. Some experienced photographers use it virtually all the time, because they prefer the feeling of complete control.

Shutter speeds can be set to any value between 30 sec and 1/4000 sec, plus **B** (or 'bulb'), in which the shutter remains open indefinitely while the shutter release is depressed. Manual mode is the only mode which allows this setting. The range of apertures that can be set is determined by the lens that is fitted.

1) To use (**M**) Manual mode, select it by rotating the Mode dial to position **M**.

2) Frame the picture.

3) Apply half-pressure to the release button to activate focusing and exposure. The focus point(s) will be displayed in the viewfinder image and shutter speed and aperture settings will appear in the viewfinder. Check the Analogue exposure display in the centre of the viewfinder and, if necessary, adjust shutter speed and aperture, or both, to achieve correct exposure. Rotate the Main command dial to alter the shutter speed; rotate the Sub-command dial to alter the aperture.

4) Fully depress the shutter release to take the picture.

Using the Analogue exposure displays

In Manual mode, an Analogue exposure display appears both in the centre of the viewfinder readouts and in the control panel, and in the Shooting Information display if it's active. This shows whether the photograph would be under- or over-exposed at the current settings. Adjust shutter speed and/or aperture until the indicator is aligned with the **0** mark in the centre of the display: the exposure now matches the camera's recommendations. The quality of the D90's metering is such that this will generally be correct, but if time allows it is always helpful to review the image and check the histogram display (see page 74) after taking the shot. If necessary, further adjustments can then be made if the camera's recommended exposure does not achieve the desired result, or for creative effect.

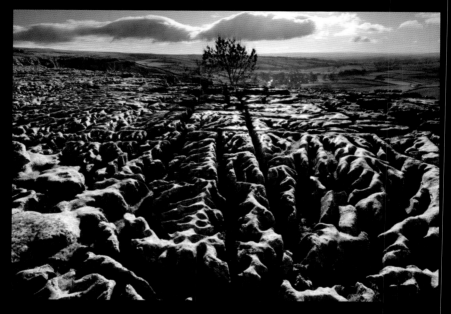

MALHAM COVE, NORTH YORKSHIRE, UK
This was a tricky subject. I used Manual mode
and checked the histogram display on playback
to make sure the exposure was correct, but it
still needed a little work in post-processing.

Settings
ISO: 200
Focal length: 12mm
1/160 sec
f/13

Metering modes

Nikon have a long-standing reputation for the quality of their metering system. The Nikon D90 provides three different metering modes that should cover any eventuality. Switch between them by holding the ◙ Metering selector button and rotating the Main command dial. The viewfinder display shows which metering mode is in use. Note that this is only possible in one of the User-control modes. In all other modes, matrix metering is automatically selected.

3D colour matrix metering II

◙ Using a 1005-segment colour sensor, 3D colour matrix metering II analyzes data on the brightness, colour and contrast of the scene. When used with Type G or D Nikkor lenses, the system also uses information on the distance to the subject to further refine its reading. With other CPU lenses, this range information is not used (colour matrix metering II). Matrix metering is recommended for the vast majority of shooting situations and will nearly always produce excellent results.

Centre-weighted metering

◉ Centre-weighted metering is a very traditional form of metering which will probably be familiar to most experienced photographers. While the camera meters from the entire frame, it gives the greatest weight to the area in the centre of the frame. At default setting, this area is a circle 8mm in diameter. This can be changed to 6mm or 10mm using Custom Setting b3. Centre-weighted metering is particularly useful for photographic genres such as portraiture, where the key subject occupies the central portion of the frame.

Spot metering

⊙ In this mode, the camera meters from a circle only 3.5mm in diameter (just 2.5% of the frame). This circle is centred on the current focus point, allowing you to meter from an off-centre subject, unless Auto-area AF is in use, when the metering point will be the centre of the frame.

KAYAKERS ON ULLSWATER, UK
This was a golden opportunity. I didn't dare leave anything to chance and took some hasty test shots before the kayakers reached me.

Effective use of spot metering probably requires more experience than the other metering modes, but in critical conditions it offers unrivalled accuracy. It is important to understand that spot metering tries to reproduce the subject area as a mid-tone and this must be allowed for (for example, by using exposure compensation) if the subject is significantly darker or lighter than a mid-tone.

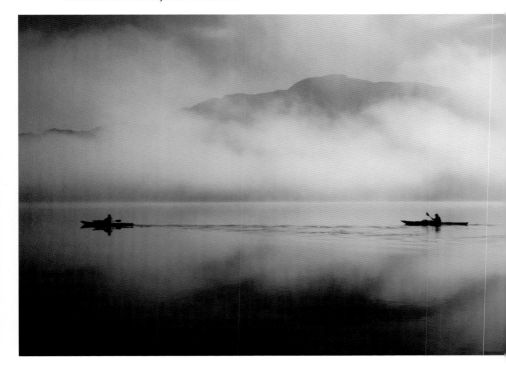

Exposure compensation

The wide range of metering options, and the incredible sophistication of matrix metering in particular, means that the D90 will produce accurate exposures under most conditions. However, no camera is infallible, nor can it read your mind or anticipate your creative intent.

All metering systems are still, to some extent, based on the assumption that key subject areas have a middling tonal value and should be recorded as a mid-tone. Where very light tones predominate, the metering system will tend to reproduce them as mid-tones – that is, darker than they should be. Most photographers will be familiar with the results that sometimes follow, such as snow scenes appearing unduly dark. The converse is naturally true for scenes in which dark tones predominate; they tend to be reproduced lighter than they should be. An example might be a portrait of a person with dark skin.

Unlike film, digital cameras offer instant feedback on exposure, and this can help you to develop the experience required to anticipate the need for exposure compensation. It's always helpful to check the image after shooting, and in particular to study the histogram (see page 74). However, the basic principle is simple: to make the subject lighter (to keep light tones looking light), allow greater exposure – in other words, apply positive compensation. Conversely, to make the subject darker (to keep the dark tones looking dark), allow less exposure by applying negative compensation.

If this proves difficult to judge, try using the camera's exposure-bracketing capability (see page 53).

FUNCTIONS

Tips
If you shoot images in NEF (RAW) format, there is significant scope to adjust the tonal value of your images and recover highlight and shadow detail in post-processing. However, for the best results, there's still no substitute for accurate exposure.

The D90 offers Active D-Lighting (see page 75) and D-Lighting (see page 105), both of which can help to achieve better results in tricky lighting conditions.

Using exposure compensation

1) Exposure compensation can be applied in increments of ⅓ Ev (default), ½ Ev or 1 Ev. Use Custom Setting b1 to change the increment. (Note that this change will also apply to flash compensation).

2) Press the ⊞ button and rotate the Main command dial to set the negative or positive compensation required. The chosen value will be displayed in the control panel and viewfinder. Exposure compensation can be set to a value between -5 Ev and +5 Ev.

3) Release the ⊞ button. The ⊞ symbol will appear in both the control panel and the viewfinder, and the **0** at the centre of the Analog exposure display will flash. The chosen exposure compensation value is shown in the viewfinder display, and can be confirmed on the control panel by pressing the ⊞ button again.

4) Take the photograph as normal. If time allows, check that the exposure achieved is satisfactory.

5) To restore normal exposure settings, press the ⊞ button and rotate the Main command dial until the displayed value returns to **0.0**.

Tips
Remember to reset exposure compensation when you've finished shooting a particular scene, otherwise you run the risk of applying an inappropriate level of exposure compensation to subsequent shots. Exposure compensation is not reset automatically even when the camera is switched off. However, like a number of other settings, it will be restored to its default value by performing a two-button reset (see page 67).

Don't try to use exposure compensation in Manual mode. It only affects the exposure readout, not the actual shutter speed and aperture values. In **M** mode, simply adjust the shutter speed and/or aperture so the Analogue exposure display indicates the desired amount of 'under' or 'over' exposure.

Exposure bracketing

Often the easiest way to ensure that an image is correctly exposed is to take a series of frames at different exposures, and select the best one later. The D90's bracketing facility allows this to be done very quickly, especially if **C**ʜ (Continuous High-speed) release mode is selected.

Using exposure bracketing

1) Select exposure bracketing using Custom Setting e4. Select **AE only** to ensure that only exposure values are varied.

2) While pressing the **BKT** button, rotate the Main command dial to select the number of shots (2 or 3) required for the bracketing burst; the selected number is displayed in the control panel. **+2** means that one shot is taken at the metered exposure and one is 'over-exposed'. **-2** means that one shot is taken at the metered exposure and one is 'under-exposed'. **3** means that one shot is taken at the metered exposure, one 'under-exposed' and one 'over-exposed'.

3) Still pressing the **BKT** button, rotate the Sub-command dial to select the exposure increment between each shot in the sequence. You can choose between ⅓ Ev, ½ Ev, 1 Ev or 2 Ev. This increment is also displayed in the control panel. A **BKT** icon is displayed in the control panel and the ⊠ icon blinks in both the viewfinder and the control panel.

4) Frame, focus and shoot as normal. The camera will vary the exposure with each frame until the sequence is completed. A progress indicator is displayed in the control panel; one segment disappears as each frame is taken.

5) To cancel bracketing and return to normal shooting, press the **BKT** button and rotate the Main command dial until **0F** appears in the control panel. The bracketing increment that you chose using the Sub-command dial will remain in effect next time you initiate bracketing.

If the memory card becomes full before the sequence is complete, the camera will stop shooting. If you replace the card or delete other images to make space, the camera will resume where it left off. Similarly, if the camera is switched off before the sequence is finished, it will resume when it is next switched on.

-1 Ev

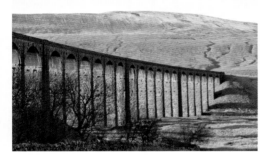

0 Ev

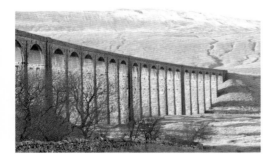

+1 Ev

RIBBLEHEAD VIADUCT, UK
The difference between the three bracketed exposures is clear, but some may prefer the 'under-exposed' shot to the 'correct' one, or feel that the ideal lies somewhere in between.

Tips

The D90 offers several bracketing options, available via Custom Setting e4. The options are AE only, AE and flash, Flash only and WB bracketing. **AE only** is discussed on page 53. **AE and flash** varies both the exposure and the flash level. **Flash only** varies the flash level but not the base exposure. **WB bracketing** varies the white-balance setting.

Using the exposure bracketing feature while shooting moving subjects is not advisable as it's fairly unlikely that the frame which has the optimum exposure will coincide with the subject being in the best position. It's best to use other means to get the exposure right before embarking on an action sequence. (This warning doesn't apply to subjects such as waterfalls which, though clearly moving, remain in the same place).

54

Focusing

The D90's focusing capabilities are flexible and powerful. The selector switch on the front of the camera, close to the lens mount, switches between manual and autofocus, but further options determine the way autofocus operates. There are two autofocus modes: Single-servo AF and Continuous-servo AF. By default, the D90 switches between them automatically, but a manual selection can be made. To select the desired autofocus mode, hold the **AF** button and rotate the Main command dial. The selected mode is shown in the control panel.

Autofocus modes

AF-A (default)	Camera automatically selects between AF-S and AF-C modes.
AF-S	Single-servo AF (right)
AF-C	Continuous-servo AF (below)

(AF-C) Continuous-servo AF

In Continuous-servo AF mode, the camera seeks focus for as long as the shutter release is depressed; if the subject moves, the camera will refocus. The camera is able to take a picture even if perfect focus has not been acquired (release priority).

The D90 employs predictive focus tracking. If the subject moves while Continuous-servo AF is active, the camera analyzes the movement and predicts where the subject will be when the shutter is released.

(AF-S) Single-servo AF

In this mode, the camera focuses when the shutter release is pressed halfway. When focus is acquired, the focus indicator is displayed in the viewfinder. Focus remains locked as long as the shutter release remains depressed. By default, the shutter cannot release to take a picture until focus has been acquired (focus priority).

(M) Manual focus

In the time-honoured fashion, focusing in this mode is performed manually using the focusing ring on the lens.

> **Tip**
> To focus the camera in AF-S or AF-C modes, pressing the **AF-ON** button has the same effect as pressing the shutter release halfway.

AF-area modes

When using autofocus, the AF-area mode determines which focus point or points the camera will employ. By default, the camera does this automatically (Auto-area AF or AF-A) in all shooting modes except 🌷 Close up and 🏃 Sports, in which the centre focus point is selected by default. In effect, it's the camera that decides what the intended subject is. When type G or D lenses are used, the camera can even distinguish a human subject from the background.

However, many photographers prefer to make their own selection. AF-area mode options are selected using Custom Setting a1. An icon in the control panel shows which mode is in operation.

[ɪ] Single-area AF

In Single-area AF mode, the user selects the focus area, using the Multi selector to move quickly through the 11 focus points. The chosen focus point is illuminated in the viewfinder. This mode is best suited to relatively static subjects.

[⫶] Dynamic-area AF

This mode is a little more complicated, as its operation differs depending on whether AF-S or AF-C autofocus mode is selected. In AF-S mode, its operation is essentially the same as Single-area AF.

Dynamic-area AF really comes into its own when using AF-C mode (Continuous-servo AF). The initial focus point is still selected by the user, as in Single-area AF, but if the subject moves, the camera will employ other focus points to maintain focus. This mode is best suited to moving subjects and is the only mode recommended for shooting moving subjects with the D90.

3D tracking (11 points)

The exact operation of this mode depends on whether AF-S or AF-C autofocus mode is selected. In AF-S mode, its operation is essentially the same as Single-area AF.

When using AF-C mode (Continuous-servo AF), the initial focus point is still selected by the user. However, if the camera moves, or you reframe the picture, 3D tracking uses a wide range of information, including subject colours, to maintain focus on the selected subject. You must keep the shutter-release button pressed down halfway for 3D tracking to operate.

Focus points

Early autofocus cameras were rightly criticized for limiting focus to the centre of the frame or to a small number of points. With its 11 focus points covering most of the frame, the D90 has no such limitations, and it's usually possible to make a quick and precise selection to focus accurately on any subject.

Focus point selection

1) Make sure the Focus selector lock (below the Multi selector) is in the unlocked position, opposite the white dot.

2) Using the Multi selector, move the focus point to the desired position. The chosen focus point is illuminated briefly in red in the viewfinder and then remains lightly outlined in black. (Illumination can be switched off using Custom setting a4).

3) Press the shutter-release button halfway to focus at the desired point; depress it fully to take the shot.

NEAR HADRIAN'S WALL, UK
Changing the focus point gives a totally different emphasis to each of these images.

> **Note**
> Custom setting a5 allows you to opt for **Focus point wrap-around**, which means that if you move the point to the edge of the available area, a further press on the Multi selector in the same direction takes it to the opposite edge of the area.

Focus lock

Though the D90's focus points cover a wide area, they do not extend all the way to the edges of the frame, and there may be times when you need to focus on a subject that does not naturally coincide with any of the focus points. To do this, the simplest procedure is as follows:

1) Adjust framing so that the subject falls within the available focus area.

2) Select an appropriate focus point and focus on the subject in the normal way.

3) Lock focus. In Single-servo AF mode, this can be done either by keeping half-pressure on the shutter-release button, or by pressing the **AE-L/AF-L** button. An AE-L icon appears in the viewfinder. In Continuous-servo AF mode, only the **AE-L/AF-L** button can be used to lock focus.

4) Reframe the image and press the shutter-release button fully to take the picture. If half-pressure is maintained on the shutter-release (in Single-servo AF mode), or the **AE-L/AF-L** button is kept under pressure (in either AF mode), focus will remain locked for further shots.

> **Tip**
> At its default setting, the **AE-L/AF-L** button locks exposure as well as focus. This default behaviour can be changed using Custom setting f6.
>
> In Continuous-servo AF mode, if 3D tracking is in operation, the camera will attempt to keep the subject in focus, providing a form of focus lock. However, this only works if the subject is in line with one of the 11 focus points.

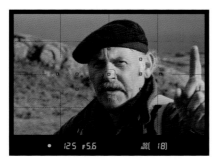

D90 VIEWFINDER
The viewfinder displays the available focus areas as well as an in-focus indicator at the left of the menu bar.

The AF-assist illuminator

The AF-assist illuminator is a small lamp that helps the camera focus in dim light. It requires the camera to be in Single-servo AF mode, and either the central focus point must be selected or Auto-area AF must be engaged. Subject to these conditions, it will illuminate automatically when required. For effective operation, the lens should be in the range 24–200mm and the subject distance should be between 1ft 8in and 9ft 10in (0.5–3m).

Tips
Remove the lens hood to avoid blocking the light from the AF-assist illuminator.

Some lenses are partly or wholly incompatible with the AF-assist illuminator. See the camera manual for details.

The AF-assist illuminator can be turned off using Custom Setting a3.

The AF-assist illuminator can get hot with repeated use and may deactivate itself for a short period to protect the lamp.

Manual focusing

The D90's sophisticated AF capabilities might appear to make manual focus redundant, but many photographers still appreciate the extra level of control and involvement that it offers. There are also certain subjects and circumstances that can bamboozle even the best AF systems. Luckily, the D90's bright, crisp viewfinder makes manual focusing straightforward. To use manual focus, set the focus mode selector to **M** and adjust the focusing ring on the lens to bring the subject into focus.

Tip
Some lenses have an A/M switch. To use manual focus, make sure this is set to **M**.

The electronic rangefinder

When focusing manually in conditions where it would also be possible to use autofocus, the D90 offers confirmation of focus using the electronic rangefinder. This effectively uses autofocus technology to support manual focusing. It requires an appropriate focus area to be selected as if you were using one of the AF modes. When the subject in that area is in focus, a green dot appears at far left of the viewfinder data display.

59

Image quality

In case anyone was wondering, the D90's Image quality settings are not a quick way to ensure great pictures; that is still down to the eye of the photographer (thank goodness). In this context the term 'image quality' refers to the file format, or the way that the image data is recorded.

The D90 offers a choice of two main file types: NEF (RAW) and JPEG. The essential difference between them is that JPEG files undergo significant processing in-camera to produce files that should be usable right away (for instance, for direct printing from the memory card), without the need for further processing on computer.

On the other hand, NEF (RAW) files record the raw data from the camera's sensor 'as is', providing much greater scope for further processing on the computer to achieve exactly the desired pictorial qualities. This requires the use of sophisticated software such as Nikon Capture NX or Adobe Photoshop. Because they preserve the raw data, the generic term for this kind of file is RAW or Camera RAW; NEF (RAW) is a specific file format used by Nikon for RAW files.

As a further refinement, the D90 allows two versions of the same image to be recorded simultaneously

– one NEF (RAW) and one JPEG. The JPEG can be used as a quick reference file for immediate needs while the NEF (RAW) version can be processed on the computer later for the ultimate result.

Setting image quality

There are two ways to set image quality:

1) Hold down the **QUAL** button and rotate the Main command dial until the required setting is displayed in the control panel. This is usually felt to be the easier method.

2) In the Shooting menu, select **Image quality** using the Multi selector, then highlight and select the required setting.

> **Tip**
> The greater the level of JPEG compression, the smaller the resulting file size – but remember that image quality also decreases accordingly. NEF (RAW) files are uncompressed and take up much more space on the memory card, but offer the greatest flexibility and the highest image quality.

Image quality options

NEF (RAW)	12-bit NEF (RAW) files are recorded for ultimate quality and creative flexibility.
JPEG fine	8-bit JPEG files are recorded with a compression ratio of approx 1:4, which should be suitable for prints of A3 size or even larger.
JPEG normal	8-bit JPEG files are recorded with a compression ratio of approx 1:8, which should be suitable for modest-sized prints.
JPEG basic	8-bit JPEG files are recorded with a compression ratio of approx. 1:16, suitable for transmission by email or website use but not recommended for printing.
NEF (RAW) + JPEG fine **NEF (RAW) + JPEG normal** **NEF (RAW) + JPEG basic**	With all three of these options, two copies of the same image are recorded simultaneously: one NEF (RAW) and one JPEG at the chosen compression ratio.

Image size

With the exception of NEF (RAW) files, which are always recorded at the maximum size, the D90 offers three options for image size. **Large** is the maximum available size from the D90's sensor, i.e. 4288 × 2848 pixels. **Medium** is 3216 × 2136 pixels, roughly equivalent to a 6-megapixel camera. **Small** is 2144 × 1424 pixels, roughly equivalent to a 3-megapixel camera. It's perhaps worth noting that even Small images exceed the maximum resolution of almost any computer monitor or HD TV, and can yield good quality prints up to around 10 × 7in at 200 dpi.

Setting image size

There are two ways to set image size:

1) Hold down the **QUAL** button and rotate the Sub-command dial until the required setting is displayed in the Control panel. This is usually felt to be the easier method.

2) In the Shooting menu, select **Image size** using the Multi selector, then highlight and select the required setting.

The buffer

Images are initially stored in the camera's internal memory ('buffer') before being written to the memory card. The maximum number of images that can be recorded in a continuous burst depends upon file quality, release mode, memory card, and how much buffer space is available. The figure for the number of burst frames possible at current settings is shown in the viewfinder at bottom right. (This figure assumes Continuous High-speed shooting, and is displayed even if another release mode is selected). If **(0)** appears, the buffer is full, and the shutter will be disabled until enough data has been transferred to the memory card to free up space in the buffer. This will normally only be an issue when shooting lengthy bursts in **Cн** (Continuous High-speed) release mode, and usually results in a noticeable slowdown (to approximately 2 frames per second) rather than a complete halt.

62

White balance

Light sources, both natural and artificial, vary enormously in colour. The human eye and brain are very good, though not perfect, at compensating for this and seeing people and objects in their 'true' colours under a wide range of conditions, so that we nearly always see grass as green, for example.

In the days of film, and especially slide film, achieving natural-looking results often required careful use of a range of filters. Digital cameras have a much greater capacity to compensate for the varying colours of light and, when used correctly, the D90 can produce natural-looking colours under almost any conditions.

The D90 has a sophisticated system for determining the correct white balance automatically, which produces very good results most of the time. For finer control, or to achieve particular creative effects, the D90 also offers a wide range of user-controlled settings.

Setting White balance

There are two ways to set White balance:

1) Hold down the **WB** button and rotate the Main command dial until the required symbol is displayed in the control panel.

2) In the Shooting menu, select **White balance** using the Multi selector, then highlight and select the required setting. In most cases, a graphical display appears, with which you can fine-tune the setting using the Multi selector. Alternatively, just press **OK** to accept the standard value. When you select **Fluorescent**, however, a sub-menu appears from which you can select the appropriate variety of fluorescent lamp (see page 64).

Notes
If you use the **WB** button and Main command dial to choose the **Fluorescent** setting, the precise value will be the one that was last selected in the sub-menu under the Shooting menu (the default is **4: Cool-white fluorescent**).

Manual white-balance setting is only available in **P**, **S**, **A** and **M** modes.

White-balance settings

Icon	Menu option	Colour temp (°K)	Description
AUTO	Auto	3500–8000	Camera sets WB automatically, based on information from imaging and metering sensors. Most accurate with Type G and D lenses.
☀	Incandescent	3000	Use in incandescent (tungsten) lighting, e.g. traditional household bulbs.
▤	Fluorescent:		
	1 Sodium-vapor lamps	2700	Use in sodium-vapour lighting, often used in sports venues
	2 Warm-white fluorescent	3000	Use in warm-white fluorescent lighting
	3 White fluorescent	3700	Use in white fluorescent lighting
	4 Cool-white fluorescent	4200	Use in cool-white fluorescent lighting
	5 Day white fluorescent	5000	Use in daylight white fluorescent lighting
	6 Daylight fluorescent	6500	Use in daylight fluorescent lighting
	7 High temp. mercury-vapor	7200	Use in high colour-temperature lighting, e.g. mercury-vapour lamps
☀	Direct sunlight	5200	Use for subjects in direct sunlight
⚡	Flash	5400	Use with built-in flash or separate flashgun. Value may require fine-tuning with large-scale studio flash
☁	Cloudy	6000	Use in daylight, under cloudy/overcast skies
⌂	Shade	8000	Use on sunny days for subjects in shade
K	Choose color temp.	2500–10,000	Select colour temperature from list of values
PRE	Preset Manual	n/a	Derive white balance direct from subject or light source, or from an existing photo

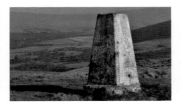

Direct sunlight

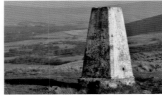

Incandescent

WHITE-BALANCE COMPARISON

These shots were taken with six different white-balance settings. The differences between them are clearly visible.

FUNCTIONS

Cool-white fluorescent

Flash

Cloudy

Shade

Notes

When shooting NEF (RAW) images, the in-camera white-balance setting is less crucial as white balance can be adjusted in later processing.

Sometimes you may not want to 'correct' colours too much. One example is shooting a landscape in the warm light of early morning or late evening, where the red hue of the sunlight is part of the appeal. Auto White Balance may neutralize this effect. To avoid this, set the White balance to Direct sunlight.

Domestic energy-saving lightbulbs are compact fluorescent units. Their colour temperature is around 2700°K, equivalent to the setting **Fluorescent 1: Sodium-vapor lamps**.

ISO sensitivity settings

The ISO sensitivity setting governs the sensor's response to greater or lesser amounts of light. At higher ISO settings, less light is needed to capture an acceptable image. Higher ISO settings are obviously suitable for lower light levels, but they are also useful when you need to use a small aperture for increased depth of field (see pages 116–7) or to use a fast shutter speed to freeze rapid movement (see page 119). Lower ISO settings are useful in brighter conditions, and/or when you want to use wide apertures or slow shutter speeds. The D90 offers ISO settings from 200 to 3200. There is some tendency for image noise to increase at higher settings, though the D90 manages this very well.

There are also **Hi** and **Lo** settings outside the standard range, but these should be used circumspectly. The **Lo** settings are -0.3 (equivalent to 160 ISO), -0.7 (125 ISO) and -1.0 (100 ISO). The **Hi** settings are +0.3 (equivalent to 4000 ISO), +0.7 (5200 ISO) and +1.0 (6400 ISO).

Setting the ISO

The most convenient way to set the ISO is normally by pressing the **ISO** button on the back of the camera and rotating the Main command dial until the desired setting is shown in the control panel and viewfinder.

Alternatively, use the **ISO sensitivity settings** item in the Shooting menu.

A third option is also available in certain exposure modes, if **Show ISO/Easy ISO** is selected in Custom Setting d3. In exposure modes **P** and **S**, the ISO setting can then be changed using the Sub-command dial. In exposure mode **A**, it can be changed using the Main command dial.

Colour space

The D90 offers a choice between **sRGB** and **Adobe RGB** colour spaces; these define the range (or gamut) of colours which are recorded. **sRGB** (the default setting) has a narrower gamut but images often appear brighter and more punchy. It's the colour space typically used on the internet and in most high-street photo printers, and is a safe choice for images that are likely to be used or printed with little or no post-processing. **Adobe RGB** has a wider gamut and is commonly used in professional printing. It's a better choice for images destined for professional applications or where significant post-processing is anticipated. To select the colour space, use the **Color space** item in the Shooting menu.

Two-button reset

The Nikon D90 offers a quick way to reset a large number of camera settings (listed below) to their default values. To carry out a two-button reset, hold down the ⚡ and AF buttons (marked with green dots) together for at least two seconds. The control panel will blank out briefly while the reset is completed.

Default setting		
Image quality	JPEG Normal	
Image size	Large	
Release mode	Single frame	
ISO sensitivity	Auto and scene modes	Auto
	User-control modes	200
White balance	Auto (fine tuning off)	
Nikon Picture Controls	Standard settings only	
Autofocus mode	AF-A 🐦, 🖼	Face-priority
Autofocus mode (Live View)	📷,🕗,🏔,🏃, P, S, A, M	Wide-area
	🌷	Normal-area
Focus point	Centre	
Metering	Matrix	
AE/AF lock hold	Off	
Flexible program	Off	
Exposure compensation	Off	
Flash compensation	Off	
FV lock	Off	
Bracketing	Off	
Flash mode	📷, 🐦, 🌷	Auto front-curtain sync
	🖼	Auto slow sync
	P, S, A, M	Front-curtain sync

Live View

The D90's Live View mode enables photographers to frame pictures using the LCD screen rather than the viewfinder, in just the way that many compact digicam users are accustomed to doing. While the viewfinder is undoubtedly superior for most normal picture-taking, Live View can prove invaluable under certain conditions, notably where it's awkward to use the viewfinder – for instance in a crowd, where you may want to hold the camera overhead. Live View also lends itself to use when framing pictures carefully with the camera on a tripod – and of course it is key to the D90's ground-breaking movie-capture feature.

Using Live View

To activate Live View, press the **Lv** button on the rear of the camera. The mirror flips up and the viewfinder blacks out, while the rear monitor screen displays a continuous live preview of the scene, just like on a compact camera. A range of shooting information is displayed at top and bottom of the screen, partly overlaying the image. You can hide most of this information by pressing the **INFO** button. When you press the release button fully, the mirror flips down again briefly, presumably to allow exposure to be set. This gives a pronounced 'double-click' effect, which is initially disconcerting. This happens even if the exposure mode is set to Manual. Inevitably this does slow the camera's response slightly. If you're shooting in **CH** or **CL** release mode, the mirror stays up, and the monitor remains blank, between shots. This does make it

hard to follow a moving subject. In Single-frame mode, too, Live View display is only resumed when you lift your finger off the shutter-release button. To exit Live View, press the **Lv** button again.

Tip
Pressing the **INFO** button a second time displays grid lines on the monitor, useful for precise framing and levelling (for instance when shooting architectural subjects). Pressing the button a third time cycles back to the standard Live View display.

68

Focusing in Live View

The focus area, a red rectangle, can be positioned anywhere on the screen. In Live View mode, the camera takes its focus information directly from the main image sensor. Though slower than normal AF operation, it is impeccably accurate, and you can also zoom in on a small portion of the scene for a critical focus check. This can be useful when ultra-precise focusing is required, as in macro work. However, it means that focusing works in a different way from normal, with a different set of autofocus modes (see table below). It's also possible to focus manually. When manual focus is set (with the focus mode

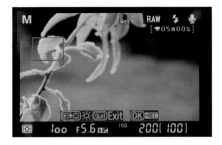

switch), the Live View display still shows a red rectangle, the same size as for 🄴🄹 Wide-area AF. This no longer has a direct bearing on focusing, but if you zoom in, the zoom still centres on this area.

AF mode	Description	Default in these shooting modes
😀 Face priority	Uses face-detection technology to identify portrait subjects. A double yellow border appears outlining such subjects. If multiple subjects are detected, the camera focuses on the closest.	🐕, 🖼
🄴🄹 Wide-area	Camera analyzes focus information from an area approximately ⅓ the width and height of the frame. The area is shown by a red rectangle.	AUTO ⏱, ⚡, 🏞, 🏃, P, S, A, M
🄴🄹 Normal-area	Camera analyzes focus information from a much smaller area, shown by a red rectangle.	🌷

FUNCTIONS

Selecting the AF mode

In Live View mode, the autofocus mode is selected by holding down the **AF** button and rotating the Main command dial. The selected mode is indicated in the monitor only, not on the Control panel.

If [WIDE] **Wide-area AF** or [NORM] **Normal-area AF** is selected, the focus point can be moved anywhere on the screen by using the Multi selector in the usual way.

Tips
Because of the slower response, Live View mode can be slightly awkward for hand-held shooting, especially with moving subjects.

Having taken great pains with precise focusing in Live View, the last thing you want is for your pictures to be marred by camera shake. To avoid this, use the self-timer or an optional remote release. A third alternative is Exposure delay mode, accessed through Custom Setting d10 (see page 96).

Pressing \oplus zooms the screen view – press it repeatedly to zoom in closer. Helpfully, the zoom is centred on the same area as the focus point. All this allows for ultra-precise focus control, which is easiest to exploit when shooting on a tripod and is absolutely ideal for macro photography (see pages 168–79). When the focus point is set, autofocus is activated as normal by half-pressing the shutter-release button.

Shooting movies

Live View is the jumping-off point for shooting movies with the D90. This is examined in detail on pages 180–95.

CYCLAMEN
Live View is a good choice for shooting static subjects where precise focusing is required.

Image playback

The Nikon D90's large, bright, high-resolution LCD screen makes image playback far more informative than on any earlier model. At the default settings, the most recent image is automatically displayed immediately after shooting, as well as whenever the ▶ button is pressed.

If CH or CL release modes are in use, playback only begins after the last image in a burst has been recorded, and images are then shown in sequence. This default behaviour, and many other playback options, can be changed via the Custom Setting menu (see page 88).

FUNCTIONS

Viewing additional pictures

To view images on the memory card other than the one most recently taken, scroll through them using the Multi selector. Scroll right to view images in the order of capture, and scroll left to view in reverse order ('go back in time').

Viewing images as thumbnails

To view more than one image at a time, press the Q▧ button once to display four images, twice to display nine images, or three times for 72 images. Use the Multi selector to scroll up and down. The currently selected image is outlined in yellow. To return to full-frame view, press the Q button once or more, as required.

Viewing photo information

The D90 records a great deal of detailed information about each image taken, and this can also be viewed on playback. Using the Multi selector, you can scroll through up to seven pages of information.

To view the three pages of Shooting Data, select **Playback mode** in the Playback menu and ensure that **Data** is checked. To make the RGB histogram display available (see page 74), select **Playback**

mode in the Playback menu and ensure that **RGB histogram** is checked. (To make changes effective you must scroll up to **Done** and press the **OK** button). GPS data is also available if a GPS device was connected to the camera during shooting (see page 243). If the options above are unchecked, only two pages are displayed: a full-screen review image and an overview page that includes basic information and a simplified histogram.

NARROWBOAT AT GARSTANG, LANCASHIRE
This image needed to sparkle but without losing detail in the highlights, so I checked the Highlight display after shooting.

Highlights

When in full-frame playback, the D90 can be set to display a flashing warning for any areas of the image that contain 'burnt-out' highlights, or 'clipping' – that is, areas that are completely white with no detail recorded (see page 135). This is a quick way of checking that an image is correctly exposed and is more objective than relying solely on a general impression of the image on the monitor.

Playback zoom

To assess sharpness or critically review an image, you can zoom in on a section of it during playback. The maximum magnification is approximately 27× for large images such as NEF (RAW) files.

1) Press the ⊕ button to zoom in on the image currently being displayed (or, in thumbnail view, the selected image). Press the ⊕ button repeatedly to increase the magnification. A small navigation window appears briefly, with a yellow outline that indicates the area currently visible in the monitor.

2) Use the Multi selector to view other areas of the image.

3) Rotate the Main command dial to view corresponding areas of other images at the same magnification.

4) To return to full-frame viewing, press the **OK** button to return instantly to full-frame view. Or exit playback by pressing the ▶ button or shutter-release button.

> **Tip**
> The camera can detect up to 10 faces in photos during playback zoom; any faces detected are outlined in white. Use the Sub-command dial to scroll quickly between faces. If only one face is detected, a touch on the Sub-command dial centres the zoom area on that face.

72

Calendar view

An extension to Thumbnail view, Calendar view displays images grouped by the date on which they were taken. Press the ⊖✖ button repeatedly to display 72 images, then press once more to reach the first

Tips
If you press **OK** in Calendar view, you do get a full-frame view, but pressing **OK** again takes you to the Retouch options screen (see page 104). There does not seem to be a quick way back to Calendar view from this point (pressing ▶ and then pressing ⊖✖ four times appears to be the only way).

calendar page, with the most recent date highlighted, and pictures from that date in a vertical strip on the right (the thumbnail list). Use the Multi selector to navigate to different dates. Press ⊖✖ again to enter the thumbnail list and scroll through pictures taken on the selected date. Press ⊕ to see a larger, but not full-screen, preview of the currently selected image.

Deleting images

To delete either the current image or the selected image in thumbnail view, press the 🗑 button. A confirmation dialogue appears. To confirm the deletion, press the 🗑 button again; to cancel it, press the ▶ button.

In Calendar view (see above) you can also delete all images taken on the selected date. To do so, press 🗑; when the confirmation dialogue appears, press 🗑 again to delete or ▶ to cancel.

Protecting images

To protect either the current image or the selected image in thumbnail view from accidental deletion, press the �🔑 button. To remove the protection, press the �🔑 button again.

Tips
Even protected images will be deleted when the memory card is formatted.

FUNCTIONS

Histogram displays

A histogram is a graphic depiction of the distribution of dark and light tones in an image. As a way of assessing whether an image is correctly exposed it's much more precise than just looking at the full-frame playback – especially in bright conditions, which make it hard to see the screen image clearly.

A single histogram is always available during playback, on the overview page. By selecting the **Playback mode** option in the Playback menu and checking **RGB histogram**, you gain access to a more detailed display that shows individual histograms for the three colour channels (red, green and blue).

The histogram display is arguably the single most useful feature of image playback and it's certainly the one I use most often. Learning to interpret the histogram is key to achieving the best results with the D90.

A typical histogram showing the overall spread of tones within the image (top) and the individual red, green and blue color channels (below).

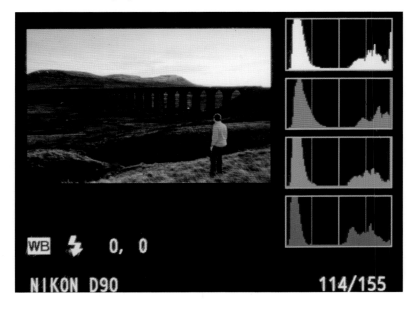

Image enhancement

The D90 provides powerful facilities for adjusting and enhancing images in-camera. This is facilitated by developments in the on-board software and by the quality of the LCD screen, which makes critical viewing of images much easier than in earlier models (although direct sunlight still reduces the screen's effectiveness).

To avoid confusion, it is crucial to distinguish between **Active D-Lighting**, an adjustment option that is applied before shooting an image, and the similarly named **D-Lighting** which – along with a number of other controls, all accessed from the Retouch

menu (see pages 104–5) – is applied after shooting to images already stored on the memory card.

Aside from all the regular user-controlled settings – exposure, white balance and so on – there are two main methods by which the Nikon D90 can enhance the qualities of an image: Nikon Picture Controls (see page 76) and Active D-Lighting.

> **Note**
> These enhancement settings are useful for improving the quality of JPEG images. Although they can be accessed while shooting NEF (RAW) files, they have no effect on the basic raw data. Picture Control settings can be applied to NEF (RAW) files when they are opened using Nikon View NX or Nikon Capture NX software, but software packages from other manufacturers will not recognize them.

Active D-Lighting

Active D-Lighting is designed to enhance the D90's already outstanding ability to capture detail in both highlights and shadows in scenes that show a wide range of brightness values, or 'dynamic range'. In simple terms, it reduces the overall exposure in order to improve capture in the brightest areas, while mid-tones and shadows are adjusted subsequently as the camera processes the image.

1) In the Shooting menu, select **Active D-Lighting**.

2) From the list of options, select **Off**, **Low**, **Normal**, **High**, **Extra high** or **Auto** to determine the strength of the effect. Press **OK**.

ADL bracketing

It's possible to set the camera to take two shots, one with Active D-Lighting off and one with it on, using the currently selected setting (see page 75).

1) In the Custom Setting menu, set Custom setting e4 to **ADL bracketing**.

2) Hold down the **BKT** button and rotate the Main command dial until a progress indicator appears in the Control panel.

From now on, alternate shots will be taken with and without Active D-Lighting, until bracketing is cancelled. To do this, either repeat step 2 until the progress indicator disappears, or change the setting again in Custom setting e4.

Note
The **Active D-Lighting** item in the Shooting menu can only be accessed in **P**, **S**, **A** or **M** modes. It is set to **Auto** by default. The inference is that in Full Auto and Scene modes, it is also set to Auto with no option to override.

Using Nikon Picture Controls

Nikon Picture Controls offer another way to influence the way in which the image is processed, especially in relation to qualities such as contrast, colour balance and colour saturation.

The D90 offers a small selection of six preset Picture Controls, with self-explanatory names such as Neutral, Vivid and Monochrome. You can fine-tune the settings for each of these, and also create and save your own Custom Picture Controls either in-camera or using the Picture Control Utility included with Nikon View NX. Optional Picture Controls are available for download from Nikon websites (see page 253).

1) Select **Set Picture Control** from the Shooting menu.

2) Use the Multi selector to highlight the required Picture Control and press **OK**.

76

Modifying Picture Controls

Both the pre-loaded Nikon Picture Controls and Custom Picture Controls from other sources can be modified in-camera. Use the Quick Adjust function to make swift, across-the-board changes or make manual adjustments to specific parameters such as Sharpening and Contrast.

1) From the Shooting menu, select **Set Picture Control**. Use the Multi selector to highlight a Picture Control and press ▶.

2) Scroll up or down with the Multi selector to select **Quick Adjust** or one of the specific parameters. Use ▶ or ◀ to change the value as desired.

3) When all parameters are as required, press **OK**. The modified values are retained until that Picture Control is modified again, or reset to default.

> **Tip**
> The controls for Sharpening, Saturation and Hue are always available, but Contrast and Brightness can only be changed if Active D-Lighting has previously been set to **OFF**.

Creating Custom Picture Controls

You can create up to nine additional Picture Controls, either in-camera or using the Picture Control Utility included with Nikon View NX (see pages 239–40).

Custom Picture Controls can also be shared with other Nikon DSLRs (see the D90 manual and the Help pages within the Picture Control Utility software).

Creating Custom Picture Controls in-camera

1) From the Shooting menu, select **Manage Picture Control**. Select **Save/edit** and press ▶.

2) Use the Multi selector to highlight an existing Picture Control and press ▶.

3) Edit the Picture Control as described above. Press **OK**.

4) Select a destination for the new Picture Control. By default, the new setting takes its name from the existing Picture Control on which it is based, with the addition of a 2-digit number, but you can give it a new name, up to 19 characters long, using the Multi selector to select text (see page 81).

5) Press **OK** to store the Picture Control.

Using the D90 menus

The numerous options you can access via buttons and command dials are just the tip of the iceberg. The full power of the D90 is only unleashed when you delve into its menus. There are six:

- Playback menu
- Shooting menu
- Custom Setting menu
- Setup menu
- Retouch menu
- My Menu

The menu screen also shows a **?** icon but there isn't a separate Help menu, as such; instead, you can access help from within the other menus by pressing the ⊙⊓ button. Help is available when the **?** icon appears in the monitor's bottom-left corner.

The Playback menu, underlined in blue, is used to control functions related to playback, such as viewing, naming and deleting images. The Shooting menu, underlined in green, is used to control shooting settings such as ISO speed or White balance (also accessible via buttons and dials) as well as Picture Controls and Active D-Lighting. The Custom Setting menu, underlined in red, is where you can fine-tune many aspects of the camera's operation. The Setup menu, underlined in orange, is used for functions such as LCD brightness and language and time settings. The Retouch menu, underlined in purple, is used to create modified copies of images already on the memory card. Finally, My Menu/Recent Settings, underlined in grey, is a handy place to store items from any of the other menus that you find yourself using most frequently.

Navigating the menus

1) To display the menu screen, press **MENU**.

2) Scroll up or down with the Multi selector to highlight the menus. To select the desired menu, press ▶ or **OK**.

3) Scroll up or down with the Multi selector to highlight the different menu items. To select a particular item, press ▶ or **OK**. In most cases this will take you to a further set of options.

4) Use the Multi selector to choose a setting. To select it, press ▶ or **OK**.

5) To return to the previous screen, press ◀ or press **MENU**. To exit the menus completely without making any changes, semi-depress the shutter-release button.

The Playback menu

The D90's Playback menu contains nine different options that affect how images are viewed, stored, deleted and printed. It is only accessible when a memory card is present in the camera.

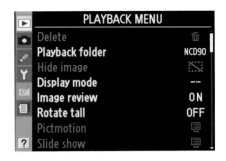

PLAYBACK MENU

Delete	🗑
Playback folder	NCD90
Hide image	
Display mode	--
Image review	ON
Rotate tall	OFF
Pictmotion	
Slide show	

Delete

Images stored on the memory card can be deleted either singly or in batches.

1) In the Playback menu, highlight **Delete** and press ▶.

2) In the menu options screen, choose **Selected**. Images in the active playback folder or folders (see page 85) are displayed as thumbnail images.

3) Use the Multi selector to scroll through the displayed images. Press and hold the ⊕ button to view the highlighted image full-screen. Press the ⊕ button to mark the highlighted shot for deletion. It will be tagged with a 🗑 icon. Press it again to remove the tag.

4) Repeat steps 1–3 to select further images. (To exit, press **MENU**.)

5) Press **OK** to see a confirmation screen. Select **YES** and press **OK** to delete the selected image(s); to exit, select **NO**.

Delete all

1) To delete all images on a card, highlight **Delete** and press ▶.

2) In the menu options screen, choose **All**.

3) Press **OK** to see a confirmation screen. Select **YES** and press **OK** to delete all the image(s); to exit without deleting any images, select **NO**.

> **Tips**
> Individual images can also be deleted when you are using the playback screen, and this is usually more convenient (see page 71).
>
> When using large-capacity memory cards, deleting all images manually can take some time. It is generally more efficient to format the card instead (see page 31). Bear in mind that formatting the card will remove protected or hidden images.

Date

This function allows you to delete all images taken on a selected date.

1) In the Playback menu, highlight **Delete** and press ▶.

2) In the menu options screen, choose **Date** and press ▶. A list of dates appears (corresponding to images on the memory card), with a sample image shown for each date. Scroll up or down to the desired date and press ▶ to select it.

3) Press **OK** to delete all images taken on that date. Or, to review those images, press ⊖⊠. You can scroll through the thumbnails with the Multi selector and press ⊕ to see an image full-screen, but you can't zoom in any further. Press ⊖⊠ again to return to the date-selection screen.

4) With one or more dates checked, press **OK** to see a confirmation screen. Select **YES** and press **OK** to delete all image(s); to exit without deleting any images, select **NO**.

Playback folder

By default, the D90's playback screen will only display images created on the D90. If a memory card is inserted that contains images captured on a different camera model, they will not be visible unless the default option is changed in the Playback folder menu, as shown below.

Note
The active folder is chosen via the Shooting menu (see page 85).

Playback folder options	
Current (default)	Displays images in the current folder only
All	Displays images in all folders on the memory card

Hide image

Hidden images are protected from deletion and cannot be seen in normal playback. They can only be seen using this menu.

1) In the Playback menu, highlight **Hide image** and press ▶.

2) In the menu options screen, choose **Select/set**. The images in the active playback folder(s) are displayed.

3) Use the Multi selector to scroll through the displayed images. Press and hold the

🔍 button to view the highlighted image full-screen. Press the 🔍✉ button to mark the highlighted shot to be hidden. It will be tagged with a 🔲 icon. If you change your mind, highlight a tagged image and press 🔍✉ again to remove the tag.

4) Repeat steps 1–3 to select further images. (To exit without hiding any images, press **MENU**.) Select **DATE** to hide all images taken on a particular date.

5) Press **OK** to complete the process.

Display mode

This menu enables you to choose what (if any) information about each image will be displayed on playback. To make checked options effective in this menu, you must scroll up to **Done** at the top of the screen and then press **OK**.

Display mode options

Detailed photo info	Highlights	Areas of 'blown' highlights are shown as black blinking areas in full-screen playback.
	RGB histogram	Makes available a separate playback page with histograms for the three individual colour channels.
	Data	Makes available three further playback pages containing detailed information about the image.

Image review

If Image review is set to **ON** (the default setting), images are automatically displayed on the monitor after shooting. If it is set to **OFF**, they can only be displayed by pressing the ▶ button. This helps to conserve battery power.

Rotate tall

Rotate tall enables you to determine whether portrait format ('tall') images will be displayed 'the right way up' during playback. If it is set to **OFF**, which is the default, these images will not be rotated, meaning that you need to turn the camera through 90° to view them correctly. If it is set to **ON**, these images will be displayed at the correct orientation, but because the monitor screen itself has a landscape orientation, they will appear smaller. This option is probably most useful when displaying images on a TV or similar.

Slide show

This enables you to display images as a standard slide show, without the music and fancy transitions of Pictmotion (see opposite). All the images in the folder or folders selected for playback (under the Playback folder menu, see page 80) will be displayed in chronological order.

1) In the Playback menu, select **Slide show**.

2) Select **Frame interval**. You can choose between intervals of 2, 3, 5 or 10 seconds. Press **OK**.

3) Select **Start** and press ▶ or **OK**.

4) When the show ends, a dialogue screen is displayed. Select **Restart** and press **OK** to play again. Select **Frame interval** and press **OK** to return to the Frame interval dialogue. Select **Exit** and press **OK** to exit.

5) If you press **OK** during the slide show, the slide show is paused and the same screen is displayed. The only difference here is that if you select **Restart** and press **OK**, the show will resume where it left off.

82

Pictmotion

Pictmotion is a specialized form of slide show, in which selected images can be played back on the monitor or through an external device such as a TV.

1) In the Playback menu, select **Pictmotion**.

2) To select which pictures to display, choose **Select Pictures**. The options are **ALL**, **DATE**, and **Selected**, all of which work in the same way already described for Delete (see page 79). When the required pictures are selected, press **OK** to return to the main Pictmotion screen.

3) Select **Background music** to choose the music which accompanies the display. Choose **Effects** to select the transition between one picture and the next.

4) In the main Pictmotion screen, press **OK** to start the show. Press **OK** again to pause; you then have options to **Restart** or **Exit**. Use ⊖ and ⊕ to adjust the sound volume. **MENU** takes you back to the Playback Menu; ▶ takes you to standard image playback. Half-press the shutter-release to go to shooting mode.

FUNCTIONS

Print set (DPOF)

This allows you to select image(s) to be printed when the camera is connected to, or the memory card is inserted into, a printer that complies with the DPOF (Digital Print Order Format) standard. For more on printing, see pages 233–4.

Note
NEF (RAW) images cannot be selected for printing by this method.

The Shooting menu

The Shooting menu contains
numerous options, but many
of them are also accessible via
the buttons and dials and have
already been discussed, so they
can be dealt with briefly here.

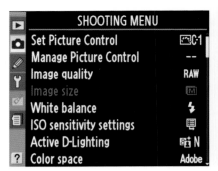

Set Picture Control and Manage Picture Control

These menus govern the use of Nikon
Picture Controls (see pages 76–7).

Set Picture Control is only available in
P, **S**, **A** and **M** exposure modes.

Image quality

Use this option to choose between NEF
(RAW) and JPEG options (see page 60).

Note
If RAW is selected for Image quality,
the **Image quality** menu item is
greyed out and cannot be accessed.

Image size

Use this option to choose between
Small, **Medium** and **Large** image
sizes (see page 62).

White balance

This menu allows you to set the White
balance, (see page 63). It is only available
in **P**, **S**, **A** and **M** exposure modes.

ISO sensitivity settings

This menu governs the ISO sensitivity
setting (see page 66).

Active D-Lighting

Governs the use of Active D-Lighting (see
page 75). This feature is only available in
P, **S**, **A** and **M** exposure modes.

Color space

The Color space menu option allows you to choose between **sRGB** and **Adobe RGB** colour spaces (see page 66).

High ISO NR

Photos taken at high ISO settings can also be subject to increased 'noise'. Normally, High ISO NR (noise reduction) comes into play at ISO settings of 800 and above, and the default setting of **Normal** applies a middling amount of NR. This can be changed to **Low** or **High**. High ISO NR can also be set to **OFF**, but a modest amount of NR will still be applied to images taken at the extreme settings of Hi 0.3 or above.

Long exp. NR

Photos taken at long shutter speeds can be subject to increased 'noise' and the D90 offers the option of extra image processing to counteract this. If Long exposure noise reduction – to give it its full name – is **ON**, it comes into play when exposure times of 8 sec or more are used. During the processing, **Job nr** appears, blinking, in the viewfinder and Control panel. The time this takes is roughly equal to the shutter speed in use, and no further pictures can be taken until the processing is complete. This can cause significant delays in shooting and many users prefer to use post-processing to reduce image noise instead. For this reason, Long exp. NR is **OFF** by default.

Active folder

By default the D90 stores images in a single folder (named 100NCD90). If multiple memory cards are used they will all end up holding folders of the same name. This isn't usually a problem but some photographers might wish to avoid it. You might also want to create specific folders for different shoots or different types of image. Generally, it is organizing your images on the computer after shooting that really matters, but having separate folders in the camera might also be useful.

However, you can't give these folders any name you like: only the last five digits of the name are editable. (The first three digits are hidden when you use this menu, but the full name appears when the camera is connected to a computer).

Creating a new folder number

1) In the Shooting menu, select **Active folder** and press **OK**.

2) Select **New** and press **OK**.

3) A screen of letters and numbers will appear. Use the Multi selector to highlight the required character. Press ⊕ to insert it in the name field. Hold down ⊝ and use the Multi selector to move around in the naming field.

4) Press **OK** to create the new folder and return to the Shooting menu. It automatically becomes the active folder. You can also rename an existing folder: at step 2 above select **Rename** and press **OK**; the procedure is then very similar.

Changing the active folder

This assumes you have previously created more than one folder.

1) In the Shooting menu, select **Active folder** and press **OK** or ▶.

2) Select **Select folder** and press **OK** or ▶.

3) Scroll up or down the list. To select the highlighted folder, press **OK** or ▶. To exit without making a change, press **MENU**.

Movie settings

This menu has two sub-menus. The first is **Quality** (which really should be called Size). This sets the image size for movie recording. The options are 640 × 424 pixels (default), 320 × 216 pixels, or 1280 × 720 pixels.

Sound determines whether sound will be recorded with the movie, and has two self-explanatory settings: **On** and **Off**.

Multiple exposure

Given the ease with which images can be combined on the computer, this facility may seem superfluous. However, the Nikon manual states that 'multiple exposures ... produce results with colours noticeably better than photographs combined in an imaging application, because they make use of RAW data from the camera image sensor.' It's not clear how this would apply if you shot individual RAW images for careful post-processing before combining them on the computer, but this feature does offer a quick way to combine images for immediate use – for example, as JPEG files for printing. It is only available in **P**, **S**, **A** and **M** exposure modes.

Creating a multiple exposure

1) In the Shooting menu, select **Multiple exposure** and press **OK**.

2) Select **Number of shots** and use the Multi selector to choose between 2 or 3. Press **OK**.

3) Select **Auto gain** and choose **ON** or **OFF** (see note below) then press **OK**.

4) Select **Done** and press **OK**.

5) Frame the photo and shoot as normal. If Cʟ (Continuous Low-speed) or Cʜ (Continuous High-speed) is selected as the release mode, the designated number of images will be exposed in a single burst. In **S** (Single Frame) release mode, one image in the sequence will be exposed each time the shutter-release is pressed. Normally the maximum interval between shots is 30 sec. This can be extended by setting a longer monitor-off delay in Custom Setting c4. The maximum interval is 30 sec longer than the monitor-off delay.

Tip
Multiple exposure is automatically reset to **OFF** after the designated number of shots is taken. To create another Multiple exposure, return to the Multiple exposure menu and repeat the steps above.

Note
Auto gain (**ON** by default) adjusts the exposure, so that if you are shooting a sequence of three shots, each is exposed at ⅓ the exposure value required for a normal exposure. You might turn Auto gain **OFF** if a moving subject is well lit but the background is dark, so that the subject is well-exposed and the background isn't over-lightened.

The Custom Setting menu

The Custom Setting menu allows almost every aspect of the camera's operation to be fine-tuned to your individual needs and preferences. The menu is divided into six main groups, identified by letters and colours, as follows:

a: Autofocus (red)
b: Metering/Exposure (yellow)
c: Timers/AE Lock (green)
d: Shooting/display (light blue)
e: Bracketing/flash (dark blue)
f: Controls (lilac)

```
┌─────────────────────────────────┐
│  ▶  │    CUSTOM SETTING MENU      │
│  ●  │ Ⓡ Reset custom settings  -- │
│  ✎  │ a Autofocus                 │
│  🔧 │ b Metering/exposure         │
│     │ c Timers/AE lock            │
│  ▦  │ d Shooting/display          │
│  ▤  │ e Bracketing/flash          │
│     │ f Controls                  │
│  ? │                             │
└─────────────────────────────────┘
```

Selecting a Custom Setting

1) Press the **MENU** button. If another menu appears first, press ◀ to highlight the icons in the left-hand column and scroll up or down to the Custom Setting menu icon. Press ▶ to enter the Custom Settings menu.

2) Use the Multi selector to scroll up or down to the desired settings group. Press ▶ to display the group.

3) Use the Multi selector to scroll up or down to the desired settings. Press ▶ to display options for that setting.

4) Highlight the desired option and press **OK** to select it.

Reset Custom Settings

This option restores all of the current Custom Settings to the standard camera default values.

Note
The Custom Setting identifier code (e.g. a4) is shown in the appropriate colour for that group. If the setting has been changed from default values, an asterisk appears over the initial letter of the code.

88

Custom Setting menu options

a: Autofocus

Custom Setting	a1 AF-area mode
Options	Single point Dynamic-area Auto-area 3D tracking (11 points)
Notes	For most exposure modes, **Auto-area** is the default setting, but there are a few exceptions (see page 56).

Custom Setting	a2 Centre focus point
Options	Normal zone (default) Wide zone
Notes	Setting a wide zone for the centre focus point can improve its performance when shooting moving subjects.

Custom Setting	a3 Built-in AF-assist illuminator
Options	Normal zone (default) Wide zone
Notes	Governs whether or not the AF-assist illuminator operates when lighting is poor (see page 59).

Custom Setting	a4 AF Point illumination
Options	Auto (default) On Off
Notes	Governs whether the active focus point is illuminated in red in the viewfinder. If **Auto** is selected, the focus point is illuminated only when the subject is dark.

FUNCTIONS

Custom Setting	a5 Focus point wrap-around
Options	Wrap No wrap (default)
Notes	Governs whether or not the active focus point wraps to the opposite edge of the available area (see page 57).

Custom Setting	a6 AE-L/AF-L for MB-D80
Options	AE/AF lock (default) AE lock only AF lock only AE lock (Hold) AF-ON FV Lock Focus point selection
Notes	Applies when the optional MB-D80 battery pack (see page 225) is attached and governs the function of the **AE-L/AF-L** button on the battery pack. If **Focus point selection** is selected, hold the **AE-L/AF-L** button and rotate the Sub-command dial to select focus point.

Custom Setting	a7 Live View Autofocus
Options	Face priority Wide-area Normal-area
Notes	**Wide-area** is the default setting for most exposure modes, but **Face priority** is the default for 🐶 and 📷 modes, and **Normal-area** is the default for 🌷 mode.

90

b: Metering/Exposure

Custom Setting **b1 EV steps for exposure cntrl**

Options	⅓ step (default) ½ step
Notes	Governs the increment used by the camera for setting shutter speed and aperture, and the increments available for bracketing.

Custom Setting **b2 Easy exposure compensation**

Options	On Off (default)
Notes	Governs how exposure compensation (see pages 51–2) operates. When **Off**, the exposure compensation button must be pressed and the Main command dial rotated. When **On**, exposure compensation can be applied simply by rotating the Main command dial. Applies in **P**, **S**, **A** and **M** exposure modes only.

Custom Setting **b3 Centre-weighted area**

Options	6mm 8mm (default) 10mm
Notes	Governs the size of the primary area when Centre-weighted metering is in use (see page 49). Requires a CPU lens. Applies in **P**, **S**, **A** and **M** exposure modes only.

Custom Setting **b4 Fine-tune optimal exposure**

Options	Yes No (default)
Notes	Allows a form of permanent exposure compensation to be applied, with separate values for each of the three main metering methods. Usually the normal exposure compensation procedure is to be preferred, but this option could be useful if you consistently find that matrix metering, for example, gives slightly darker or lighter results than you want. Use this setting to apply a consistent correction (+/- 1 Ev in steps of ⅓ Ev) to all shots taken with matrix metering.

c: Timers/AE Lock

Custom Setting	**c1 Shutter-release button AE-L**
Options	On Off (default)
Notes	Governs whether exposure is locked by half-pressure on the shutter-release button. If **Off**, exposure can only be locked using the AE-L/AF-L button (see page 34).
Custom Setting	**c2 Auto Meter-off delay**
Options	4 sec 6 sec (default) 8 sec 16 sec 30 sec 1 min 5 min 10 min 30 min
Notes	Governs how long the exposure meter (and shutter speed/aperture displays in the viewfinder and control panel) remain active if no further actions are carried out. A shorter delay is good for battery economy. The meters will not turn off automatically when the D90 is connected to a mains adaptor.
Custom Setting	**c3 Self-Timer**
Options Self-timer delay	2 sec 5 sec 10 sec (default) 20 sec
Options Number of shots	1–9
Notes	Governs the delay in Self-timer release mode (see page 35). **Number of shots** determines how many shots will be taken after that time.

Custom Setting	c4 Monitor-off delay
Options	Can be set separately for: Playback Menus Shooting info display Image review 10 sec 20 sec 1 min 5 min 10 min
Notes	Governs how long the LCD monitor screen remains active if no further operations are carried out. A shorter delay is good for battery economy. A 10-minute delay applies when the D90 is connected to a mains adaptor.

Custom Setting	c5 Remote on Duration
Options	1 min (default) 5 min 10 min 15 min
Notes	When using the optional ML-L3 remote control (see page 226), this governs how long the camera will wait for a signal from the remote before reverting to normal shooting mode.

d: Shooting/display

Custom Setting	d1 Beep
Options	High (default) Low Off
Notes	Governs the volume of the beep which is used when the self-timer operates, and to signify that focus has been acquired when shooting in Single-servo AF mode.

Custom Setting	d2 Viewfinder grid display
Options	Off (default) On
Notes	Displays grid lines in the viewfinder for assistance with precise composition.

Custom Setting	d3 ISO display and adjustment
Options	Show ISO sensitivity Show ISO/Easy ISO Show frame count (default)
Notes	Determines whether the figure at the bottom right of the LCD control panel and viewfinder displays shows the selected ISO or the number of exposures remaining. If **Show ISO/Easy ISO** is selected, ISO setting can be changed with a command dial in some exposure modes (see page 66).

Custom Setting	d4 Viewfinder warning display
Options	On (default) Off
Notes	Choose whether a warning is displayed in the viewfinder if any of the following conditions apply: A monochrome Picture Control is selected The battery is approaching exhaustion No memory card is inserted

Custom Setting	d5 Screen tips
Options	On (default) Off
Notes	Governs the availability of on-screen tips when items are selected in the Shooting info display.

94

Custom Setting	d6 CL mode shooting speed
Options	4 fps 3 fps 2 fps 1 fps
Notes	Governs the frame rate when using Cʟ (Continuous Low-speed) release mode (see page 35).

Custom Setting	d7 File number sequence
Options	On Off (default) Reset
Notes	Controls the way file numbers are set. If **On**, file numbering is reset to 0001 whenever a new memory card is inserted, the card is formatted, or a new folder is created. If **Off**, numbering continues from the previous highest number used. **Reset** means that 1 is added to the largest number used in the current folder.

Custom Setting	d8 Shooting info display
Options	Auto Manual
Notes	Governs the way shooting information is displayed on the monitor. (To display shooting info, press the **INFO** button when the camera is inactive or in shooting mode). Can be switched from light-on-dark to dark-on-light to suit lighting conditions.

Custom Setting	d9 LCD illumination
Options	On Off (default)
Notes	Governs illumination of the control panel. If **On**, the control panel will be illuminated when the exposure meter is active. If **Off**, the control panel is only illuminated when the power switch is moved to the ☼ position.

FUNCTIONS

Custom Setting	d10 Exposure delay mode
Options	On Off (default)
Notes	Can be used to create a shutter delay of approx 1 sec when the shutter-release button is pressed; the mirror also flips up. A possible alternative to the self-timer or cable release to reduce vibration when shooting on a tripod.
Custom Setting	**d11 Flash warning**
Options	On (default) Off
Notes	Displays a warning in the viewfinder when low light may require the use of flash. Applies in **P**, **S**, **A** and **M** exposure modes only (in other modes, the flash operates automatically when required).
Custom Setting	**d12 MB-D80 battery type**
Options	LR6 (AA alkaline) (default) HR6 (AA Ni-MH) FR6 (AA lithium) ZR6 (AA Ni-Mn)
Notes	When the optional MB-D80 battery pack (see page 225) is attached and AA cells are inserted, set this menu to match the type of cells in use.

e: Bracketing/flash

Custom Setting	e1 Flash shutter speed
Options	Can be set between 1/60 sec (default) and 30 sec in increments equal to 1 Ev.
Notes	Governs the slowest shutter speed which the camera can set when using **P** or **A** exposure modes (see pages 44–5). When using **M** or **S** exposure modes, any speed down to 30 sec can be set, independent of this menu setting.

96

Custom Setting	e2 Flash cntrl for built-in flash
Options	TTL (default) Manual Repeating flash Commander mode
Notes	Governs how the built-in flash is regulated. **TTL** means flash output is regulated automatically. **Manual** means it is set manually, using a sub-menu. **Repeating flash** fires multiple flashes, giving a strobe-like effect. **Commander mode** uses the built-in flash as a trigger for remote flash unit(s).
Custom Setting	**e3 Modeling flash**
Options	On (default) Off
Notes	Applies when the built-in flash is active or one of certain optional flash units (see page 158) is attached. If **On**, a modelling flash is emitted, giving a preview of the flash effect, when the Depth-of-field preview button is depressed. Applies in **P**, **S**, **A** and **M** exposure modes only.
Custom Setting	**e4 Auto bracketing set**
Options	AE & flash (Default) AE only Flash only WB bracketing ADL bracketing
Notes	Determines which settings are bracketed when Auto bracketing is activated (see page 54). If flash is not active, **AE & flash** has the same effect as **AE only**. **ADL bracketing** takes one shot with Active D-Lighting on and another with it off (see page 76).

FUNCTIONS

Custom Setting	e5 Auto FP
Options	On Off (default)
Notes	If Auto FP is **On**, it is possible to use flash at higher shutter speeds than the normal sync speed of 1/200 sec. This only applies with certain optional flash units and in **P**, **S**, **A** and **M** exposure modes only.

Custom Setting	e6 Bracketing order
Options	MTR>under>over (Default) Under>MTR>over
Notes	Determines the order in which auto-bracketed exposures are taken. By default, the first exposure is taken at the metered exposure, while the alternative places it, perhaps more logically, in the middle of the sequence.

f: Controls

Custom Setting	f1 ☀ switch
Options	LCD Backlight (default) Both
Notes	At the default, moving the power switch to the ☀ position illuminates the LCD control panel for approximately 6 secs. If **Both** is selected, operating this switch also activates the Shooting information display on the rear monitor screen.

Custom Setting	f2 OK button (shooting mode)
Options	Select centre focus point (default) Highlight active focus point Not used
Notes	Determines what, if anything, is the effect of pressing the **OK** button when in shooting mode.

98

Custom Setting	f3 Assign FUNC. button
Options FUNC button	Framing grid AF-area mode (hold FUNC button and select with Main command dial) Centre focus point (hold FUNC button and use Main command dial to switch between normal and wide zones) FV lock (default) Flash off (effective while FUNC button is pressed) Matrix metering (active while FUNC button is pressed) Centre-weighted metering (active while FUNC button is pressed) Spot metering (active while FUNC button is pressed) Access top item in My Menu + NEF (RAW) (Only effective if **Image quality** is set to JPEG; means that a NEF (RAW) copy will be saved along with the JPEG image for the next shot taken after the FUNC button is pressed)
Notes	A wide range of functions can be assigned to the FUNC button. For an explanation of the default FV Lock setting, see page 156.

Custom Setting	f4 Assign AE-L/AF-L button
Options	AE/AF lock (default) AE lock only AF lock only AE lock (hold) AF-ON FV lock
Notes	The default **AE/AF lock** setting locks both exposure and focus while the button is pressed. When **AE lock (hold)** is selected, exposure remains locked when the button is released; press the button again to unlock it. When **AF-ON** is selected, only the **AE-L/AF-L** button (not the shutter-release button) can be used to initiate autofocus. For an explanation of FV Lock, see page 156.

FUNCTIONS

Custom Setting	f5 Customize command dials
Options	Reverse rotation Change main/sub Menus and playback
Notes	Normally, the Main command dial sets shutter speed and the Sub-command dial sets aperture. **Change main/sub** reverses these roles. **Menus and playback**, when set to **On**, allows the command dials, as well as the Multi selector, to be used to navigate images during playback and image review. **On (Image review excluded)** allows this during playback only.

Custom Setting	f6 No memory card?
Options	Release locked (default) Enable release
Notes	If **Enable release** is selected, the shutter can be released even if no memory card is present. Images are held in the camera's buffer and can be displayed on the monitor in demo mode, but are not recorded.

Custom Setting	f7 Reverse indicators
Options	+ 0 - (default) - 0 +
Notes	Governs how exposure displays in the viewfinder and control panel are shown – i.e. with over-exposure to left or right.

100

The Setup menu

The Setup menu controls a number of important camera functions, though many of them are ones you will need to access only occasionally.

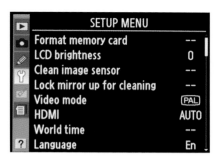

Format memory card

This is the one item in the Setup menu that many D90 users will use regularly, though many find the alternative two-button method of formatting the memory card more convenient (see page 67).

1) In the Setup menu, select **Format memory card** and press **OK** or ▶.

2) Select **Yes** and press **OK**.

> **Note**
> Cleaning is most effective if the camera is placed base-down. This is a normal working attitude, but you might be in the habit of switching the camera on or off while you're stowing it in a bag, or taking it out again, which could put it in a different attitude.

LCD brightness

Allows the brightness of the LCD to be altered to suit ambient lighting conditions.

Lock mirror up for cleaning

Allows access to the low-pass filter for manual cleaning (see pages 246–9).

Clean image sensor

Strictly speaking, it's not the sensor itself but the low-pass filter in front of it that can attract dust and require cleaning. The D90 has an automatic procedure to do this, by vibrating the low-pass filter at several different frequencies. Experience suggests that this is very effective and greatly reduces both the incidence of dust spots on images and the need for more invasive forms of cleaning. The Clean image sensor menu allows you to actuate cleaning at any time, and also to set the camera to clean automatically at startup, at shutdown, or both.

Video mode

Confusingly, this is not directly related to the D90's movie mode. You can connect the camera to a TV or VCR to view images or movies; this menu allows you to set the camera to PAL or NTSC standards to match the device you're connecting to.

World time

Allows you to set date, time and time zone, and to specify the format in which the date is displayed (Y/M/D, M/D/Y or D/M/Y). It's best to set your home time zone first and set the time correctly. Then, if you travel to a different time zone, you need only change the time zone setting and the time will be corrected automatically.

Image comment

This allows you to add comments to images as they are shot. Comments appear in the third page of the photo info display (if this is activated using **Display mode** in the Playback menu) and can also be viewed in Nikon View NX and Nikon Capture NX. To input a comment, select **Input comment** and press **OK**. Use the Multi selector to move around the text screen and press ⊕ to use the highlighted character. Press **OK** to finish. **Attach comment** adds the same comment to all subsequent shots until it is turned off.

HDMI

You can also connect the camera to HDMI (High Definition Multimedia Interface) TVs and monitors, but you'll need a special cable. This menu allows you to set the camera's output to match the HDMI device using information from the specifications or instructions for the device.

Language

Set the language that the camera uses in its menus. The options include most major European languages, Chinese, Japanese and Korean.

Auto image rotation

If set to **ON** (default), information about the orientation of the camera is recorded with every photo taken, ensuring that they will appear right way up when viewed with Nikon View NX, Nikon Capture NX or most third-party imaging applications.

102

Dust off ref photo

Nikon Capture NX features automatic removal of dust spots on images by reference to a photo which maps dust on the sensor. If you know there are stubborn dust spots that don't succumb to the normal sensor cleaning, this can save a lot of grunt-work in Capture NX or another imaging application. The **Clean sensor and then start** option should not be used if the pictures from which spots are to be removed have already been taken.

1) To take a dust-off reference photo, fit a lens of at least 50mm focal length. If a zoom lens is fitted, use the longest setting. Locate a bright, featureless white object such as a sheet of A4 paper that is large enough to fill the frame.

2) Select **Dust off ref photo** and press ▶ or **OK**. Select **Start** or **Clean sensor and then start** and press **OK**.

3) When the camera is ready to shoot the reference photo, **REF** appears in the viewfinder and Control panel.

4) Frame the white object at a distance of approximately 4in (10cm). Press the shutter-release button halfway; focus will automatically be set at infinity. If the camera is set to manual focus, set focus to infinity manually. Press the shutter-release button fully. If the reference object is too bright or dark, a warning will be displayed; change exposure settings or choose another reference object and reshoot.

Battery info

Displays information about the status of the battery, including percentage of charge remaining and how many shots have been taken since the battery was last charged.The precise information displayed may change if an optional battery pack is fitted.

GPS

This option is used to set up a connection between the D90 and a compatible GPS device (see page 243).

Firmware version

Displays the firmware version currently installed in the camera. Updates are issued by Nikon from time to time and this enables you to keep track of whether your camera has the current firmware.

The Retouch menu

RETOUCH MENU

- D-Lighting
- Red-eye correction
- Trim
- Monochrome
- Filter effects
- Color balance
- Small picture
- Image overlay

The Retouch menu is used to make corrections and enhancements to images, including cropping, colour balance and red-eye correction. These do not overwrite the original image on the memory card but create a copy to which the changes are applied. Further retouch options can be applied to this new copy, but there are some limitations: for example, you can make a monochrome copy and then Trim (crop) it, but you can't apply further corrections to an image which has already been trimmed. Copies are always created in JPEG format, but the size and quality depends on the original format, as shown in the box on the right.

Format of original photo	Quality and size of copy
NEF (RAW)	JPEG Fine, Large
JPEG	Quality and size match original

Creating a retouched image

1) If you are starting from the Image playback screen, display the image you wish to retouch. Press **OK** and the Retouch menu appears over the image. Select the desired retouch option and press ▶ . If subsidiary options appear, make a further selection and press ▶ again. A preview of the retouched image appears.

2) If you are starting from the Retouch menu, select the desired retouch option and press ▶. If subsidiary options appear, make a further selection and press ▶ again. A screen of image thumbnails

appears. Select the image you wish to retouch using the Multi selector, just as you would during normal image playback. Press **OK**. A preview of the retouched image appears.

3) Further options depend on the type of retouching to be done (see pages 105–9).

4) Press **OK** to create a retouched copy. The access lamp will blink briefly as the copy is created. Press ▶ to go back to the options screen or ▶ to exit without creating the copy).

D-Lighting

D-Lighting should not be confused with Active D-Lighting (see page 75): Active D-Lighting is applied before shooting, while D-Lighting is applied later and creates a retouched copy. Both aim to deal with high-contrast subjects, lightening shadow areas. Active D-Lighting usually has a greater effect on over-bright highlights. The D-Lighting screen shows a side-by-side comparison of the original image and the retouched version; press ⊕ to zoom in on the retouched version. Use ▲ and ▼ to select the strength of the effect – **High**, **Medium** or **Low**.

Red-eye correction

This is aimed at dealing with the problem of 'red-eye', caused by on-camera flash (see page 153). This option can only be selected for photos taken using flash. The camera analyzes the photo looking for evidence of red-eye; if none is found, the process will go no further. If red-eye is detected, a preview image appears on the screen. Use the Multi selector and the zoom controls to view it more closely.

Trim

This option allows you to crop an image to eliminate unwanted areas or to fit it to a print size. When this option is selected, a preview screen appears in which the crop area is shown by a yellow rectangle. You can change the aspect ratio of the crop by rotating the Main command dial: choose from **3:2** (the same as the original image), **4:3** and **5:4**. Adjust the size of the cropped area using the ⊖ and ⊕ buttons. Adjust its position using the Multi selector. Press **OK** to save the cropped image.

Monochrome

Not surprisingly, this creates a monochrome copy of the original image. You can choose between straightforward **Black and white**, **Sepia** (a brownish, toned effect similar to many antique photos) and **Cyanotype** (a bluish toned effect). If you select Sepia or Cyanotype, a preview screen appears and you can make the toning effect stronger or weaker using ▼ and ▲.

Color balance

Creates a copy with adjusted colour balance. When this option is selected, a preview screen appears and the Multi selector can be used to move around a colour grid. The effect is shown both in the preview and in the histograms alongside; you can also zoom in on the preview to see the effect more clearly in specific areas.

105

Filter effects

This mimics the effects of two common photographic filters. **Skylight** cuts out some of the blue cast that can affect shots taken on clear days with a lot of blue sky. Applied to other images, its effect can be very subtle and almost undetectable. **Warm filter** has a more distinct warming effect, akin to an 81B or 81C filter.

Red intensifier, **Green intensifier** and **Blue intensifier** are all self-explanatory, but **Cross screen** is not. This option creates a 'starburst' effect around light sources and other very bright points, such as sparkling highlights on water. There are several options within the Cross screen item, as shown in the table below.

Option heading	Options available
Number of points	Create 4-, 6- or 8-pointed star
Filter amount	Choose the brightness of light sources that are affected
Filter angle	Choose angle of the star points
Length of points	Choose length of the star points
Confirm	See a preview of the effect; press ⊕ to see it full-screen
Save	Create a copy incorporating the effect

Small picture

As you might expect, this option creates a small copy of the selected picture or pictures, which are suitable for immediate use with various external devices. Three possible sizes are available, as shown in the table below.

Size (pixels)	Possible uses
640 × 480	Display on standard (not HD) television
320 × 240	Display on mobile devices such as iPhone and BlackBerry
160 × 120	Display on small-screen mobile devices such as mobile phones

106

Small picture can be accessed from the Retouch menu or from Image playback, but there are slight differences in the procedure. If you are starting from the Retouch menu, select a picture size first and then select the picture(s) to be copied at that size. If you are starting from Image playback, select a picture first and then choose the desired size for the copy. Small pictures appear with a grey border around them in normal image playback and it's not possible to zoom in on them.

Image overlay

Akin to double exposure, but applied after shooting, this allows you to create a new combined image from two existing photos. Note that this can only be applied to originals in NEF (RAW) format, but Nikon claim that the results are better than combining the images in an application such as Adobe Photoshop because Image overlay makes direct use of the raw data from the camera's sensor.

Although Image overlay works from NEF (RAW) images, the size and quality of the new image are not automatically set to Fine, Large as they are with other retouch options starting from a NEF (RAW) image. Before using Image overlay, make sure the **Image Quality** and **Image Size** options are set to the desired state.

1) In the Retouch menu, select **Image overlay** and press **OK**. A dialogue screen appears with sections labelled **Image 1, Image 2** and **Preview**. Initially, Image 1 is highlighted. Press **OK**.

2) The camera displays thumbnails of NEF (RAW) images on the memory card. Select the first image you want to use for the overlay and press **OK**. It now appears as Image 1.

3) Select **Gain:** this determines how much 'weight' this image has in the final overlay. Use the ▲ and ◄ buttons to adjust gain.

4) Press ▶ to move to Image 2. Repeat steps 2 and 3 for the second image.

5) If necessary, press ◄ to return to Image 1. You can make further gain adjustments, or press **OK** to select a different image.

6) Finally, press ▶ to highlight **Preview**. Select **Overlay** and press **OK** to preview the overlay. If you are not satisfied, you can return to the previous stage by pressing ⊖⊟. If you are satisfied, press **OK** again and the overlay will be saved. You can also skip the preview stage by highlighting **Save** and pressing **OK**.

Quick Retouch

Provides basic one-step retouching as a quick fix, boosting saturation and contrast. D-Lighting is applied automatically to retain shadow detail. Use the ▲ and ▼ buttons to increase or reduce the strength of the effect, then press **OK** to create the retouched copy.

Straighten

Use this option to straighten horizons by up to 5° in increments of 0.25°. Press ▶ to rotate the image clockwise and ◀ to rotate it anti-clockwise. Note that this inevitably crops the image slightly. Press **OK** to create the retouched copy or **MENU** to exit without creating a copy.

NEF (RAW) Processing

This option allows you to create JPEG copies in-camera from images originally shot as NEF (RAW) files. While it's no substitute for full RAW processing in an image-editing application, it can be very useful for creating a quick copy for immediate sharing or printing, and the availability of Nikon Picture Controls (see pages 76–7) gives a good deal of control over the quality of the JPEG image produced.Options available for the processing of NEF (RAW) images are displayed in a column to the right of the preview image, as shown in the table below. When you're satisfied with the previewed image, select **EXE** and press **OK** to create the JPEG copy. Press **MENU** to exit without creating a copy.

Option heading	Description
Image quality	Choose Fine, Normal or Basic (see pages 60–1)
Image size	Choose Large, Medium or Small (see page 62)
White balance	Choose a White-balance setting; options are similar to those described on page 64. Only available with originals taken in **P**, **S**, **A** or **M** exposure modes.
Exposure comp.	Adjust exposure (brightness) levels from +3 to -3. Not available if the original image was shot with Active D-Lighting.
Set Picture Control	Choose any of the range of Nikon Picture Controls (see pages 76–7) to be applied to the image. Only available with originals taken in **P**, **S**, **A** or **M** exposure modes.

Distortion control

Some lenses create noticeable curvature of straight lines (see page 210). This option enables you to correct them in-camera. Note that the process inevitably crops the image slightly. **Auto** automatically compensates for the known characteristics of Nikkor Type G and Type D lenses and cannot be used on images taken with other lenses. **Manual** can be applied irrespective of the lens used: use ▶ to reduce barrel distortion and ◀ to reduce pincushion distortion. The Multi selector can also be used for fine-tuning after Auto control is applied.

Side-by-side comparison

This option is only available when a retouched copy, or its 'parent' image, is selected. It cannot be accessed directly from the Retouch menu. It displays the copy alongside the original from which it is derived. Highlight either image with ◀ or ▶ and press 🔍 to view it full-frame. Press 🖻 to return to normal playback. To return to the playback screen with the highlighted image selected, press **OK** or the centre of the Multi selector.

FUNCTIONS

Fisheye

This option is almost the opposite of the Distortion control option described above, applying exaggerated barrel distortion to produce a fisheye-lens effect. Press ▶ to increase the effect and ◀ to reduce it.

DISTORTION
The inward curve of straight lines near the edges of the frame is called barrel distortion. In this image, the effect has been exaggerated in Photoshop. Modern lenses are rarely this bad!

THE EXPANDED GUIDE

109

My Menu and Recent Settings

Recent Settings automatically stores the most recent settings (up to 20 items) made using any of the other menus, and often provides the quickest way to access controls that you have used recently. As an alternative, you can opt for a more customized approach and activate My Menu. Items from all the other menus can be added to My Menu to create a handy shortlist. Again, a maximum of 20 items can be stored in My Menu. Making the most effective use of My Menu requires a

little forethought but means that you can always have quick access to key settings that you use often.

Activating My Menu

1) In the Recent Settings menu, select **Choose tab** and press ▶.

2) Select **My Menu** and press **OK**.

3) The name of the menu changes to **My Menu**. This continues in effect even if you navigate away from this menu and return to it later. To revert to **Recent Settings**, repeat the **Choose tab** procedure.

Note
If My Menu is active, the camera does not update the Recent Settings. If you switch from My Menu to Recent Settings, the menu will not include items used immediately before switching.

Adding items to My Menu

1) In My Menu, highlight **Add items** and press ▶.

2) A list of the other menus now appears. Select the appropriate menu and press ▶.

3) Select the desired menu item. Press **OK**.

4) My Menu reappears with the new item at the top. Use ▼ to move it down the list if desired. Press **OK** to confirm.

Tip
Choose tab always appears at the bottom of the list of items in both My Menu and Recent Settings when you first open the menu. The quickest way to reach it is not by scrolling down through a list of up to 20 items, but by scrolling up instead.

Removing items from My Menu

1) In My Menu, highlight **Remove items** and press ▶.

2) Highlight the item of your choice in the list and press ▶ to select it for deletion. A check mark appears beside the item.

3) Use ▲ or ▼ to move the item up or down the list. A yellow line shows where its new position will be. Press **OK** to move it to the new position.

4) Highlight **Done** and press **OK**. A confirmation dialogue appears. To confirm the deletion(s), press **OK** again. To exit without deleting anything, press **MENU**.

You can also quickly delete the currently highlighted item by pressing the 🗑 button. A confirmation dialogue appears. To confirm the deletion, press 🗑 again.

Rearranging items in My Menu

1) In My Menu, highlight **Rank items** and press ▶.

2) Highlight an item and press **OK**.

3) Use ▲ or ▼ to move the item up or down the list. A yellow line shows where

its new position will be. Press **OK** to move it to the new position.

4) Repeat steps 2 and 3 to move further items. Finally, press **MENU** to exit.

Chapter 3

In the field

Modern cameras, especially top-flight models like the Nikon D90, are so capable that achieving correct focus and exposure is much easier than it used to be. The old question 'will it come out?' is rarely heard. However, there's a big difference between photos that 'come out' and those that come out exactly the way you want them. A great camera does not guarantee stunning shots – there is still plenty of scope for individual expression, vision and skill.

Real satisfaction arises when you know that the D90 is working for you, rather than the other way round. Understanding the camera's many options, as explained in the preceding chapter, is key to this. However, technical mastery is nothing without vision. Knowing what you want to achieve is the real secret of success, no matter what camera you use. The clearer your ideas on what you want the photo to say and how you want it to look, the better. If you know why you're taking the shot and what you want it to show – and, equally importantly, what you want to leave out – then the 'how' part will flow much more naturally.

Of course, the 'how' part is the main concern of this book. Vision is a personal thing, but it's much easier to realize that vision if you understand how light works and how lenses and digital images behave.

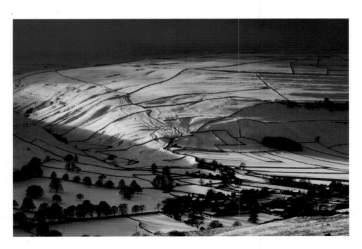

LITTONDALE, YORKSHIRE DALES, UK
Familiarity with the D90 builds confidence and makes it easier to capture the moment, even in rapidly changing light.

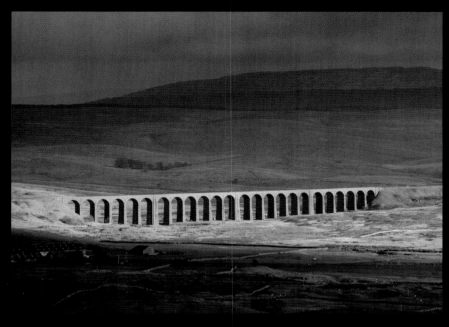

**RIBBLEHEAD VIADUCT,
NORTH YORKSHIRE, UK**
Exposure, framing, and light all play their
part, but there's still no substitute for being
in the right place at the right time.

Settings
ISO: 200
Focal length: 105mm
1/100 sec
f/11

Depth of field

No camera, however sophisticated it may be, always sees what the eye sees. Nothing illustrates this better than depth of field. The eye scans the world dynamically and therefore we normally perceive the world as being in focus, both near and far. (At least it does if you have good eyesight, or you're wearing glasses or contact lenses.) The camera frequently fails to match this perception.

In simple terms, 'depth of field' means what's in focus in an image and what isn't. A more precise definition is that depth of field is the zone – extending both before and behind the point of focus – in which objects appear to be sharp in the final photographic image.

Depth of field is a crucial part of the relationship between what the eye sees and what ultimately appears in the photograph. For example, in landscape photography, tradition suggests that pictures should appear sharp throughout, and for good reason: it matches our normal view of the world. At other times, however, creative intent or simple necessity may lead us to take photographs with much narrower depth of field.

Three main factors determine depth of field: the focal length of the lens, the aperture, and the distance to the subject. As focal length and subject distance are often at least partly predetermined by other factors, aperture is key. The simple rule is small aperture = big depth of field, and vice versa. (Remember that aperture numbers are really fractions, so f/16 is small and f/4 is large.)

Depth of field preview

When you look through the D90's viewfinder, the lens is set at its widest aperture; if a smaller aperture is selected, it will stop down at the moment the picture is actually taken. This means that the viewfinder image frequently has less depth of field than the final picture. The D90's depth-of-field preview button stops the lens down to the selected aperture, giving a sense of the depth of field in the final image. Unfortunately, it also darkens the viewfinder image, but it's usually still possible to assess the sharpness of defined edges (e.g. trees against the sky). If time allows, check your images on the monitor after shooting, using the zoom function for a closer look.

116

Long lenses (telephotos) produce less depth of field than short ones (wide-angles). This naturally ties in with camera–subject distance, but the relationship is complex. If you're photographing a single subject like a tree, you may get more depth of field by using a wide-angle, but this requires you to move in closer, which reduces depth of field. And if you're photographing a broader landscape, you may already have decided on the viewpoint and angle you want.

Apparent sharpness

The definition of depth of field refers to objects *appearing* to be sharp. In a small image, subjects may appear sharp but begin to look fuzzy when the image is enlarged. Depth of field is a relative value rather than an absolute. It's easy to forget this and become obsessed with using the smallest apertures and determining the hyperfocal distance. All this may be overkill unless you are planning to make big prints or submit your images for magazine reproduction. The depth of field preview is a more than adequate guide for images that will be printed at small sizes or only viewed on screen.

DEPTH OF FIELD
The same setup, focused on the heather plant, taken at f/5.3, f/11 and f/25, shows the effect on depth of field. Which shot you prefer is, of course, subjective.

For various reasons, images shot with the D90, or any DX-format camera, will have greater depth of field than comparable images shot on a 35mm or 'full-frame' camera. This gain is only partly offset by the extra enlargement needed in printing.

f/5.3

f/11

f/25

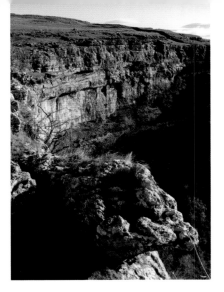

MALHAM COVE, NORTH YORKSHIRE, UK
With strong foreground interest in this photograph, it was essential that depth of field stretch from the nearest rock to the skyline. Focusing at the hyperfocal distance was the best way to ensure this.

Note
Nikon's documentation is not entirely clear, but it looks as if the D90's Landscape mode uses the hyperfocal principle, or something like it, to keep both foreground and background in focus as far as possible. However, it clearly does not always set the smallest possible aperture; for full control over this, use Aperture Priority mode.

Hyperfocal distance

When you really need an image to be sharp throughout, remember that depth of field extends both in front of and behind the point of exact focus. If you focus at infinity, there's nothing beyond that, so you are in effect wasting half your depth of field. In fact, depth of field extends to a greater depth behind the point of focus than in front of it. To exploit this, you'll frequently see advice to 'focus one-third of the way into the picture', although this doesn't really help: what's one-third of the way from here to infinity?

You can maximize depth of field by focusing at what's called the hyperfocal distance. This is the point, for any given aperture, at which depth of field extends to infinity. A rough way to find the hyperfocal point for any combination of lens and aperture begins by focusing on infinity. Use the depth of field preview and find the nearest objects that appear sharp: they are at the hyperfocal point. Refocus at this distance for maximum depth of field.

Recording motion

Motion is another area in which the camera doesn't see what the human eye sees. We perceive movement, but the camera produces still images. However, there are several effective ways to convey a sense of movement in a still photograph.

Freezing the action

Dynamic posture and straining muscles shout 'movement', even in a figure frozen by a fast shutter speed. In fact, the pin-sharp definition of muscles or facial expression can enhance the feeling of dynamism. But what is a 'fast' shutter speed? Do you need to use the D90's maximum 1/4000 sec every time?

The exact shutter speed needed to render a sharp, frozen image depends on various factors: not just the speed of the subject, but its size and distance. What really matters is the scale of movement and its relation to the image frame. It's often easier to get a sharp image of a train travelling at 180mph (300km/h) than of a cyclist doing 30mph (50km/h), because you need to be much closer to the latter. Subjects travelling across the frame require a faster shutter speed than those moving towards or away from you.

Many photographers play it safe by setting the fastest shutter speed possible under the prevailing light conditions. This is, in essence, how the D90's Sports mode works. When you want more control, Shutter Priority is the obvious exposure mode to use. There's also a 'back-door' method, using Aperture priority mode instead and selecting the widest aperture. Check your images on the monitor if possible, and if a faster shutter speed appears to be necessary, be prepared to increase the ISO setting (see page 66). If you shoot a particular activity on a regular basis, you'll soon discover what works for your particular needs.

BLACKPOOL, LANCASHIRE, UK
A shutter speed of 1/800 sec froze both the figures and the splashes.

Panning

With the right subject, panning is an excellent way to capture a feeling of movement. It works best with subjects moving across the frame, such as runners or cyclists. By following the subject with the camera, it can be recorded sharply while the background becomes a streaky blur. The exact effect varies, but much slower shutter speeds are usually employed; experimentation is advisable. Anything from 1/8 to 1/125 sec can work and you may even go outside this range. This means, of course, that Sports mode is no longer suitable and Shutter priority mode is the best option.

Panning is usually easiest with a standard or short telephoto lens, but the decision may be made for you according to working distance – for example, if you're behind barriers at sports events. Shutter priority is again the natural exposure mode to use. To maintain a smooth panning movement during the exposure, keep following through even after pressing the shutter.

Tip
Try adding a discreet amount of flash to panned or blurred shots to give a sharp image of the subject against the background blur. The D90's flash metering is very good at balancing exposures between subject and background, but you may want to experiment and change the settings (by using flash compensation, for example) to get the results you want.

RUNNER, WESHAM, LANCASHIRE, UK
At a shutter speed of 1/10 sec the figure is not entirely sharp, but still contrasts with the thoroughly blurred background.

NIKON D90

Camera shake

Sometimes, when you're shooting action, you'll move the camera intentionally – panning is the most common example. Unintentional movement of the camera is a different story. Camera shake can lead to anything from a slight softening of the image (easily mistaken for poor focusing) to a hopeless mess. Careful handling or the use of camera supports (see pages 228–9) help to prevent camera shake, and Nikon also make a number of Vibration Reduction (VR) lenses (see page 200).

Blur

Sometimes a blurred image is most effective in conveying movement. It may be a necessity, because you can't set a fast enough shutter speed, or it may be a creative choice, like the silky effect achieved by shooting waterfalls at exposures measured in whole seconds. For other moving subjects, slightly faster speeds may be more effective. To ensure that only the moving elements are

CATRIGG FORCE, NORTH YORKSHIRE, UK
This waterfall usually lies in deep shade, making it relatively easy to achieve the long exposures required for such smooth results – in this case, 1.6 sec. Compare this image to the same scene shot at 1/20 sec (see page 41).

blurred, secure the camera on a tripod or other support, but you can also achieve a more impressionistic effect by hand-holding.

Composition

Composition is probably the cause of more grief than any other single aspect of photography. Composition, in its widest sense, is the reason why some photographs are perfectly exposed and focused yet have no emotional or aesthetic impact, while others may be technically flawed yet heart-stopping.

Every time you take a picture you make decisions (consciously or unconsciously) about where to shoot from, where to aim the camera, how wide a view you want, what to include and what to leave out. These are the essence of composition. Personally, I would prefer to avoid the term 'composition' altogether – 'framing' is a much better word that relates far more closely to what photographers actually do.

Perhaps by jettisoning the word 'composition' we can also liberate ourselves from all its associated 'rules' – deadliest of which is the Rule of Thirds. If you are unfamiliar with this, count yourself lucky, though there are plenty of other photographic books that will enlighten you at great length.

Tip
In the words of Ansel Adams, revered by millions as perhaps the greatest ever landscape photographer, 'There are no rules for good photographs, there are only good photographs'.

ABOVE MALHAM COVE, NORTH YORKSHIRE, UK
A wide-angle lens makes the most of a strong, well-lit foreground.

NIKON D90

Principles of framing

Whether you choose to follow a mechanical rule, or to work more intuitively, there are two basic principles that underpin effective framing: know where the edges are, and see what the camera sees.

No 'rule' of framing can be applied without reference to the edges of the frame. The edges define the picture. The picture is everything within them. Our eyes and brains are very good at selecting specific parts of a scene, but fixating on a single subject makes it all too easy to overlook all the other stuff that may appear within the frame. The camera, of course, doesn't distinguish in the same way, and that's when pictures become cluttered or confusing. Hence, see what the camera sees.

Looking through a traditional viewfinder, even a top-notch one like the D90's, is rather like looking through a window. With this in mind it is interesting to experiment with the D90's Live View mode (see pages 68–9). Now, instead of looking through a viewfinder, you're watching a screen. If the viewfinder is like a window, the screen is like a picture. And of course a picture is what we want to end up with. I've yet to see any scientific studies of this, but intuition suggests that using the screen to frame a shot might

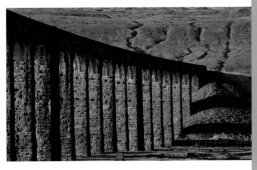

RIBBLEHEAD VIADUCT, NORTH YORKSHIRE, UK
In this image, a relatively long lens and tight cropping helped to emphasize the massive scale of the magnificent viaduct.

make it easier to see the whole picture – the bits you're interested in and the bits you aren't.

Using Live View all the time isn't recommended: it drains batteries fast; it can be hard to see in bright sunlight; and the resultant 'praying mantis' posture increases the risk of camera shake. A good viewfinder like the D90's is usually much more convenient. Still, trying this exercise may help you to use the viewfinder more like a screen. Aim consciously to look at the whole viewfinder image. See it as a picture. Take note of the edges and what's included. Look for distractions that dilute the story you're trying to tell.

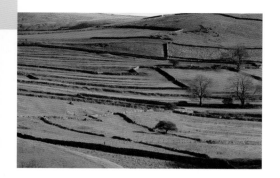

ANCIENT FIELD SYSTEM NEAR MALHAM, UK
There is no single 'point of interest' in this shot. Framing was a matter of working until the balance felt right.

Framing the landscape

Landscape photography can be particularly challenging in terms of composition or framing because there is no single, defined subject; landscape is boundless. Be selective, look for the essence of a place and try to capture what makes it appeal to you. Remember the old saying, 'can't see the wood for the trees'.

'Views' are fine, but landscape is a totality, an all-round sensory experience. A lot of the views that people take end up looking small, or flat, or otherwise disappointing. Very often there's a simple reason for this: no foreground. Foregrounds do many things. They show texture and detail, and they often evoke sounds and smells and the rest of the sensory totality. They help to convey depth and distance: the third dimension, in fact. Foregrounds can bring life and crispness when a distant scene is hazy or the light cast upon it is flat. Above all, using foregrounds connects you to the location, distinguishing your shots from the more detached views that anyone might get from a train window or hotel balcony.

Foregrounds are also a great way to enhance the sense of scale. If you want a photo of a mountain that gives a sense of its awesome size, filling the picture with it may not be the best way. For most people, especially those with limited experience of mountains, a shot of a peak in isolation, without context, is hard to 'read'. Including a relatively familiar object, like a tree, helps us make sense of the unfamiliar. Human figures are also ideal for this, because we all know how big,

Note
Unfortunately for those who aspire to precise framing, the D90's viewfinder does not show the whole image, giving around 96% coverage. That 4% cut-off may not sound like much but it can mean that unseen distractions creep in at the edges of the frame. Live View gives 100% coverage.

124

or small, human beings are. Even a really tiny figure can be very effective, as long as it remains large enough to be recognizably human. To capture strong foregrounds, the first principle is to move in close. The second is to move closer still. Get down low: sit, kneel, crouch, crawl – do whatever it takes.

Wide angles

A wide-angle lens is a big help when you want to include both the foreground and the distant vista. The D90 has a 1.5x magnification factor, so that a typical wide-angle zoom, with a focal length of 18mm at its widest, gives the same coverage as a 27mm lens on a 35mm SLR or a 'full-frame' digital SLR like the Nikon D3. Dedicated landscape

photographers who wish to make the most of foregrounds or big vistas may well hanker after something significantly wider, such as the 12–24mm f/4G ED-IF AF-S DX Nikkor, which is ideal for use with the D90 (see page 207).

Bear in mind, though, that small details can often say as much about the essence of a place as the bigger picture. Variations in scale and focus are important to liven up sequences of pictures. However good they may be individually, an unrelieved barrage of grand landscape images can become tedious. And if the light is not magical, or distant prospects look flat or hazy, the miniature landscapes of a rock-pool or forest clearing can help to bring a set of photographs back to life.

GREAT SCAR, NORTH YORKSHIRE, UK
Looking towards Pen-y-Ghent, I aimed to concentrate on the interesting and beautifully lit foreground while retaining a sense of the wider view.

Lighting

What makes a good photograph? Come to think of it, what makes any photograph? The answer – the one thing without which there would be no photographs – is light. It's all too easy to take light for granted, to think 'the camera will take care of it'. Up to a point this is true: cameras like the D90 are very good at dealing with varying amounts of light. But there's a lot more to light than just whether there's a lot or a little of it, so it's worth tuning in to some of the other ways that it varies, such as colour and direction.

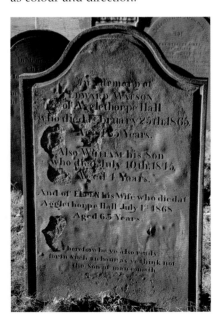

Light sources

Directly or indirectly, the main source of natural light is the sun. Even moonlight is reflected sunlight. Exceptions like fires and lightning are of secondary significance. Yet sunlight is anything but uniform. It can be modified in many ways by its passage through the atmosphere. As a direct source, the sun is very small, giving strongly directional light and hard-edged shadows – qualities similar to a small flashgun. Yet on an overcast day the sun's light can be soft and even. Studio photographers use softboxes or banks of lights to replicate this effect; the closest most photographers can get, and then on a small scale, is usually with bounce flash (see page 159).

There is also a wide range of other artificial light sources, whose colour varies enormously – making the D90's White-balance control a vital tool – but their other qualities, such as direction and contrast, can usually be understood by comparison with the more familiar sources, sunlight and flash.

CHURCHYARD AT COVERHAM, NORTH YORKSHIRE, UK
Strong oblique lighting creates high contrast and powerful modelling, bringing out every detail of this gravestone.

Contrast and dynamic range

Contrast, dynamic range, tonal range: these terms all refer to the spread of tones between the brightest and darkest areas of a scene or subject. It's all too easy to ignore this, as our eyes are very adaptable and can show us detail in both bright areas and deep shade.

Unfortunately, even the best camera can't always match this ability. In high-contrast conditions, it's all too common for either the brightest highlights to end up completely blank and white, or for the deeper shadows to turn an empty black. 'Clipping', as it's called, can even affect both ends of the tonal scale simultaneously. High-contrast conditions typically occur when the sun shines from a clear sky. The clearer the sky, the higher the contrast, so the most extreme examples of the problem are often found in deserts and at high altitude.

In cloudy or misty conditions, contrast is lower; photographers often speak of 'soft' light. This is usually not very helpful for wide landscapes but can be excellent for portraits and details. In fact, for some subjects, soft light is virtually essential; photographers who specialize in shooting wild flowers will often carry diffusers to create it.

RUINS OF ROUND ING, CUMBRIA, UK
The soft light of an overcast day suited the melancholy atmosphere of this deserted farm.

High-contrast options

The D90 offers several options for dealing with high contrast, notably Active D-Lighting (see page 75) and D-Lighting (see page 105). Shooting NEF (RAW) files also gives you some chance of recovering highlight and shadow detail in post-processing. However, there comes a point when it's impossible to capture the entire brightness range of a scene in a single exposure. Checking the camera's histogram display will tell you when this is the case, and the monitor can also be set to display 'blown' or 'clipped' highlights (see page 72). In such instances, one option is to reframe your shot to exclude or minimize areas at the extremes of the brightness range.

Reflectors

For nearby subjects, such as portraits, you can compensate for high contrast by throwing some light back into the shadows. You can use the D90's built-in flash (or an accessory flashgun) for fill-in light, or you may prefer some sort of reflector. The advantage of the reflector is that you can more easily see the effect for yourself. Something as simple as a white T-shirt will do remarkably well at close range. You can also sometimes find natural reflectors: light-coloured rocks like limestone can be effective, and snow

and ice are excellent. Every now and then you'll even find a big white cloud drifting into just the right place to act as a mega-reflector.

Multiple exposures

Digital imaging offers another solution. This involves making multiple exposures – one for the bright areas, one for the mid-tones and one for the shadows – which are combined in post-processing. The D90's exposure-bracketing facility is ideal for this. A solid tripod is essential to keep the images aligned. This approach can become unusable if there's movement in the scene.

Tips

Instead of shooting bracketed exposures, it's possible to make multiple conversions from a single NEF (RAW) file – one optimized for the shadows, one for the highlights, and perhaps one for the mid-tones. This obviates the need for a solid tripod and allows moving subjects to be dealt with.

High Dynamic Range (HDR) software is designed to facilitate the merging of images that cover an unusually wide dynamic range. Adobe Photoshop CS2, CS3 and CS4 have HDR capabilities.

Colour

Hold a glass prism up to a sunbeam and you can see that it contains all the colours of the rainbow. 'White' light is a misnomer, and the colour of outdoor light varies enormously. Most of the time our eyes adjust automatically, so that we see green leaves as green, oranges as orange, and so on. Only at its most extreme, perhaps in the intense red of a spectacular sunset, are the changing colours of light really obvious.

This is due to the way the sun's light is filtered by the atmosphere. When the sun is high in a clear sky, the light is affected least; when the sun is low, its path through the atmosphere is much longer and the direct light is biased towards yellow and ultimately red, while the 'lost', or scattered, light turns the sky blue. The warmer light of a low sun is another reason why landscape photographers tend to favour mornings and evenings. It's not just that that we tend to find warm colours more pleasing; if that was all that mattered, it would be easy to mimic the effect with a filter or a Photoshop adjustment. But remember that blue sky – while

sunlit surfaces pick up a warm hue, shadows receive light from the sky, which tints them blue. It's most obvious in snow scenes, but it's almost always true.

This contrast in colour between sunlit and shadow areas increases as the direct sunlight becomes redder, adding vibrancy to morning and evening shots. Filters can't duplicate this effect. With shifting colours being part of the attraction,

CLITHEROE, LANCASHIRE, UK
The warm light of early morning contrasts with the cool shadows and the blue of the sky.

the last thing you want to do is neutralize or 'correct' them back to normal. However, if White balance is set to Auto, the D90 may attempt to do exactly that. Try changing the White-balance setting to **Direct sunlight** instead, and remember that you can also employ White-balance bracketing (see page 97).

Artificial light

The same principle applies when you're dealing with artificial light. Sometimes you'll want to correct its colour, sometimes it may be better not to do so.

If you're shooting a portrait under fluorescent lamps (other than 'daylight' ones), there's a risk that the subject will look a ghastly greenish hue, which you will almost certainly want to correct. Here, Auto white balance will generally do a pretty good job. The monitor screen shows image colour with reasonable accuracy but your perception may be distorted because you are viewing it under the same, problematic fluorescent light. On the other hand, if you're shooting floodlit buildings, for example, the variations in colour may be part of the appeal. The results you'll get with Auto white balance are less predictable here and may be some way from either what you see or what you want.

TREE DETAIL
All three shots show the same tree, and were taken within the space of a minute or two. A simple shift in camera position makes a dramatic difference in lighting.

Direction of light

In a scene lit by direct sunlight or a single flashgun, the direction of the main light source is obvious, and the same subject, seen from different angles, can be totally transformed. Under an overcast sky, the quality of light is much less sensitive to the viewing angle but there is usually at least a vague directionality to it. Completely even lighting is quite rare, but the effects of the direction of light are much easier to see and appreciate when there is a distinct main source like the sun. As an initial approximation of these lighting effects we can speak of frontal lighting, back-lighting and oblique lighting.

Frontal lighting

Frontal lighting is what you get with on-camera flash, or with the sun behind you. Naturally, this floods everything with light, especially in open surroundings. While this might sound positive, the lack of shadows tends to make everything look flat and uniform. This is rarely ideal for big landscape views, but it may work very well on smaller-scale subjects that rely on pure colour, shape or pattern for their impact. Frontal lighting does not lead to extremes of contrast, so making a correct exposure is easy.

Back-lighting

Back-lighting can give striking results in almost any sphere of photography, but needs to be approached with care. By definition, a backlit subject will be in shadow and can easily appear as nothing more than a silhouette. Sometimes, of course, this may be exactly what you want: strong shapes such as bare trees can look fantastic against a colourful sky. If this is the effect you are aiming for, meter for the bright areas to maximize colour saturation there, perhaps using exposure lock (see page 34). If you don't want a silhouette effect, a reflector or fill-in flash can throw some light back into the shadow, but don't overdo it or you risk negating the backlit effect. This only works at close range; the distance depends on the size of the reflector or power of the flash, but it definitely applies to smaller subjects rather than large buildings or landscapes. Back-lighting, combined with a reflector, often produces memorable portraits.

Oblique lighting

Oblique lighting is both more interesting and more complex. Shadows help to outline hills and valleys. The flatter the terrain, the lower the sun needs to be for

shadows to appear. When the sun is really low, the light starts to pick out fine details and textures, from crystals in rock to individual blades of grass. This helps to explain why dedicated landscape photographers like to do most of their work in the 'golden hour' at the beginning and end of the day.

However, if flatter terrain needs a low sun, the converse is equally true. The hillier it is, the better the chance that even a high sun will cast those shadows that make so much difference to a picture.

In some places, a high sun may be not just okay but essential. In deep gorges, for instance, it may only be when the sun's high that any direct light penetrates. It's not the angle of the sun above the horizon that ultimately counts; it's the angle at which the light strikes whatever it is you want to photograph. Oblique lighting is widely preferred for landscapes and many other subjects, but is much more likely to be associated with high contrast than frontal lighting, so exposure may be problematic.

GREAT SCAR, NORTH YORKSHIRE, UK
In this shot, oblique lighting produced strong forms but created a high level of contrast.

Image properties

Cameras and lenses handle light and images in a fundamentally different way from the human eye and they can sometimes produce results that don't match what you see, expect or want. Some of these properties are common to both digital and film cameras; others are unique to digital.

Flare

Lens flare results from stray light reflecting off surfaces within the lens. It's most prevalent when shooting towards the sun. One obvious form of lens flare is a string of little coloured blobs, often hexagonal, lined up as if radiating out from the sun. This is sometimes exploited, especially in films and TV,

to emphasize how bright or hot the sun is. However, in general, flare is an unwelcome distraction.

Advanced lens coatings, like those used in Nikkor lenses, greatly reduce the incidence of flare. Keeping lenses (and filters) scrupulously clean is vital. Flare sometimes diminishes when the lens is stopped down. Otherwise, look for ways to reframe the shot or to mask the sun. If the sun isn't in the frame, try to shield the lens from its direct rays. A good lens hood is essential, but further shading may be needed, especially with zoom lenses – use a piece of card, a map, or even your hand. This is easiest with the camera on a tripod; otherwise it requires one-handed shooting (or a friend). Check the viewfinder and/or monitor carefully to check that the flare has gone away, and that the shading object hasn't crept into the frame.

MALHAM COVE, UK
Flare is very evident in the first shot. In the second shot, I shielded the lens carefully, eliminating the flare.

Distortion

Simply, distortion is seen when things that are straight in reality appear curved in the image. It's a result of lens design and as this continually improves it's less and less of an issue; the worst offenders are likely to be zoom lenses that are old, or cheap, or both, and distortion is often worst at the extremes of the zoom range.

When straight lines bow outwards, it's called barrel distortion; when they bend inwards it's pincushion distortion. Both problems can be corrected using Distortion Control in the Retouch menu, or in later processing with software such as Nikon Capture NX or Adobe Photoshop, but it's always better to avoid them in the first place.

Distortion may go unnoticed when shooting natural subjects with no straight lines, but can still rear its ugly head when a level horizon appears in a landscape or seascape, especially when that horizon is near the top or bottom of the frame.

Aberration

Aberration is a lens property that occurs when light rays from the subject aren't all focused together. Chromatic aberration occurs when light of different colours is focused in slightly different places on the sensor and can be seen as coloured fringing when images are examined closely. To some extent it can be corrected in post-processing using Nikon Capture NX, Photoshop or other software, at least with images shot in NEF (RAW) format.

Chromatic aberration can be exaggerated by the way light strikes a digital sensor. These effects are exaggerated by smaller sensors and therefore lenses such as Nikon's DX series are specifically designed for DX-format cameras. With the D90's larger sensor, older lenses designed for 35mm SLRs will probably give good results, but it's always a good idea to take some test shots and examine them closely before engaging in any critical work. The latest Nikkor lenses are optimized for use with the D90.

Vignetting

Vignetting is a darkening, or fall-off in illumination, towards the corners of the image. It's most conspicuous in even-toned areas like clear skies. Almost all lenses have a slight tendency to vignetting at maximum aperture, but it should quickly disappear on stopping down. Like all these faults, it can be tackled in post-processing, but this is a last resort.

Vignetting can also be caused, or exaggerated, by unsuitable lens hoods or filter holders, or by the 'stacking' of multiple filters on the lens, which is rarely a good idea.

LAKE BLED, SLOVENIA
Vignetting may be an unwanted flaw, or it may be deliberately added for creative effect, as it was in this image. Along with the toning of the image, it gives a strong period feel.

Noise

Image noise is created by random variations in the amount of light recorded by each pixel, and appears as speckles of varying brightness or colour. It's most apparent in areas that should have an even tone, especially in the darker areas of the image. Unfortunately, noise becomes more prevalent as the individual photosites on the sensor get smaller, which results from cramming more megapixels onto the same-sized sensor. However, this has driven big improvements in the software which compensates for image noise. Although the D90 has more than 12 million photosites on its 23.6 × 15.8mm sensor, its noise-reduction abilities are excellent. This is applied to JPEG images as part of in-camera processing but you may prefer to apply noise reduction to NEF (RAW) files during post-processing.

To further reduce the incidence of noise, shoot at the lowest ISO rating possible and expose carefully, because under-exposure increases the risk of visible noise.

Clipping

Clipping occurs when highlights or shadows are rendered without detail; i.e. when highlights are an empty white and shadows are a dead black. Clipping can be detected as a 'spike' at either end of the histogram (see page 74) and, in full-frame playback, the D90 can also highlight areas of clipping by flashing that part of the image (see page 72).

The D90 performs exceptionally well in this respect, but no current camera is completely immune to clipping under high-contrast conditions. There can be some scope to recover clipped areas if you shoot NEF (RAW) files. Other options for forestalling or dealing with this issue include Active D-Lighting (see page 75) and D-Lighting (see page 105).

Artefacts and aliasing

Generally, when viewing a digital image, it's not immediately apparent that it is made up of individual pixels. However, pixels sometimes become apparent as 'artefacts', or visible faults, of various kinds. They are more evident in low-resolution images because of the smaller number (or coarser mapping) of pixels.

Aliasing is most evident on sharp diagonal or curved lines, giving them a jagged appearance. Moiré or maze artefacts can occur when there is interference between fine-patterned areas in the subject and the grid pattern of the sensor itself. This often takes the form of aurora-like swirls or fringes of colour. To compensate, digital cameras employ a low-pass filter directly in front of the sensor, which works by blurring the image slightly. It is effective in removing artefacts but means that images need to be re-sharpened either in-camera or in post-processing.

JPEG artefacts look similar to aliasing but are created when JPEG images are compressed, either in-camera or on the computer. Avoid it by moderate use of JPEG compression. Use the Fine setting for images that may later be printed or viewed at large sizes.

Sharpening images

Because of the effect of the digital camera's low-pass filter, some degree of sharpening is required to make digital camera images look acceptable. However, too much sharpening can produce artefacts, including white fringes or halos along defined edges. JPEG images will be sharpened in-camera, and it's normally best to leave the D90's sharpening at its default setting.

If necessary, it is relatively easy to perform additional sharpening later, but it's virtually impossible to get rid of artefacts once they have been created by over-sharpening. If time allows, sharpening may be best left until the post-processing stage, so you can assess the effect accurately at 100% magnification on the computer screen.

Tip
Repeatedly opening and re-saving JPEG images on the computer can multiply the effect of JPEG artefacts.

136

High dynamic range

I love the sculptural forms of hawthorn trees in winter, and this solitary specimen could hardly have been better placed. I positioned it to mask the brightest part of the sky, but the contrast was still high. I used bracketed exposures, but found that I could capture a full range of tones in a single RAW file. I made two separate conversions in Adobe Lightroom – one to capture the luminosity of the sky, the other to hold detail in the foreground – and combined them in Photoshop.

BLENGDALE, WASDALE, LAKE DISTRICT, UK

Settings
ISO: 200
Focal length: 18mm
1/160 sec
f/13

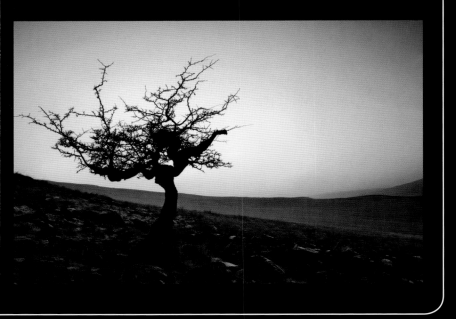

GARRY REED, ON HADRIAN'S WALL, NORTHUMBERLAND, UK

Settings
ISO: 320
Focal length: 150mm
1/400 sec
f/11

Garry is a guide who specializes in the Hadrian's Wall area and this strong lighting seemed to suit his character perfectly. Sometimes direct sunlight can be overpowering for portraits, but in this case there were big clouds in the east which acted as giant reflectors, throwing some light back into the shadows (see page 128). Not long afterwards they gave us a thorough soaking.

After sunset

For once I wasn't too concerned about foreground detail. I reckoned that Ribblehead Viaduct, the finest piece of landscape art in England, could hold its own as a silhouette. I knew there was a train due at around this time (that's elementary homework) but I was lucky that it coincided so perfectly with the best of the colours in the sky.

TRAIN ON RIBBLEHEAD VIADUCT, NORTH YORKSHIRE, UK

Settings
ISO: 320
Focal length: 48mm
1/25th sec
f/7.1

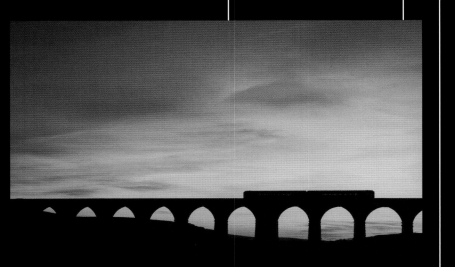

Motion

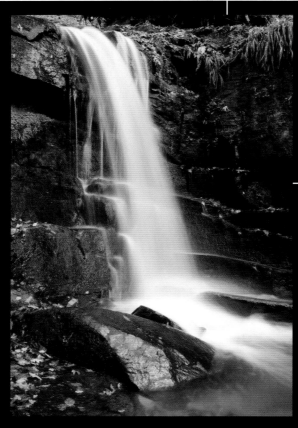

FAIRY GLEN, APPLEY BRIDGE, LANCASHIRE, UK

Settings
ISO: 200
Focal length: 22mm
1 sec
f/22

This small waterfall in a shady glen was an ideal subject for a 'dull' day. A sprinkle of rain kept the rocks in the foreground damp, which only enhanced the feel of the image. This is the sort of situation, with the camera on a tripod and plenty of time, where the D90's Live View function is most helpful, allowing precise framing. An exposure of 1 second was sufficient to smooth out the flow of the water.

Keeping it simple

Magnificent, magical Wadi Rum is a big, complex, tangled landscape, but that can easily lead to photographs which look confused and jumbled. This image was a case in point. I used a 200mm lens (equivalent to 300mm on a 35mm/full-frame camera). The hazy atmosphere helped to accentuate the sense of distance that helps the viewer to appreciate the scale of the peaks in the background. I also placed the riders close to the bottom of the frame, with only a narrow strip of desert floor visible. This image is a perfect example of why the so-called Rule of Thirds (see page 122) is best forgotten.

CAMELS, WADI RUM, JORDAN

Settings
ISO: 200
Focal length: 200mm
1/250 sec
f/6.3

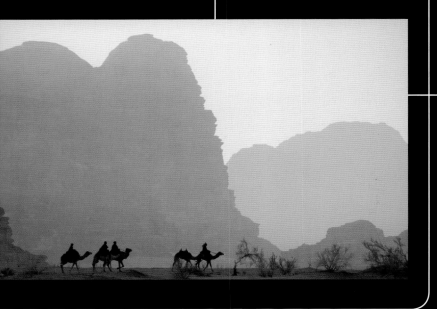

Painting with light

Down in a narrow fissure, with only a little light percolating through from above, there was still very high contrast between the brighter areas and the deepest shadows. When the camera was set up on its tripod, I tripped the shutter with the self-timer. This gave me time to scramble round the corner and hide in the passage beyond. I then fired a hand-held flashgun repeatedly at different angles to spread the light around as widely as possible. There's a distinct difference in colour between the cool light coming from the sky and the (relatively) warm light of the flash.

**FISSURE AT GREAT SCAR,
NEAR RIBBLEHEAD,
NORTH YORKSHIRE, UK**

Settings
ISO: 320
Focal length: 18mm
25 sec
f/16

NIKON D90

Figure in the landscape

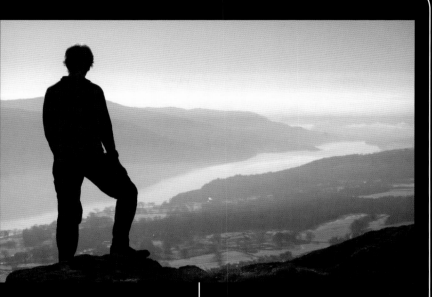

**ON YEWDALE FELLS, OVERLOOKING
CONISTON WATER, LAKE DISTRICT, UK**

Settings
ISO: 200
Focal length: 66mm
1/1000 sec
f/9.0

A perfect morning in one of my
favourite places. Although the light
over the lake and the lowlands
beyond was spectacular, long shots
felt a bit remote and didn't really
provide a sense of being there, so
I asked my long-suffering partner
to stand on a suitable outcrop.
I positioned her near the left edge
of the frame to leave plenty of room
for the view beyond. Contrast was
high but not unmanageable, and it
only took a few RAW adjustments
to produce the final image.

143

Chapter **4**

Flash

Flash can cause photographers a great deal of confusion and frustration. Many struggle to obtain satisfactory results, often because the underlying principles remain a mystery.

The key point is that all flash units are small, relatively weak light sources; this is particularly true for built-in flash units like that on the D90. The small size means that the light is strongly directional and tends to be harsh. Various accessories are available (or can be improvised) to help modify these qualities (see pages 166–7). The weakness of flash is even more fundamental, and means that all flashguns have a limited range. If the subject is too far away, the flash can't deliver enough light. A useful way to compare the power of different units, and to work out their operating range, is the Guide Number (see below).

Guide Numbers

The guide number (GN) of a flash unit indicates its power and enables you to work out its range. GNs are specified in either feet or metres (often both) and vary with the ISO rating. Nikon state that the GN for the D90's built-in flash at ISO 200 is 17(m)/56(ft). However, this conflicts with Nikon's own figures for the flash range (see page 150), which suggest that 17 is correct at ISO 400, and the GN at 200 is 12(m)/39(ft). My own tests suggest that the published GN is about right. The GN can be related to subject distance, and the f-stop (aperture setting) in use, as follows:

f-stop = GN/distance
distance = GN/f-stop

This means that a subject 17m (56ft) away would require an aperture of f/1; however, Nikon don't make any f/1 lenses. A subject 8.5m (28ft) away could be correctly illuminated at f/2 and at f/4 the range would be 4.25m (14ft). However, if you double the ISO, the GN also doubles. At ISO 400 you can shoot a subject 8.5m (28ft) away at f/4, and so on. You may not want to carry all these figures around in your head, but it is important at least to have an idea of what is possible.

Operating the built-in flash

The D90's built-in flash, like all such units, has inevitable limitations due to its small size, modest power and fixed position close to the lens axis. As well as limiting its working range, these factors mean it produces a rather flat and harsh light that is not very flattering for portraits, for example. However, there are many occasions when it's a great deal better than nothing, and it really comes into its own when used for fill-in light.

1) Select a metering method. Matrix or centre-weighted metering is most appropriate for fill-in flash using i-TTL balanced fill-flash. Spot metering is more appropriate when flash is the main light.

2) Press the ⚡ flash pop-up button (on the left side of the pentaprism) and the flash will pop up and begin charging. When the flash is charged, the flash-ready indicator ⚡ is displayed in the viewfinder. In some modes, the flash unit may pop up automatically when low light levels are detected.

3) Choose a flash mode by pressing the ⚡ button and rotating the Main command dial until the appropriate icon appears in the Control panel. See pages 151–3 for an explanation of the different flash modes.

4) Apply half-pressure to the shutter-release button to focus and take a meter

Tips
The built-in flash is recommended for use with CPU lenses of between 18 and 300mm focal length. Due to its position, some lenses may block part of the flash output at close range, and it's best to remove lens hoods for the same reason. The D90 manual contains details of the limitations of using the built-in flash with certain lenses.

Remember that the D90's built-in flash is not available in 🌣 Auto (flash off), 🏔 Landscape, and 🏃 Sports modes.

reading. Fully depress the shutter-release button to take the photograph.

5) When you've finished, lower the built-in flash by pressing it gently downwards until it clicks into place.

Fill-in flash

One of the most important uses of flash is for 'fill-in' light – pumping a little light into dark shadows such as those found in subjects under direct sunlight. This is why you'll often see professionals using flash in bright, sunny conditions, something that puzzles many observers. Fill-in flash doesn't need to fully illuminate the shadows, just lighten them a little, so any flash can be used at a smaller aperture, or greater distance, than its GN might suggest – typically one to two stops smaller, or two to four times the distance. As part of its Creative Lighting System (CLS), Nikon has developed i-TTL balanced fill-flash, which helps to achieve natural-looking results when using the flash for fill-in.

i-TTL balanced fill-flash for DSLR

i-TTL balanced fill-flash automatically comes into play provided (a) matrix or centre-weighted metering is selected, and (b) a CPU lens is attached or lens data has been specified. It also requires a CLS-compatible flashgun. The flash emits a series of virtually invisible pre-flashes immediately before exposure. The light reflected from these is detected by the metering sensor and analyzed together with information about the ambient light. If type D or G lenses are used, distance information is also incorporated.

Standard i-TTL flash for DSLR

If spot metering is selected, this mode is activated instead (it can also be selected directly on some accessory flashguns). In this mode, flash output is controlled to provide correct illumination of the subject, but background illumination is not taken into consideration. Standard i-TTL mode is more suitable when flash is being used as the main light source rather than for fill-in.

NEAR GARSTANG, LANCASHIRE, UK
The background exposure is the same for both shots, but in the second, the fill-in flash ensures that the figure is properly lit.

NIKON D90

Flash exposure

The combinations of shutter speed and aperture available when using flash depend on the exposure mode that is in use. The information in the following table applies to the majority of compatible flash units; with the optional SB-900, SB-800 and SB-600 Speedlight units it is possible to use all shutter speeds down to 1/4000 sec (see page 160).

Exposure mode	Shutter speed	Aperture
AUTO Auto Portrait P	Set automatically. The normal range is between 1/200 and 1/60 sec, but in certain flash modes all settings between 1/200 sec and 30 sec are available.	Set automatically
S	Selected by user. All settings between 1/200 sec and 30 sec are available. If user sets a faster shutter speed, the D90 will fire at 1/200 sec when the flash is active.	Set automatically
A	Set automatically. The normal range is between 1/200 and 1/60 sec, but in certain flash modes all settings between 1/250 sec and 30 sec are available.	Selected by user
M	Selected by user. All settings between 1/200 sec and 30 sec are available. If user sets a faster shutter speed, the D90 will fire at 1/200 sec when the flash is active.	Selected by user
🌷 Close up	Set automatically. The normal range is between 1/200 and 1/125 sec. Maximum aperture limited to f/5.6 at ISO 200, f/8 at 800, f/11 at 3200 and so on.	Set automatically
Night portrait	Set automatically. The normal range is between 1/200 and 1 sec.	Set automatically

Flash range

As discussed on page 146, the range of any flash depends on its GN, ISO sensitivity setting and the aperture selected. The following table details the approximate range of the built-in flash for selected distances, apertures and ISO settings. These figures are based on Nikon's stated guide numbers and supported by practical tests, but note that they do not agree with the range table published in the D90 manual. In any case, the most important thing is not to memorize all these figures but to have a general sense of the very limited range that always applies when using flash. A few quick test shots will soon establish a working range that achieves good results for the type of shot you are interested in.

ISO equivalent setting					Range	
200	400	800	1600	3200	metres	feet
2	2.8	4	5.6	8	1.0 – 8.5	3' 3" – 27' 11"
2.8	4	5.6	8	11	0.7 – 6.1	2' 4" – 20'
4	5.6	8	11	16	0.6 – 4.2	2' – 13' 9"
5.6	8	11	16	22	0.6 – 3.0	2' – 9' 10"
8	11	16	22	32	0.6 – 2.1	2' – 6' 11"
11	16	22	32		0.6 – 1.5	2' – 4' 11"
16	22	32			0.6 – 1.1	2' – 3' 7"
22	32				0.6 – 0.8	2' – 2' 7"

Flash synchronization and flash modes

Flash, as the name implies, is virtually instantaneous: a burst of flash lasts just a few milliseconds. If the flash is to cover the whole image frame it must be fired when the shutter is fully open, but at faster shutter speeds, SLRs like the D90 do not in fact expose the whole frame at once. In the case of the D90, the fastest shutter speed that can normally be used with flash is 1/200 sec. This is therefore known as the sync (for synchronization) speed.

The D90 has a number of flash modes; the differences between them are largely to do with options relating to synchronization and shutter speed. Choose a flash mode by pressing the ϟ button and rotating the Main command dial.

Auto flash

In ⓐ Auto and most Scene modes, the default setting is **Auto flash**, which means that the flash will operate automatically if the camera judges that light levels are too low. Alternative modes which can be set are Red-eye reduction and Flash off.

In ⊛ Auto (flash off), ⛰ Landscape, and ⚡ Sports modes, the effective mode is **Flash off** and this cannot be overridden. Even if you fit a separate flashgun, the choices are limited to turning red-eye reduction on or off.

In **P**, **S**, **A** and **M** exposure modes, Auto flash is not available and the flash must be activated by pressing the ϟ button.

Standard flash mode

This is the default flash mode when using **P**, **S**, **A** and **M** exposure modes. In standard flash operation, the flash fires as soon as the shutter is fully open, i.e. as soon as possible after the shutter-release button is pressed. This is also known as front-curtain sync and is generally appropriate for fast response. In **P** and **A** exposure modes, the camera will set a shutter speed in the range 1/60–1/200 sec. In **S** and **M** exposure modes, the camera can set any shutter speed down to 30 sec, and standard flash becomes indistinguishable from Slow sync (see page 152). The 'opposite' of front-curtain sync is, naturally enough, rear-curtain sync (see page 152).

Slow sync

This mode allows longer shutter speeds (up to 30 secs) to be used in **P** and **A** exposure modes, so that backgrounds can be captured even in low ambient light. Movement of the subject or camera (or even both) can result in a partly blurred image combined with a sharp image where the subject is lit by the flash. This is often used for specific creative effect. This mode is also available in Night portrait mode, but the longest exposure is limited to 1 sec. Slow sync cannot be selected in **S** and **M** exposure modes, in which longer shutter speeds are available anyway.

Rear-curtain sync

Rear-curtain sync triggers the flash at the last possible instant. This can be useful when photographing moving subjects because any image of the subject created by the ambient light then appears behind the subject. This looks more natural than having it appear to extend ahead of the direction of movement. Rear curtain sync can only be selected in **P, S, A** and **M** exposure modes. In **P** and **A** modes it also allows slow shutter speeds (below 1/60 sec) to be used. This is referred to as slow rear-curtain sync. Shooting with rear-curtain sync can be difficult at longer exposure times as you need to predict the position of your subject at the end of the exposure. It is often best suited to working with co-operative subjects, so that the timing can be fine-tuned after reviewing the images on the monitor.

RUNNERS' FEET
The use of rear-curtain sync in this image means that the motion blur on the runners' feet trails behind the sharp image created by the flash.

TRAM, BLACKPOOL PLEASURE BEACH, UK
Slow sync balanced the flash on the tram with the lights of the funfair and the evening sky, but because of the front-curtain sync, the lights of the tram trail ahead of the flash image, not behind it.

Red-eye reduction

On-camera flash, especially a built-in unit, is very prone to the problem of 'red-eye'. This is because the flash is so close to the lens axis that light reflects straight back off the subject's retina. The red hue is caused by the blood vessels of the retina (although when photographing some animals, you may see different colours). Red-eye reduction works by shining a light onto the subject about a second before the exposure, causing the subject's pupils to contract. This delay makes it little use for moving subjects, and it kills spontaneity. It's often much better to remove red-eye using the Red-eye correction facility in the Retouch menu (see page 105). Better still, use a separate flash, away from the lens axis, or no flash at all.

Red-eye reduction with slow sync

This combines the two modes described above. It allows backgrounds to register, which may give a more natural look to portraits than red-eye reduction mode on its own. Red-eye reduction with slow sync is only available when using **P** and **A** exposure modes and, in a more limited form, with ![icon] Night portrait mode.

Flash compensation

Flash compensation adds another refinement to the D90's flash capabilities. Although the onboard metering and flash control are very sophisticated, there may be times when you want to adjust the flash output, perhaps for creative effect. The Nikon D90's excellent monitor allows accurate judgement of the effect of a particular flash level, enabling you to apply flash compensation with confidence.

Using flash compensation

To use flash compensation, hold down the ⚡ button and rotate the Main command dial. Flash compensation can be set from -3 Ev to +1 Ev in increments of ⅓ Ev. Positive compensation will brighten areas lit by the flash while leaving other areas of the image unaffected. Negative compensation makes flash-lit areas darker, again leaving other areas unaffected. After use, reset the flash compensation level to zero, otherwise the camera will retain the setting next time flash is used.

Tip
If the flash is already at the limit of its range, positive compensation can't make it any brighter. In this case, if you need to brighten the flash image, use a wider aperture, move closer to the subject, or increase the ISO rating.

Note
Flash compensation works in the same way when a compatible external flash unit like the SB-900, SB-800 or SB-600 is attached.

154

+1 Ev

Standard
flash

-1 Ev

FLASH COMPENSATION
The three shots were taken
with flash compensation set
to +1, 0 and -1 respectively.
A very similar result could
have been achieved with
flash exposure bracketing.

FV lock

FV lock works in a very similar way to exposure lock (see page 34), allowing flash output to be locked and the image to be reframed. FV lock is most useful when you want to shoot using flash with an off-centre subject, especially if it's outside the area covered by the focusing sensors and spot metering.

Using FV lock with the D90 is a rather involved process because it requires assigning the FV lock function to the **Fn** button or the **AE-L/AF-L** button. Unless you expect to use FV lock frequently, it will generally be more convenient to use flash compensation instead (see page 154), fine-tuning the compensation level with reference to the monitor screen.

1) To assign the **Fn** button to the **FV lock** function, navigate to Custom Setting f3, **Assign FUNC button**. Select **FV lock** and press **OK**. To assign FV lock to the **AE-L/AF-L** button, use Custom Setting f4.

2) Raise the built-in flash.

3) Position the subject in the central area of the frame and use half-pressure on the shutter-release button to activate focus and metering.

4) Check that the flash-ready indicator ⚡ is shown in the viewfinder. Press the **Fn** button. A pre-flash is fired to set the flash level, after which FV lock icons appear in the viewfinder and Control panel.

5) Recompose the image and shoot by pressing the shutter-release button fully. You can take further shots and the flash level will remain locked.

6) To release the FV lock, press the **Fn** button again.

> **Tip**
> If you use FV lock frequently, but don't want to leave the **Fn** button or the **AE-L/AF-L** button assigned to this function, the Recent Settings menu (see pages 110–1) will often provide the most convenient way to make changes.

> **Note**
> FV lock works in the same way when a compatible flash unit like the SB-800 or SB-600 is attached.

156

Flash exposure bracketing

Flash exposure bracketing is another way in which the D90 allows you to achieve the precise level of flash illumination you require. It works in the same way as exposure bracketing (see pages 53–4), and indeed it's possible to bracket both flash and the main exposure simultaneously.

1) Select flash bracketing using Custom setting e4: set to **Flash only** to ensure that only flash values are varied, or **AE & flash** to vary the main exposure as well.

2) While pressing the **BKT** button, rotate the Main command dial to select the number of shots (2 or 3) for the bracketing burst; the selected number is displayed in the Control panel.

If **+2** is selected, one shot is taken at the metered flash exposure and one is 'over-exposed'.

If **-2** is selected, one shot is taken at the metered exposure and one is 'under-exposed'.

If **3** is selected, one shot is taken at the metered exposure, plus one 'under-exposed' and one 'over-exposed'.

3) While pressing the **BKT** button, rotate the Sub-command dial to select the exposure increment between each shot in the sequence. You can choose between 0 and 2 Ev in steps of ⅓ Ev. This increment is also displayed in the Control panel. A **BKT** icon is displayed in the viewfinder and Control panel.

4) Frame, focus and shoot normally. The camera will vary the flash output (and also the background exposure, if **AE & flash** was selected) with each frame until the sequence is completed

5) To cancel bracketing and return to normal shooting, press the **BKT** button and rotate the main command dial until **OFF** appears in the Control panel. The bracketing increment that you chose in step 3 will remain in effect next time you initiate bracketing.

FLASH

Optional Speedlights

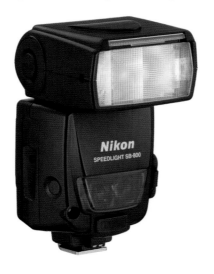

Speedlight is the term Nikon, and some other manufacturers, use for a flashgun. Accessory speedlights enormously extend the power and flexibility of flash with the D90. Nikon's current range offers the SB-900, SB-800, SB-600, SB-400 and SB-R200. Those who use flash extensively will maximize the benefits of i-TTL advanced flash control by using a Speedlight that is specifically designed to work with the Nikon system. Independent makers such as Sigma offer alternative units that may be cheaper, but there is only space in this book to cover Nikon's own units.

Mounting an external speedlight

1) Ensure that both the camera and the Speedlight are switched off, and check that the pop-up flash is down. Slide the foot of the Speedlight into the camera's hotshoe. If resistance is encountered, do not use force. The mounting lock pin on the Speedlight may already be extended. Check and try again.

2) Rotate the lever at the base of the speedlight to secure it in position with the locking pin.

3) Switch on both the camera and the Speedlight.

Tip
Speedlights are greedy for battery power and it is wise to carry at least one set of spares.

Bounce flash and off-camera flash

Direct flash, especially when mounted on or close to the camera, gives a light that is both flat and harsh, and far from ideal for attractive results in most cases. Taking the flash off the camera gives you far greater control over the direction and quality of its light. This usually requires a remote cord (see page 166).

A huge improvement can be achieved simply by bouncing the flash light off a suitable surface such as a ceiling or a reflector, such as those made by Lastolite. This spreads the light, softening hard-edged shadows, and changes its direction, producing better modelling on the subject.

Nikon's SB-900, SB-800 and SB-600 Speedlights have heads which can be tilted and swivelled through a wide range,

allowing light to be bounced off walls and other surfaces. The SB-400 has a more limited tilt capability, allowing light to be bounced off the ceiling or a reflector.

> **Tips**
> Effective flash range is significantly reduced when using bounce flash. Most surfaces will absorb some of the light, and the light has to travel further to reach the subject.
>
> Coloured surfaces will impart their hue to the bounced light and so to the subject of the shot. This can be used for creative effect, but for neutral results, use a white surface.

ICELANDIC FIGURES
The first shot (top) was taken using the built-in flash, giving generally flat lighting combined with an ugly shadow. The second (above right) uses indirect flash from the right, giving much more interesting light. The third image uses a bounce flash setup (similar to that shown on page 160) to give a much softer, more even light.

INDIRECT FLASH
Using an external
Speedlight with a
dedicated sync cord
(see page 166) allows
you to put the light
exactly where you
want it. A few sheets
of watercolour paper
complete the 'studio'.
A similar setup was
used for the images
on page 159, and
several other photos in
Chapter 5 of this book.

High-speed flash sync

Nikon's SB-900, SB-800, SB-600 and SB-R200 Speedlights all offer Auto FP High-speed sync. This enables the flash output to be phased or pulsed, allowing flash to be used at all shutter speeds. Combining flash with fast shutter speeds is useful when ambient light levels are high or you wish to use a wide aperture. Enable Auto FP High-speed sync using Custom setting e5, **Auto FP**. If a suitable

Speedlight is attached, flash can then be used at any shutter speed from 30 sec to 1/4000 sec. Note, however, that the effective power (and therefore working range) of the Speedlight will be reduced as the shutter speed gets faster. See the manual for the individual Speedlight for further details, and take test shots and review them on the camera's monitor if at all possible.

160

Speedlight SB-900

Introduced in 2008, the SB-900 is the flagship of Nikon's Speedlight range. It offers multiple illumination patterns, a 12–135mm zoom range and automatic detection of sensor format (FX or DX). Coverage can be made even wider with the built-in diffuser, but there's no lens available for the D90 that can match this angle (it might be useful, however, when using the flash off-camera). The Guide Number is quoted as 34 (ISO 100/metres), but the effective GN varies according to the zoom setting; however, as a guide, the SB-900 offers at least four times the power of the D90's built-in flash, and its reach is even greater at longer focal lengths. The SB-900 can also be employed as the 'commander' unit giving integrated fully auto flash control with multiple Speedlights.

Guide number
34 (metres) (ISO 100, set at 35mm zoom).

Flash coverage (lens focal length range)
12–135mm with Nikon D90; can be widened to 10mm with built-in adaptor or separate diffusion dome.

Tilt/Swivel Yes

Recycling time
2.3 sec with Ni-MH batteries; 4.5 sec with Lithium batteries

Approximate number of flashes per set of batteries:
190 with Ni-MH batteries; 230 with Lithium batteries

Dimensions (w × h × d) 78 × 146 × 118.5mm

Weight 415g (without batteries)

Included accessories
Diffusion Dome SW-13H, Speedlight Stand AS-21, Colour Filter Set SJ-900, Colour Filter Holder SZ-2, Soft Case SS-900.

Speedlight SB-800

Although now supplanted at the top of the range by the SB-900, the SB-800 is still a highly capable unit offering plenty of power plus all the capabilities of Nikon's Creative Lighting System. The SB-800 can also be employed as the 'commander' unit, giving integrated fully auto flash control with multiple Speedlights.

Guide number
38 (metres) (ISO 100, set at 35mm zoom).

Flash coverage (lens focal length range)
24–105mm with full-frame cameras, equivalent to 16–70mm on the D90; can be widened to 14mm with built-in adaptor or supplied diffusion dome.

Tilt/Swivel Yes

Recycling time
2.7 sec with supplied SD-800 attached;
6 sec with standard AA batteries

Approximate number of flashes per set of batteries: 150 at full power

Dimensions (w × h × d) 70.6 × 127.4 × 91.7mm

Weight 350g (without batteries)

Included accessories
Quick Recycle Battery Pack SD-800
(for one AA-size battery), Diffusion Dome SW-10H,
Speedlight Stand AS-19, Colour Filter Set SJ-800
(FL-G1 and TN-A1), Soft Case SS-800.

162

Speedlight SB-600

Though less powerful or versatile than the SB-900 or SB-800, the SB-600 is still a highly advanced flash unit and fully integrated with Nikon's Creative Lighting System. It can be used very effectively as a stand-alone unit and its extensive tilt and swivel ability makes it ideal for bounce flash. It also fits capably into multi-flash setups.

Guide number
GN 30 (metres) (ISO 100, set at 35mm zoom)

Flash coverage (lens focal length range)
Equivalent to 16–56mm on D90

Tilt/Swivel
Yes

Recycling time
3.5 sec

Approximate number of flashes per set of batteries: 200

Dimensions (w × h × d)
68 × 123.5 × 90mm

Weight
300g (without batteries)

Included accessories
Speedlight Stand AS-19, Soft Case SS-600

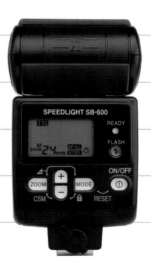

Speedlight SB-400

A compact, light and simple flash.

Guide number
GN 21 (metres) (ISO 100, set at 35mm zoom)

Tilt/Swivel
Tilt only

Dimensions (w × h × d)
66 × 56.5 × 80mm

Weight
127g (without batteries)

Included accessories
SS-400 soft case

Speedlight SB-R200

Designed principally to work as part of a
close-up lighting system (see pages 176–7).
Can't be used as a stand-alone or attached
to the camera's hotshoe. It can be triggered
using the D90's built-in flash as a commander,
or for greater versatility either an SU-800
commander or SB-800 Speedlight.

Wireless Speedlight Commander SU-800

The Wireless Speedlight Commander SU-800 allows complete control over a complex setup of multiple SB-900, SB-800, SB-600 and/or SB-R200 Speedlights. In Commander mode it can control up to three groups of SB-900, SB-800 and/or SB-600 Speedlights.

Speedlight Commander Kit R1C1 and Speedlight Remote Kit R1

Dedicated kits for close-up photography (see pages 176–7).

Flash accessories

Flash accessories such as diffusers, reflectors and remote leads allow more flexibility and greater control of lighting effects. Nikon has an extensive range, but when time is short or money is tight, substitutes can sometimes be improvised.

Water Guard WG-AS3
Fits round the base of the SB-900 Speedlight to seal it and the camera's hotshoe against moisture.

SD-800 BATTERY PACK
The SD-800 adds a fifth battery to shorten recycle time.

Battery Pack SD-800
Quick recycling battery pack supplied with the SB-800. An extra AA battery cuts recycling time to 2.7 sec.

Battery Pack SD-8A
External power source for a higher flash capacity, compatible with the SB-800 and some earlier Speedlight models.

Speedlight Stand AS-19
Allows compatible Speedlights in a wireless setup to stand on any flat surface. Also has a tripod socket.

Colour Filter Set SJ-1
Colour filter system for the SB-800 with eight different filters that can easily be attached to the flash head (a more limited set is supplied with the SB-800).

Flash Adaptor AS-15
Slots into the D90's accessory shoe and allows connection of any flash unit using a standard PC cable (including large-scale studio flash units). The adaptor may provide an inexpensive alternative to Nikon's dedicated sync cords (see below).

TTL Sync Cord SC-28
Extending to 5ft (1.5m), this cord allows a compatible Speedlight to be positioned well away from the camera.

TTL Sync Cord SC-29
Adds an AF Assist illuminator to the SC-28 (this only works with the SB-800).

166

Flash diffusers

Flash diffusers are a simple, economical way to spread and soften the hard light from a flash head. They may slide over the flash head like Nikon's SW-10H diffusion dome (included with the SB-800) or be attached by other means such as elastic bands or Velcro. The Jessops Universal Flash Diffuser is an ultra-cheap option while Sto-Fen make a range of Omni-Bounce diffusers to fit most flash units, and an even an Omni-Flip which works

with built-in flash units like that on the D90. Diffusers inevitably reduce the light reaching the subject; the D90's metering system will allow for this. Remember that the effective range will be reduced.

Flash extenders

A flash extender slips over the flash head, using mirrors or a lens to create a tighter beam and therefore extend the effective range of the flash. Again, the D90's metering system will automatically accommodate the use of an extender. Nikon do not make flash extenders so a third-party option will have to be sought.

Flash brackets

The ability to mount the flash off-camera, and therefore change the angle at which the light hits the subject, is invaluable in controlling the quality of light. Nikon's Speedlights can be mounted on a tripod or placed on any flat surface using the AS-19 stand. For a more portable solution, many photographers prefer a light, flexible arm or bracket which attaches to the camera and supports the Speedlight. Novoflex is one manufacturer that produces a number of such products, but because all such systems normally attach to the camera base via a standard tripod screw, a suitable system might easily be found in the bargain bin at a good camera shop.

FLASH BRACKET
Here, a flash bracket is coupled with a 'brolly' style reflector to give a broad spread of light.

Chapter **5**

Close-up

Usually, photography is about capturing on camera what you can see with the naked eye. True close-up photography goes beyond this, opening up a whole new world, or at least a new way of seeing the world. For many it casts a spell that can last a lifetime.

Without doubt, for close-up photography, the 35mm SLR and its digital successors like the Nikon D90 reign supreme. Reflex viewing is an advantage at ordinary working distances but becomes essential in close-up work. Also, the D90 is part of the legendary Nikon system of lenses and other accessories, which offers many possibilities for those seeking to delve deeper into the world of close-up photography.

One of the key issues that will quickly become apparent to anyone exploring close-up and

Working distance

The working distance is the distance required to obtain the desired reproduction ratio with any given lens, and is related to the focal length of the lens. With a 200mm macro lens, the working distance for 1:1 reproduction is double that of a 100mm. Because the D90's sensor is smaller than a 35mm film frame, the effective focal length of any lens is multiplied by about 1.5, so working distance also increases. This extra distance can be valuable when photographing living subjects, and it can also make it easier to avoid your own shadow falling onto the subject.

macro photography is depth of field (see pages 116–8). As working distance decreases, depth of field becomes increasingly narrow. This has several consequences. First, it's often essential to stop down to small apertures, necessitating

FROST ON WINDOWPANE
Close-up on a conservatory window, just as the rising sun reached it.

SD MEMORY CARD
Life-size reproduction (1:1) illustrated with
an object every D90 user will have to hand.

longer exposures. Second, the
slightest movement of either
subject or camera can ruin the
focus. For both reasons, a tripod
or other solid camera support is
often required, and it may also
be necessary to take steps to
prevent the subject from moving.

Tip
There's a trick that many macro
photographers use to ensure that
they are as close to the subject as
possible. Use manual focus and set
the lens to its closest focusing
distance. Don't touch the focus
control again; instead, move either
the camera or the subject until the
image is sharp. This may take a
little time, but does guarantee the
closest possible shot.

CLOSE-UP

Reproduction ratio

The reproduction ratio (also referred to
as image magnification) is the ratio
between the actual size of the subject
and the size of its image on film or, in
this case, on the D90's imaging sensor.
This sensor measures 23.6 × 15.8mm,
so an object of these dimensions
captured at 1:1 would exactly fill the
image frame. For example, the long
side of the sensor is almost exactly
equal to the diameter of a 10p coin,
so at 1:1 the image of the coin will
completely fill the frame.

Of course, when the image is printed,
or displayed on a computer screen, it
may appear many times larger than
life, but that's another story.

A 1:4 reproduction ratio means that
the smallest subject that would give
you a frame-filling shot is one that's
four times as long or wide as the
sensor. With a DX-format camera like
the D90, that size is approximately
94 × 63mm (4 x 2½in).

The D90's depth of field preview becomes extremely valuable when working at close range. Because of the minimal depth of field, focusing is critical. Often, merely focusing on the subject is no longer good enough and it becomes necessary to determine which part of the subject – the eye of an insect, the stamen of a flower – should be in sharp focus. With its 11 AF points, the D90 is capable of focusing accurately within much of the frame, but this is also an area where Live View mode comes into its own. Provided 🄴🄳 Wide-area AF or 🄽🄾🅁🄼 Normal-area AF mode is in use (see page 70), the focus point can be set anywhere in the frame. If you prefer to use manual focus, Live View, with its ability to zoom in, also makes this process ultra-precise.

Whichever focusing method you choose, remember that the slightest movement of camera can negate all the trouble you've taken to get the focus right.

BUTTONS (1)
The minimal depth of field obtained in extreme close-up work is shown in the first shot (top), taken at f/2.8, but even at f/16 (below) the largest button is not pin-sharp throughout.

Close-up attachment lenses

Close-up attachment lenses are probably the simplest and most economical way to enter the world of macro photography. Each is a single magnifying lens that screws into the front of the camera lens like a filter. They are light, easy to carry and attach, and relatively inexpensive. They are also easy to use as they are fully compatible with the camera's exposure and focusing systems. For the best results, it's advised to use them in conjunction with prime (fixed focal length) lenses.

Nikon has long produced a range of seven close-up attachment lenses (see table below). However, apart from no. 0, these are no longer listed and appear to have been withdrawn. As this happened fairly recently, it is certainly worth

BUTTONS (2)
Shooting straight down on the subject kept everything in almost the same plane, reducing the depth of field required. Even so, the slate background is not sharp.

enquiring at Nikon dealers, and these products may also be available second-hand at even lower cost.

Product number	Attaches to filter thread	Recommended for use with
0, 1, 2	52mm	Standard lenses
3T, 4T	52mm	Short telephoto lenses
5T, 6T	62mm	Telephoto lenses

Extension tubes

Extension tubes (also known as extension rings) are another simple and economical way of extending the close-focusing capabilities of a lens. An extension tube is essentially just a tube fitted between the lens and the camera. This has the effect of decreasing the minimum focusing distance, thereby increasing the magnification factor. Extension tubes are light, compact and easy to attach.

Unlike close-up attachment lenses (see page 173), extension tubes contain no glass elements

and should have no detrimental effect on the optical quality of the lens. They can also be used in conjunction with almost any lens (see Note below).

The Nikon system includes four extension tubes, PK-11A, PK-12, PK-13 and PN-11, which extend the lens by 8mm, 14mm, 27.5mm and 52.5mm respectively Because of its greater length, the PK-11 also incorporates a tripod mount.

The only real drawback of these extension tubes is that many of the camera's functions are not available: there's no autofocus, although this is arguably less of a drawback in macro photography than in most other areas; no auto-exposure modes (manual only) and no matrix metering. Compatible extension tubes are also produced by other manufacturers such as Kenko. For those prepared to use the D90 in a good old-fashioned way, they arguably offer the best low-cost way into true macro photography.

Note

Nikon state that some recent lenses, including the AF-S DX Nikkor 18–105mm f/3.5-5.6G ED VR, which is often supplied as a 'kit lens' with the D90, are not compatible with accessories such as extension tubes, bellows (see page 175) and teleconverters (see page 211). Check the lens manual before using any lens with these accessories. Such restrictions may make you glad you hung on to an older lens, or send you hunting for second-hand bargains.

Bellows

Bellows work on the same basic principle as extension tubes, by extending the spacing between the lens and the camera body, but are not restricted to a few set lengths. There's no extra glass to impair the optical quality of the lens, but they are expensive, heavy and cumbersome, and take time to set up. They are usually employed in controlled shooting situations, such as a studio.

Nikon's PB-6 bellows set offers extensions between 48mm and 208mm, giving a maximum reproduction ratio of about 11:1. Bellows are also made by Novoflex.

Reversing rings

Also known as reverse adaptors – or, in Nikon's own jargon, inversion rings – these allow lenses to be mounted in reverse; the adaptor screws into the filter thread. This allows much closer focusing than when the lens is used normally. Ideally used with a prime lens, a reversing ring could be coupled with an inexpensive manual focus 50mm f/1.8. Nikon's Inversion ring BR-2A fits a 52mm filter thread.

Light reduction

Because accessories like extension tubes and bellows increase the effective physical length of the lens, they also increase the effective focal length. However, the physical size of the aperture does not change. The net result is that a lens with a maximum aperture of f/2.8 starts to behave like an f/4 or f/5.6 lens. This makes the viewfinder image less bright than normal, and of course affects the exposure required. When you stop down to a nominal f/22, it may be effectively f/32 or less. While checking depth of field with the preview button is a good idea in macro photography, it may be very difficult at small apertures as the viewfinder image becomes very dim. Taking a test shot and viewing it on the D90's big, bright monitor screen often gives a much better idea of depth of field. Live View may also prove advantageous in this respect.

Macro flash

The Nikon SU-800 Wireless Speedlight Commander unit fits onto the D90's hotshoe.

Tip
One reason why flash is often favoured in close-up work is to overcome the problem of subject movement. An inexpensive way to reduce movement due to breeze is with a light-tent, which also helps to give a diffused, even light on the subject. Proprietary examples are available from Lastolite, who also produce the collapsible ePhotomaker, but it's not too difficult to produce your own. The trick lies in finding the right fabric, which ideally needs to be colour-neutral.

Controlled lighting is often required for serious macro work and that usually means flash. However, regular Speedlights are not designed for such close-range work and, if mounted on the hotshoe, the short working distance means that the lens barrel may throw a shadow onto the subject. The built-in flash is even less useful for real close-up work.

Specialist flash units are available for macro work, usually taking the form of either ring-flash or twin flash. Because of the close operating distances they do not need a high power and therefore can be (relatively) light and compact.

Ring-flash units fit round the lens itself, giving an even spread of light even on ultra-close subjects. They are also favoured by some portrait photographers. Nikon's own SB-29s ring-flash unit has now been discontinued, but examples can still be found at some dealers. Alternatively, Sigma produce the EM-140 DG Electronic Macro Flash.

Note

Dedicated macro-flash units may be unaffordable or unjustifiable for those who only want to get a taste for macro work. With a little ingenuity a great deal can be done with a single flashgun, a sync cord, and a reflector; this is exactly the setup that was used for several of the shots in this chapter. A piece of white card can be all you need for a reflector; position it as close to the subject as possible for maximum benefit. This system can even be more flexible than a twin-flash or ring-flash setup, allowing the light to be directed as you choose.

For the present, Nikon has chosen to concentrate on the twin-flash approach to macro work, with its Speedlight Commander Kit R1C1 and the Speedlight Remote Kit R1. These are both based around two Speedlight SB-R200 flashguns (see page 164) that are mounted either side of the lens. The difference is in the way these are controlled.

The R1C1 uses a Wireless Speedlight Commander SU-800 unit which fits into the camera's hotshoe, while the Remote Kit R1 uses either a separate SB-800 flash or the D90's own built-in flash as the commander. These kits are not cheap but they do give very flexible and precisely controllable light on macro subjects.

SEDUM FLOWERS
These tiny flowers were captured at almost 1:1 reproduction ratio. Lighting was by a single flashgun to the right, with a reflector on the left to balance the light.

Macro lenses

Many lenses are sold as 'macro' lenses when their reproduction ratio falls well short of 1:1. True macro lenses achieve 1:1 or better and are optically optimized for close-up work, though they normally prove more than capable for general photography too. This is certainly true of Nikon's widely admired macro lenses, known as Micro Nikkors, of which there are three in the current line-up.

Nikkor 105mm macro lens

The most recent addition to the range is the 60mm f/2.8G ED AF-S Micro Nikkor: advances over the previous 60mm f/2.8D AF Micro Nikkor (which may still be available at some dealers) include the use of ED (Extra-low dispersion) glass for superior optical quality; Silent Wave Motors (SWM) for ultra-quiet autofocus; and a non-rotating front element, which makes life easier when you're using front-mounted macro-flash.

The 105mm f/2.8G AF-S VR Micro Nikkor also features internal focusing, ED glass and Silent Wave Motor, but its main claim to fame is as the world's first macro lens with VR, or Vibration Reduction. As the slightest camera shake is magnified hugely at high reproduction ratios, this technology – designed to combat exactly that – is extremely welcome, allowing the photographer to make use of shutter speeds as much as four stops slower than would otherwise be possible. Be warned, however: though it may neutralize camera shake, it has no effect on subject movement.

Finally, the 200mm f/4D AF Micro Nikkor is a particular favourite with those shooting the animal kingdom, as its longer working distance means there is much less chance of frightening away your subject.

Nikkor 60mm macro lens

LEMON TETRA
A single flashgun and remote cord were
used to create this close-up image. The flash
was positioned just above water level (taking
care not to splash water on it). Shooting with
the flash in front of the tank would have
created horrible reflections.

Settings
ISO: 400
Focal length: 50mm
1/20 sec
f/8

Chapter **6**

Movies

There's no doubt that the headline-grabbing innovation of the Nikon D90 is its ability to record moving images. While this feature has been available on many digital compact cameras for some years, the D90 is the first DSLR to offer it. Movie mode is essentially an extension of Live View (see pages 68–70), and as a result it has certain idiosyncrasies and limitations that need to be understood if the best results are to be obtained.

Movie quality

The D90's highest quality setting records movies at a frame size of 1280 × 720 pixels, which is referred to as an HD (High Definition) setting. This does qualify under current HD TV standards, but many HD TV sets have a higher native resolution, typically 1920 × 1080 pixels, which is also the standard for HD camcorders. The D90's HD movies can be played through an HD TV and will look fine; they will also look good on most computer screens. The HD resolution is much higher than that of most compact cameras and, because the D90 has a larger sensor, image quality should be better in other respects too.

The D90's default resolution is 640 × 424 pixels, which is more than adequate for uploading to the internet or playing on the majority of mobile devices (the iPhone screen, for example, is 480 × 320 pixels). The lowest setting is 320 × 216 pixels, which allows you to capture a lot more video on the same memory card, and is still adequate for many purposes.

The D90 produces movies in a standard Motion-JPEG format (the file extension is .AVI) which can be played through most media players such as QuickTime, RealPlayer and Windows Media Player.

Advantages

Although most dedicated movie-makers will probably want to stick to a camera designed specifically for shooting video, the D90 does have some advantages over these. The biggest plus is its ability to use the entire range of Nikon-fit lenses (see pages 198–217), offering a range that is almost impossible to match with any conventional video camera, especially for wide-angle shooting.

Another advantage is that the D90's larger sensor and facility for using lenses with wide maximum apertures means that it's possible to achieve shallower depth of field (see pages 116–8) than most camcorders and compact cameras. The ability to shoot at ISO settings of 3200 and above also means that results in low

182

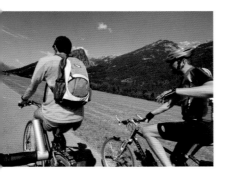

LECHTAL, TIROL, AUSTRIA
The D90 allows wide-angle video shooting.

FOOTPATH SIGN NEAR MALHAM, UK
It's much easier to achieve really shallow depth of field with the D90 than with most video cameras.

light should be better than many of the alternatives. In addition, the full range of exposure settings, Scene Modes, Nikon Picture Controls and many other options can be used in Movie mode, offering a high level of creative control.

CANAL NEAR CATFORTH, LANCASHIRE, UK
The D90's movie mode scores highly when it comes to low-light shooting.

Digital and optical zoom

Most digital video cameras claim enormous zoom ranges (often 800× or more) but these are only achieved by 'digital zoom', which is a software function that enlarges the central portion of the image. Anything more than a small amount of digital zoom will inevitably result in loss of image quality. It's the camera's 'optical zoom' range that really matters, and the wide variety of interchangeable lenses available for the Nikon D90 give it a potential optical zoom range of at least 50× (12mm–600mm).

Limitations

Probably the biggest limitation of video with the D90 is that there's no autofocus while shooting. You either have to set focus first and leave it there, or focus manually. While the quality of the Live View display does make manual focusing fairly easy, it is hard to operate the controls really smoothly, especially when hand-holding the camera (see page 185).

The D90 does adjust brightness levels ('gain') during shooting, but the initial exposure level needs to be set correctly. Any of the camera's automatic modes should do this, but it's a good idea to shoot a still frame first and check that it looks the way you want it. Gain is then adjusted automatically during a shot, for instance if you pan from a bright part of the scene to a darker one. Mostly this is helpful, but it can produce unwanted shifts in brightness. For instance, your main subject may appear to become darker as it moves against a brighter background. There's no way to avoid this, even in Manual exposure mode.

The D90 captures video from the sensor by a 'rolling' scan, rather than capturing the whole frame at one go. This has an odd effect when dealing with fast movement, either of the camera or of the subject itself; objects can appear distorted, with rectangular shapes turning to parallelograms and so on. If you rock the camera violently from side to side you can even achieve a remarkable 'wobbly jelly' effect.

Another potential limitation is the time limit on movie clips. You can shoot a maximum of approximately five minutes in one take at the HD setting and 20 minutes at the other quality settings.

Sound quality

Sound is not the D90's strongest point. It can only be recorded through the built-in microphone, which produces modest-quality mono output. It's very sensitive to wind noise and is prone to picking up the sounds you make while operating the camera (focusing, zooming, even breathing). You have the option to add a soundtrack later, but this is difficult if you want to record speech. If you want your movie to include sections of dialogue or someone talking straight to camera, keep these subjects close to the camera and ensure that extraneous noise is kept to a minimum.

Shooting movies

The basic procedure for shooting movies with the D90 is simplicity itself (see page 186). Of course, getting the best results demands a little more input. The golden rule when shooting movies with the D90, even more than for still photographs, is to think ahead. If you shoot a still frame and it isn't quite right, you can review it, change position or settings, and be ready to shoot again within a second or two. To shoot and review even a short movie clip eats up a lot more time, and often you won't get a second chance anyway. Therefore it's helpful – if not essential – to make sure your shooting position, framing, and camera settings are correct before you start. It's easy to check the look of the shot by taking a still frame before you start the movie and it makes sense to get into the habit of doing this every time.

However, a still frame can only tell you so much, and it does not allow for movement of either the subject, the camera, or both. The D90 will adjust exposure while recording movies, but it will not focus automatically. This could be an issue if your subject is moving towards or away from the camera, or you plan to pan across a scene which contains objects at a range of different distances. You can sometimes rely on depth of field (see pages 116–8) to cope with this; naturally, this is more true when shooting with wide-angle lenses than long telephotos.

There's no doubt that shooting movies is a more complex business than shooting stills. It makes sense to start with simple shots; don't try zooming, panning and changing focus all at once, but change one thing at a time. Many moving subjects can be filmed with the camera in a fixed position; good examples include waterfalls and fountains, birds coming and going at a feeder, and musicians playing or singing. Equally, you can become familiar with camera movement while shooting static subjects: try panning across a wide landscape or zooming in from a broad cityscape to a detail of a single building

Hand-held and tripod shooting

A tripod is a blessing when shooting still images, but really essential for movies. In fact, shooting movie clips handheld is a good way to reveal just how unsteady you really are, especially as you can't use the viewfinder when shooting movies. Of course, even 'real' movie directors sometimes use hand-held cameras to create a specific rough, gritty,

'reportage' feel, but there's a big difference between intentional wobble used for a specific effect, and unwanted, uncontrolled and incessant shakiness. Using a tripod or other suitable camera support is the best and simplest way to give movie clips a polished, even professional, look. It's true for static shots, and even more so when you start panning or zooming.

If you choose to hand-hold the camera, or decide to shoot a movie when there's no tripod available, it pays to approach it carefully. Pick a comfortable stance in a place where you won't be jostled and look for something solid on which you can rest your elbows. Sometimes you can get better results by sitting, with elbows braced on your knees. And, whatever else you do, 'think steady'.

Recording a movie

1) Activate Live View by pressing the **Lv** button. Check the initial exposure level and set focus just as you would when shooting a still image.

2) Press **OK** to start recording the movie. A red **REC** icon flashes at the top of the monitor screen while recording.

3) To stop recording, press **OK** again. Alternatively, press the shutter-release; this stops video recording and takes a still image using the current settings.

Tip
A standard tripod with a pan-and-tilt head is a good start for movie shooting. The alternative ball-and-socket heads are fine for static shots but less suitable for panning. If you're serious about shooting movies, consider investing in a dedicated video tripod. This isn't necessarily bigger or heavier than its standard counterpart, but the tripod head is specifically designed for smooth panning and tilting. The best models are fluid-damped for ultra-smooth results. If you're lucky, your existing tripod legs may be fine and you will only require a video head.

186

Panning

The panning shot is one of the basics of movie-making. It may be essential when you need to follow a moving subject, but it can also be used to great effect with static subjects. For instance, a panning shot enables you to capture a vast panorama in a way that's impossible in a single still frame.

Hand-held panning is difficult to get right. It might look acceptable when dealing with a moving subject, but is all too likely to grate on the viewer when it is applied to a static scene. A tripod is almost certainly the only answer here.

Setting up a tripod for a panning shot takes a little care. It's essential that the tripod is properly levelled. Otherwise you may start with the camera aimed at the horizon but finish the pan with it showing nothing but ground or sky. Many tripods have a built-in spirit level;

failing this, you can get good results by visually checking that the tripod's centre-column looks vertical from all angles. A 'dry-run' is useful before shooting to make sure that the shot is framed as you want it, both at the start and end of the pan.

If you're following a moving subject, you must also consider its projected path. Some subjects move along predictable paths – trains and trams being obvious examples. At the other extreme, trying to follow a player in a soccer match can be very challenging, and even seasoned pros don't always get it right.

When you're getting to grips with the panning shot, it's probably best to start with static subjects such as

THE KENT ESTUARY FROM HAVERBRACK BANK, CUMBRIA, UK
A wide landscape like this lends itself well to a panning shot.

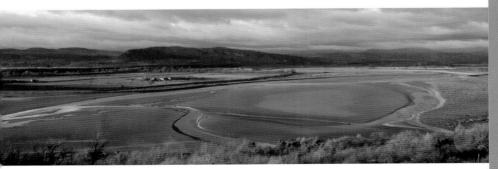

DISTORTION
Panning too rapidly across a scene can make objects appear violently distorted.

GOING DOWNHILL
The camera was level at start of the pan, but not at the end, and this boat is going rapidly downhill.

landscapes. Of course, landscapes don't always remain static, and the combination of a panning shot with waves breaking on the shore or grass blowing in the breeze can produce really beautiful results. If there's a stream or river in the shot, quite a different feeling can be evoked by panning with the current or in the opposite direction.

As a general rule, try to keep the panning movement both slow and steady. Too rapid a pan can make it hard to 'read' the shot and may make the viewer feel seasick. In the case of the D90, it can also cause objects to appear distorted (see page 184). Smooth panning is easiest with a video tripod, but perfectly possible with a standard model: leave the pan adjustment slack but make sure all the other adjustments are tight. It's probably better to hold the tripod

head rather than the camera. It can be easier if you try not to look at the screen, but use the front of the lens as a reference to track steadily across the scene. If you've framed the shot properly in advance, there should be no need to look at the screen.

When shooting moving subjects, the speed and direction of the pan is effectively decided for you by the need to keep the subject in frame. In such cases it is much more likely that you will want to watch the screen in order to keep the subject in approximately the same place in the frame throughout the shot. Fast-moving subjects can be very hard to track accurately, again creating a distorted or misshapen effect. This is an inherent limitation of the way the D90 captures video, so you either have to grin and bear it or choose alternative subjects to shoot instead.

188

Tip
Many tripod heads have projecting arms which are used to lock and unlock the movements. One of these controls the pan adjustment, and holding it lightly at its end is often the best way to get a smooth, even panning movement. Extra length gives even finer control, so if you do a lot of panning shots it could be worth adding an extension, which could be as simple as a length of dowelling secured with strong elastic bands.

PANNING AID
An improvised but effective extension aids panning with this standard tripod head.

Zooming

The zoom is another fundamental movie technique. Moving from a wide view to a tighter one is called zooming in, and naturally the converse is zooming out. A bit of forethought makes all the difference to using the zoom effectively – consider, for instance, which zoom direction you want (in or out), and think about the framing of the shot both at the start and at the end.

The D90 and the range of lenses available for it are not designed specifically for shooting movies and this is demonstrated clearly when it comes to zooming. Firstly, none of them has as wide a zoom range as

video camera lenses, so sometimes you may have to cut from one shot to another instead of linking them with a continuous zoom. Secondly, whether the lens in question uses a zoom ring or a 'trombone' action, it's quite tricky to achieve a smooth, even-paced zoom action with the D90. Practice does help, and having the camera firmly set on a solid tripod helps even more. Trying to zoom while hand-holding is a perfect recipe for jerky zoom and overall wobbliness. If you have a selection of lenses available, it's worth experimenting to see which has the smoothest zoom action.

A really quick zoom, called a 'whip zoom' in the trade, is hard to execute with the D90. If your results are disappointing, you can replace the zoom with a quick cut from wide shot to close at the editing stage.

When zooming, remember that depth of field (see pages 116–8) decreases at the telephoto end of the range. Your subject may appear sharp in a wide-angle view but end up looking fuzzy when you zoom in.

To avoid this, set your focus at the telephoto end of the zoom, whether you're starting there and zooming out, or zooming in to end up there. Trying to adjust focus in mid-zoom is certainly a challenging prospect!

NORTH FACE OF TRIGLAV, SLOVENIA
Zooming in from an overall view of a scene (top) to a specific detail (the peak, below) is a classic 'establishing shot' technique.

Focusing

The D90's large sensor and facility for using long telephoto lenses make it possible to achieve very shallow depth of field, which is usually unattainable with compact cameras or camcorders. This can give some very striking effects. However, the D90 does not focus automatically while recording movies, so it is necessary to either fix the focus for each shot or to shift focus manually.

Unless tackled carefully, manual focus is a quick route to wobbly pictures. The use of a tripod is recommended, especially as focusing is most critical with longer lenses, which magnify the slightest shake or wobble. As with zooming, some lenses have a smoother action than others. The design of older lenses often makes them more suited to manual focusing, with large and well-placed focus rings; this includes early autofocus lenses as well as specifically manual-focus ones. Also, on older lenses, operating the manual focus ring drives the focusing mechanism directly, which gives better feedback to the operator; such lenses could be a good bet if you're looking for a really smooth focusing action. Older lenses are also more likely to have a distance scale marked on the lens barrel, which can sometimes provide a viable

alternative to using the Live View display to focus. Note, however, that older lenses which lack a CPU can only be used on the D90 in Manual (M) mode. If a lens has an A/M switch, make sure it's set to M.

Pulling focus

Study the credits of movies and TV shows and you'll often come across a 'focus puller'. This is an assistant to the camera operator whose sole task is to adjust the focus, normally between predetermined limits (for instance, shifting from one character's face to another). This leaves the camera operator free to concentrate on framing, panning and zooming. The focus puller often uses the distance scale on the lens barrel, relying on previously measured distances. This may seem a long way from shooting simple clips on the Nikon D90, but it is worth experimenting with teamwork, especially if you want to pan or zoom at the same time as adjusting focus.

And the corollary is, if you are operating the camera on your own, don't try and do too much at once. At first, concentrate on panning or zooming or focusing. Don't expect to be able to do two things at the same time – let alone all three.

Editing movies

With still images, you wouldn't keep, print, or share every shot you take. The same goes for movies, only more so. A single clip straight from the camera might be acceptable for some purposes (if you happen to have captured a bank raid in progress it could even earn you a reward!) and of course you can very easily upload it to YouTube or other websites. That doesn't mean anyone will watch it, or even know it is there. To turn a collection of clips into a movie that people actually want to see means editing.

The name of the game here is non-linear editing (NLE), which may sound complicated but simply means that clips in the final movie don't have to appear in the same order in which they were shot.

For example, you might shoot a stunning tropical sunset on the first night of your holiday, but use it as the very last shot in your movie.

In fact, with modern software, editing digital camera movies is easier to do than it is to describe. The D90's .AVI movies employ a standard format that can be used with almost all editing programs. And, even better, if you own a reasonably up-to-date computer, you probably already have the software you need, free of charge. For Mac users the obvious choice is Apple's own iMovie, part of the iLife suite included with all new Macs. The Windows equivalent is Windows Movie Maker, which came pre-installed with Windows Vista; for Windows 7 it needs to be downloaded from windowslive.com.

Importing movies

The basic procedure for importing movies onto your computer is much the same as for stills (see page 238). Nikon Transfer will recognize and import them, but it's likely you will want to store movies in a different folder from your still images. Other dedicated photo software (Adobe Lightroom, for example) will not import movie files. In most cases the best way to import movie files is through your movie-editing software (see above). This ensures that all your movie clips are stored in the same place and that the software can immediately locate them for editing purposes.

192

iMOVIE
The iMovie editing
program is included
with all new iMacs.

Earlier incarnations of Windows
Movie Maker were heavily criticized,
comparing poorly with iMovie, but
more recent versions have closed the
gaps substantially. Both programs
offer non-linear editing. The key to
NLE is that it is non-destructive,
which means that the editing
process keeps your original clips
intact (unlike cutting and splicing
film). The new movie is effectively
produced by copying the desired
sections of your
movie clips. During
the editing process
you work with
preview versions of
these clips and the
software merely
keeps 'notes' on the
edit. A new movie
file is created only

WINDOWS MOVIE MAKER
Windows Movie Maker
software is bundled with
most Windows PCs.

when you select the Export Movie menu option in iMovie, or the Save option in Windows Movie Maker.

The two programs work in similar ways and both are very easy to learn. iMovie has a more intuitive, visual interface, while Windows Movie Maker relies more on text-based menus. In both cases, the movie clips you work with are displayed in one pane of the screen and you simply drag the one you want to the Project pane (iMovie) or Timeline (Windows Movie Maker). You can drag-and-drop clips at any time to rearrange them and trim any clip to a desired length. A Viewer pane allows you to preview your movie as a work-in-progress at any stage.

Effects and transitions

iMovie and Windows Movie Maker allow you to adjust the look of any clip or segment of the movie. There are basic controls for brightness, colour, and so on, just as with any photo-editing program, and there is also a range of special effects: you can, for instance, make your movie look 'aged' (scratched and faded), as if it had been shot on film 50 years ago rather than yesterday with a D90. These effects are great fun, and non-destructive editing means you can experiment to your heart's content, but it's best to use them sparingly in the final version.

Another basic feature common to both programs is the transition. This means that instead of simply cutting instantaneously from one shot to the next, you can apply a range of effects such as dissolves, wipes, and fades. Again, transitions are fun to play with and can add a lot of polish to the look of the final movie, but it's generally better to work with just a few transitions rather than using every possible trick in the course of a five-minute movie. Generally, transitions should enhance the shots on either side and help the narrative flow of the movie, rather than drawing attention to themselves.

Adding other media

Both iMovie and Windows Movie Maker also enable you to add other media to your movie, including still photographs and sound.

With a camera of the quality of the D90, adding stills to your movie is a natural and easy thing to do, but you can use photos from many other sources too. You can insert them individually at appropriate points, or create slideshows within the main movie. Again, various effects and transitions can be applied to provide a more dynamic feel as you move from one image to the next.

It's equally easy to add a new soundtrack to part or all of your movie. Given the D90's limitations

194

The Lancaster Canal

in recording sound (see page 184), this may well be a desirable option. You can also record a new voiceover or add music. Remember that music is subject to copyright law, and unless you've written and recorded your own, you need permission to use recorded music in any public

performance – which could include uploading your movie or playing it to a bunch of friends.

Finally, it's a simple matter to add titles and captions to your movie – perhaps crediting yourself as director, producer, camera operator, editor, Best Boy and Key Grip.

MOVIES

Forward planning

The editing process can transform a jumbled assortment of clips into a coherent movie. But it can also lead to frustration, if you start to wish you had a wider shot of X, or a close-up of Y. Editing can work wonders, but it can't restore shots that were never captured in the first place. Forward planning is vital, and it's the reason big movie productions start with a

screenplay, and then go on to create a storyboard, before a single scene is shot. A storyboard looks very much like a giant comic strip, with sketches or mock-ups of every shot and scene that's envisaged for the final movie. You may not want to go that far, but thinking your movie through before you start makes all the difference to the quality of the end product.

Chapter **7**

Lenses

While Nikon's continuity of design means that almost any Nikkor F-mount lens will fit the D90, and work (with some limitations), there are still sound reasons why the best lenses for the camera will be found among the more recent range.

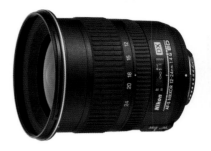

Key to these is the way light actually reaches the minute individual photodiodes or 'photosites' on the camera's sensor. Because these are slightly recessed, there can be some cut-off if light hits them at an angle. 35mm film is relatively indifferent to this, and of course older Nikkor lenses were designed for 35mm cameras. Nikon's DX-series lenses are specifically designed for digital use, ensuring that light hits the

sensor as near to perpendicular as possible, maintaining image illumination and optical quality right across the frame.

This is not to say that non-DX lenses can't be used. They can, and will often give very good results, but super-critical examination may show some fall-off of brightness at the edges of the frame, and also a greater tendency to chromatic aberration (colour fringing). Wide-angle lenses are most susceptible to these issues, telephotos much less so. Much may depend on the size of print or reproduction you require, and shortcomings such as these can, to some extent, be corrected in processing – especially if you shoot NEF (RAW) files – using an application like Nikon Capture NX. Still, for the very best results, DX lenses are recommended and will therefore be listed first in the table of Nikkor lenses on pages 212–7.

> **Tip**
> Because they are designed specifically for digital cameras with image sensors smaller than a 35mm film frame, most DX lenses (and digital-specific lenses from independent makers) will not give full-frame coverage on 35mm cameras or 'full-frame' digital SLRs like the Nikon D3 or D700.

198

Nikon lens technology

Nikon's range of lenses has long been renowned for its technical and optical excellence, and many lenses incorporate special features. These are referred to extensively in the table at the end of this chapter (see pages 212–7), but explanations of the main terms and abbreviations are given here.

Abbreviation	Term	Explanation
AF	Autofocus	Lens focuses automatically. Most current Nikkor lenses are AF but a substantial manual focus range remains.
ASP	Aspherical lens elements	Precisely configured lens elements that reduce the incidence of certain aberrations. Especially useful in reducing distortion with wide-angle lenses.
CRC	Close-range Correction	Advanced lens design that improves picture quality at close focusing distances.
D	Distance information	D-type and G-type lenses communicate information to the camera about the distance at which they are focusing, supporting functions like 3D matrix metering.
DC	Defocus-image Control	Found in a few lenses aimed mostly at portrait photographers. Allows control of aberrations and thereby the appearance of out-of-focus areas in the image.
DX	DX lens	Lenses specifically designed for DX-format digital cameras (see page 198).
G	G-type lens	Modern Nikkor lenses with no aperture ring; aperture must be set by the camera.
ED	Extra-low Dispersion	ED glass minimizes chromatic aberration (the tendency for light of different colours to be focused at slightly different points).

LENSES

Abbreviation	Term	Explanation
IF	Internal Focusing	Only internal elements of the lens move during focusing: the front element does not extend or rotate.
M/A	Manual/ Auto	Most Nikkor AF lenses offer M/A mode, which allows seamless transition from automatic to manual focusing if required.
N	Nano crystal coat	Said to virtually eliminate internal reflections within lenses, guaranteeing minimal flare.
PC	Perspective Control	See page 210.
RF	Rear Focusing	Lens design where only the rearmost elements move during focusing; makes AF operation faster.
SIC	Super Integrated Coating	Nikon-developed lens coating that minimizes flare and 'ghosting'.
SWM	Silent Wave Motor	Special in-lens motors that deliver very fast and very quiet autofocus operation.
VR	Vibration Reduction	System which compensates for camera shake. VR is said to allow hand-held shooting up to three stops slower than would otherwise be possible (i.e. 1/15 instead of 1/125 sec). New lenses now feature VRII, said to offer gain of an extra stop over VR (1/8 instead of 1/125 sec).

HELSINKI RAILWAY STATION, FINLAND
Distance information from D-type or G-type
lenses supports 3D matrix metering, giving
better results in difficult lighting conditions.

Settings
ISO: 200
Focal length: 18mm
1/100 sec

Focal length and field of view

There can be few photographers who are not familiar with the term 'focal length', but the term is often misapplied. The focal length of any lens is a basic optical characteristic, and it is not changed by fitting it to a different camera. A 20mm lens will always be a 20mm lens and nothing else. Unfortunately, the lenses on most digital compact cameras are described not by their actual focal length but by their '35mm equivalent'; that is, the focal length that would be needed to achieve the same angle of view on a 35mm camera.

Of course zoom lenses do have variable focal length (that's what zoom means), but an 18–55mm zoom is an 18–55 whether it's fitted on a DX format camera like the D90 or a full-frame camera like the D3. However, because the D90 has a smaller sensor than the D3, the angle of view obtained with that lens is reduced.

Crop factor

The D90's smaller sensor, relative to the 35mm standard, means that it has a crop factor, also referred to as focal length magnification factor, of 1.5. If you fit a 200mm lens to a D90, the field of view is equivalent to what you'd get with a 300mm lens on a 35mm camera or a D3. For sports and wildlife this is often seen as an advantage, allowing long-telephoto style shooting with relatively light and inexpensive lenses. On the other hand, the crop factor means that wide-angle lenses effectively become less wide, which is bad news for landscape shooters. One consequence of this has been the development of new lenses with very short focal lengths, like the 14mm f/2.8D ED AF Nikkor.

Field of view

The field of view, or angle of view, is the area covered by the image frame. While the focal length of a lens remains the same irrespective of the camera it's fitted to, the angle of view in the image will change according to the format of the film of digital sensor in use. The angle of view can be measured horizontally, vertically or diagonally; if this is not specified, it's usually safe to assume that the angle given is measured diagonally (as in the table on pages 212–7).

ANGLE OF VIEW
This series of images was shot on a Nikon D90 from a fixed position with lenses ranging from 12mm to 300mm.

12mm

17mm

24mm

35mm

50mm

100mm

200mm

300mm

Perspective

Perspective concerns the relationship between objects at different distances. The apparent fading of distant objects due to haze or scattering of light is known as atmospheric perspective. Optical perspective refers to the apparent changes in the size of objects at different distances.

It's commonly asserted that different lenses provide different perspective, but this is untrue: in fact, perspective is purely a function of distance. What is true, however, is that different types of lenses lend themselves to exploring different kinds of perspective.

Placing a dramatic emphasis on the foreground may be loosely referred to as 'wide-angle perspective', because a wide-angle lens allows you to get closer to the foreground object. The apparent compression of perspective in telephoto shots is equally a result of the greater working distance that the telephoto lens allows. In the series of shots shown below and to the right, the column remains the same apparent size even though it is viewed from different distances, but both its apparent shape and its relationship to the background are altered.

12mm

24mm

50mm

100mm

Standard lenses

It makes sense to look at standard lenses first, because both 'wide' and 'long' lenses are defined in relation to them. Traditionally, a 50mm lens was referred to as a standard, because its field of view was considered to approximately match that of the human eye. Because of its crop factor, the equivalent lens for the D90 would be around 35mm. Standard lenses are typically light and simple and have wide maximum apertures. Zoom lenses (see page 209) whose range includes the 50mm focal length are often referred to as 'standard zooms'.

Nikkor 50mm lens

NEAR GARSTANG, LANCASHIRE, UK
The standard lens can be used for a wide variety of subjects.

Wide-angle lenses

A wide-angle lens is really any lens with a wider view than a standard lens; for the D90, this means any lens with a focal length shorter than 35mm. Wide-angle lenses are valuable for working close to subjects or bringing foregrounds to greater prominence. They lend themselves to photographing expansive scenic views, and also to working in interiors or other cramped spaces where it's simply not possible to step further back. Because of the D90's crop factor, a lens like a 17mm, once regarded as 'super-wide', gives a less extreme angle of view and this has promoted the development of a new breed of lenses like Nikon's 12–24mm f/4G ED-IF AF-S DX, which has a field of view equivalent to an 18–36mm lens on a 35mm camera.

Nikkor 14mm f/2.8D ED AF lens

GREAT SCAR, NORTH YORKSHIRE, UK
Wide-angle lenses don't just add width but also enhance the third dimension: depth.

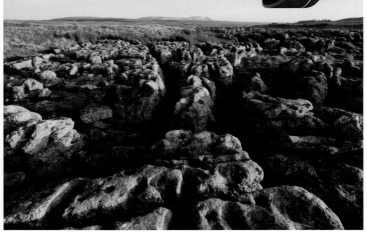

LENSES

Telephoto lenses

Telephoto or 'long' lenses provide a narrow angle of view. They are often associated with areas where working distances need to be longer, such as wildlife and sports photography. They also have many other uses, such as singling out small and/or distant elements in a landscape. Modest telephoto lenses are also associated with portrait photography, because the greater working distance is generally deemed to give a more natural-looking result, and is also more comfortable for nervous subjects. The traditional 'portrait lens' range is approximately 85–135mm, or 60–90mm with the D90.

The laws of optics, coupled with the greater working distance, produce limited depth of field when working with telephoto lenses. While this is an advantage for portraiture, wildlife and sport, drawing attention to the subject by throwing the background out of focus, it can be problematic for landscape shooting.

The size and weight of longer lenses makes them harder to hand-hold, and their narrow angle of view also magnifies any movement. High shutter speeds can help, and the use of a tripod or other camera support is preferable, if not essential. Nikon's Vibration Reduction technology (see page 200) can also help to combat the effects of camera shake.

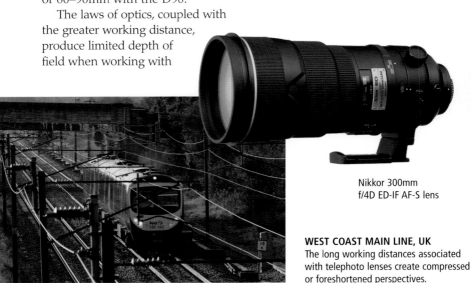

Nikkor 300mm
f/4D ED-IF AF-S lens

WEST COAST MAIN LINE, UK
The long working distances associated with telephoto lenses create compressed or foreshortened perspectives.

Zoom lenses

The term 'zoom' is now used for any lens with a variable focal length, like the AF-S DX Nikkor 18–105mm f/3.5–5.6G ED VR. The advantages of such a lens are obvious, as it can replace a bagful of prime lenses and cover the gaps in between. For weight, convenience and economy, zoom lenses score highly, and their flexible focal length also allows very precise framing of images.

Nikkor 12–24mm zoom lens

While they were once looked upon as the poor relation in terms of optical quality, there is now little to choose between a good zoom and a good prime lens. Cheaper zooms, and those with a very wide range (18–200mm or 28–300mm, for example) may still be compromised in this respect, and may also suffer from a relatively small ('slow') maximum aperture. However, a wide zoom range is a real asset for shooting movies, and the smaller pixel dimensions of the movie image mean that any optical limitations of the lens are unlikely to be visible.

RIBBLEHEAD VIADUCT, NORTH YORKSHIRE, UK
Zoom lenses are a real advantage when precise framing is required.

Macro lenses

For specialist close-up work there is little to beat a true macro lens (see page 178).

ORCHID
Ultra-close up work is best tackled with a true macro lens.

LENSES

Perspective control lenses

Perspective control (or 'tilt and shift') lenses give a unique flexibility in viewing and controlling the image. Their most obvious, but by no means their only, value is in photographing architecture, where with any other lens it often becomes necessary to tilt the camera upwards, resulting in converging verticals (buildings appearing to lean backwards or even to one side). The shift function of the PC lens allows the camera back to be kept vertical, which in turn means that vertical lines in the subject remain vertical in the image.

The current Nikon range features three PC lenses, the established 24mm f/3.5D ED PC-E having been joined by 45mm and 85mm versions. These lenses retain many of the camera's automatic functions, but require manual focusing.

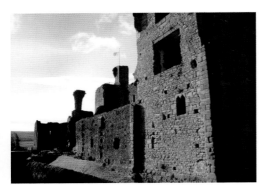

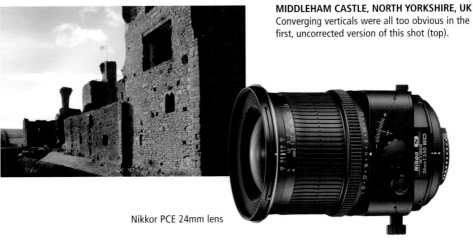

MIDDLEHAM CASTLE, NORTH YORKSHIRE, UK
Converging verticals were all too obvious in the first, uncorrected version of this shot (top).

Nikkor PCE 24mm lens

Teleconverters

Teleconverters are not stand-alone lenses but supplementary optics that fit between the main lens and the camera body to magnify the focal length of the main lens. Nikon offers three examples, the TC-14E II, TC-17E II and TC-20E III, with magnification factors of 1.4x, 1.7x and 2x respectively. Their advantages are obvious, allowing you to extend the available focal length range relatively cheaply and with minimal additional weight – the TC-14E II, for example, weighs just 7oz (200g).

Warning!

Nikon state that some recent lenses – including the AF-S DX Nikkor 18–105mm f/3.5–5.6G ED VR, which is often supplied as a 'kit lens' with the D90 – are not compatible with teleconverters. Check the lens manual before using any lens with a teleconverter.

However, there's no such thing as a free lunch. Teleconverters may slightly degrade image quality and there is an inevitable loss of light. Fitting a 2x converter to a 300mm f/4 lens turns it into a 600mm f/8. One consequence of this with the D90 is that its autofocus may become impaired or may not work at all.

Lens hoods

A lens hood serves at least two functions: it protects the lens against knocks and rain but, more importantly, it helps to exclude stray light. This, rather than helping to form the image, may degrade it by causing flare. Most Nikkor lenses come with a dedicated lens hood.

Teleconverters

CLITHEROE CASTLE, LANCASHIRE, UK
A teleconverter may save the cost and weight of a separate long lens, but a tripod is often required.

LENSES

Nikkor lens chart

This table lists currently available Nikkor autofocus lenses, starting with the DX-series which is specifically designed for DX-format cameras like the D90.

	Optical features/notes
DX Lenses	
10.5mm f/2.8G DX Fisheye	CRC
12–24mm f/4G ED-IF AF-S DX	SWM
16–85mm f/3.5-5.6G ED VR AF-S DX	VRII, SWM
17–55mm f/2.8G ED-IF AF-S DX	ED, SWM
18–55mm f/3.5-5.6G AF-S VR DX	VR, SWM
18–55mm f/3.5-5.6GII AF-S DX	ED, SWM
18–70mm f3.5-4.5G ED-IF AF-S DX	ED, SWM
18–105mm F/3.5–5.6G ED VR AF-S DX	ED, IF, VRII, NC, SWM
18–135mm f/3.5-5.6 ED-IF AF-S DX	ED, SWM
18–200mm f/3.5-5.6G IF-ED AF-S VR DX	ED, SWM, VRII
55–200mm f/4-5.6 AF-S VR DX	ED, SWM, VR
55–200mm f/4-5.6G ED AF-S DX	ED, SWM
AF Prime lenses	
14mm f/2.8D ED AF	ED, RF
16mm f/2.8D AF Fisheye	CRC
20mm f/2.8D AF	CRC
28mm f/2.8D AF	
35mm f/2D AF	

212

Angle of view with D90 (°)	Min. focus distance (m)	Filter size (mm)	Dimensions dia. × length (mm)	Weight (g)
180	0.14	Rear	63 × 62.5	300
99–61	0.3	77	82.5 × 90	485
83–18.5	0.38	67	72 × 85	485
79–28.5	0.36	77	85.5 × 11.5	755
76–28.5	0.28	52	73 × 79.5	265
76–28.5	0.28	52	70.5 × 74	205
76–22.5	0.38	67	73 × 75.5	420
76–15.3	0.45	67	76 × 89	420
76–12	0.45	67	73.5 × 86.5	385
76–8	0.5	72	77 × 96.5	560
28.5–8	1.1	52	73 × 99.5	335
28.5–8	0.95	52	68 × 79	255
90	0.2	Rear	87 × 86.5	670
120	0.25	Rear	63 × 57	290
70	0.25	62	69 × 42.5	270
53	0.25	52	65 × 44.5	205
44	0.25	52	64.5 × 43.5	205

	Optical features/notes
50mm f/1.8D AF	
50mm f/1.4D AF	
50mm f/1.4G AF-S	IF, SWM
85mm f/1.4D AF	IF
85mm f/1.8D AF	RF
105mm f/2D AF DC	DC
135mm f/2D AF DC	DC
180mm f/2.8D ED-IF AF	ED, IF
200mm f/2G ED-IF AF-S VR	ED, VR, SWM
300mm f/4D ED-IF AF-S	ED, IF
300mm f/2.8 ED-IF AF-S VR	ED, SWM, NC
400mm f/2.8G ED VR AF-S	ED, IF, VRII, NC
400mm f/2.8D ED-IF AF-S II	ED, SWM
500mm f/4G ED VR AF-S	IF, ED, VRII, NC
500mm f/4D ED-IF AF-S II	ED, IF
600mm f/4G ED VR AF-S	ED, IF, VRII, NC
600mm f/4D ED-IF AF-S II	ED, SWM
AF Zoom lenses	
14–24mm f/2.8G ED AF-S	IF, ED, SWM, NC

Angle of view with Nikon D90 (°)	Min. focus distance (m)	Filter size (mm)	Dimensions dia. × length (mm)	Weight (g)
31.3	0.45	52	63 × 39	160
31.3	0.45	52	64.5 × 42.5	230
31.3	0.45	58	73.5 × 54	280
18.5	0.85	77	80 × 72.5	550
18.5	0.85	62	71.5 × 58.5	380
15.2	0.9	72	79 × 111	640
12	1.1	72	79 × 120	815
99–61	1.5	72	78.5 × 144	760
83–18.5	1.9	52	124 × 203	2900
5.2	1.45	77	90 × 222.5	1440
5.2	2.2	52	124 × 268	2850
4	2.9	52	159.5 × 368	4620
4	3.8	52	160 × 352	4800
3.1	4	52	139.5 × 391	3880
3.1	5	52	140 × 394	3800
2.4	5	52	166 × 445	5060
2.4	6	52	166 × 455	5900
90–61	0.28	Rear	98 × 131.5	970

	Optical features/notes
17–35mm f/2.8D ED-IF AF-S	IF, ED, SWM
18–35mm f/3.5-4.5D ED	ED
24–85mm f/2.8-4D IF AF	
24–120mm f/3.5-5.6G ED-IF AF-S VR	ED, SWM, VR
24–70mm f/2.8G ED AF-S	ED, SWM, NC
28–70mm f/2.8 ED-IF AF-S	ED, SWM
70–200mm f/2.8G ED-IF AF-S VR	ED, SWM, VR
70–300mm f/4.5-5.6G AF-S VR	ED, IF, SWM, VRII
80–400mm f/4.5-5.6D ED VR AF	ED, VR
200–400mm f/4G ED-IF AF-S VR	VR, SWM
Macro lenses	
60mm f/2.8G ED AF-S Micro	ED, SWM, NC
60mm f/2.8D AF Micro	CRC
105mm f/2.8G AF-S VR Micro	ED, IF, VRII, NC, SWM
200mm f/4D ED-IF AF Mi-cro	ED, CRC
Perspective control	
24mm f/3.5D ED PC-E (manual focus)	ED, NC
45mm f/2.8D ED PC-E (manual focus)	ED, NC
85mm f/2.8D ED PC-E (manual focus)	ED, NC

216

Angle of view with Nikon D90 (°)	Min. focus distance (m)	Filter size (mm)	Dimensions dia. × length (mm)	Weight (g)
79–44	0.28	77	82.5 × 106	745
76–44	0.33	77	82.7 × 82.5	370
51–18.5	0.5	72	78.5 × 82.5	545
51–13.2	0.5	72	77 × 94	575
51–22.50	0.38	77	83 × 133	900
53–22.5	0.7	77	88.5 × 121.5	935
22.5–8	1.5	77	87 × 215	1470
22.5–5.2		67	80 × 143.5	745
20–4	2.3	77	91 × 171	1340
8–4	2	52	124 × 358	3275
26.3	0.185	62	73 × 89	425
26.3	0.219	62	70 × 74.5	440
15	0.31	62	83 × 116	720
8	0.5	62	76 × 104.5	1190
56	0.21	77	82.5 × 108	730
34.5	0.25	77 x 94	83.5 × 112	780
18.9	0.39	77	82.7 × 107	650

Chapter **8**

Accessories

As part of the vast Nikon system, a wide range of accessories is available for the D90. In addition to Nikon's own products, there are numerous third-party items that further extend your options. Accessories can be grouped under four main headings: image modification (such as filters and flash), camera performance, camera support, and storage.

Filters

Flash and close-up accessories have already been dealt with in preceding chapters, leaving filters as the other main group of accessories concerned with image modification.

It's true that some types of filter are almost redundant with digital cameras. The ability to set the white balance, for instance (see page 63), has largely eliminated the need for colour-correction filters that were virtually essential for accurate work with film, especially transparency film. As a general principle, it's best to avoid the use of filters unless they are strictly necessary, as there's always a risk that adding extra layers of glass in front of the camera lens can increase flare or otherwise degrade the image. 'Stacking' of multiple filters increases this risk, and that of vignetting (darkening of the corners) with wide-angle lenses.

There is an exception to this rule: it's generally a good idea to keep a UV or skylight filter (see page 222) permanently attached to each lens as a first line of defence against knocks and scratches – filters are much cheaper to replace than lenses.

DAMAS DUBS AND SCAFELL, LAKE DISTRICT, UK
A polarizing filter can help to intensify image colours, but results may sometimes appear 'over the top'.

Filter types

In terms of the way they attach to the lens, there are three main types of filter: round, screw-in filters; slot-in filters; and rear or drop-in filters.

Round filters screw to the front of the lens and are normally made of high-quality optical glass. The filter-thread diameter (in mm) of most Nikon lenses is specified in the table on pages 212–7, and will be given on the front of the lens next to the Ø symbol. For many years Nikon has produced its own screw-in filters in sizes matching the range of Nikkor lenses and to the same high optical standards. A more extensive range comes from Hoya, the world's largest producer of optical glass, including the Pro1 series designed specifically for digital cameras.

Slot-in filters work on a different principle and can be more economical and convenient for those who use filters extensively. The filters – which are normally square or rectangular and made of optical resin or gelatin – fit into a slotted holder. With a simple adaptor ring for each lens, one holder and one set of filters can serve any number of lenses. The best-known maker of such filter systems is Cokin, while the Lee Filters range is highly respected by the most demanding users.

There are a few lenses for which neither of the above filter types is suitable. These are mostly super-telephotos with huge front elements, or extreme wide-angle and fish-eye lenses that have protruding front elements. These require filters that fit either to the rear of the lens or are dropped in to a slot in the lens barrel. Nikon lenses that have such a slot are supplied with a holder which takes gelatin filters.

COLOUR FILTERS
With digital software, filters for colour correction and enhancement have been rendered largely redundant.

UV and skylight filters

These two types of filter are almost interchangeable; both cut out excess ultraviolet light which can cause a blue cast in images. The skylight filter also has a slight warming effect. As already suggested, their main benefit is often in protecting the front element of the lens.

Polarizing filters

The polarizing filter is highly prized by many landscape photographers. It cuts down on reflections from many surfaces, intensifying the colours of rocks and vegetation. It can make reflections on water and glass virtually disappear, restoring transparency; this is most effective at an angle of around 30°. Rotating the polarizing filter can intensify or reduce its effect.

In addition, the polarizer can cut through atmospheric haze and make blue skies appear more dramatic and colourful. The effect

Notes
Polarizing filters come in two types: linear and circular. This is a little confusing as all polarizing filters are circular in shape. The terms 'linear' and 'circular' refer to the direction of polarization. In the days of manual focus, linear polarizers were common but they interfered with autofocus operation, and as a result circular polarizers have become the norm. The D90 cannot be used with a linear polarizer.

is only seen at its fullest extent when shooting at right angles to the direction of the sunlight, vanishing when the sun is directly behind or in front. Results can sometimes appear unnatural, and with wide-angle lenses the effect can be conspicuously uneven across the field of view. The polarizer should be used with discrimination. Leaving it permanently attached is not a good idea but, as it achieves effects that cannot be replicated in any other way, it is a valuable addition to the photographer's armoury.

NEAR HADRIAN'S WALL, UK
A UV or skyight filter helps to protect the lens from rain, spray, dust, dirt and other hazards.

Neutral density filters

Neutral density (ND) filters cut down the amount of light reaching the lens. 'Neutral' simply means that they don't affect the colour of the light, only its intensity. ND filters can be either plain or graduated. A plain ND filter is typically used when you want to set a slower shutter speed and/or wider aperture, and can't reduce the ISO setting any further. A classic example is when shooting waterfalls, where a long shutter speed is often used to create a silky blur from the falling water. For obscure reasons, the strength of neutral density filters is measured on a scale in which 0.3 represents a reduction of one full stop (1 Ev) of light; 0.6 is two stops and so on.

Graduated ND filters have neutral density over half their area, with the other half being clear, and a gradual transition in the centre. They are widely used in landscape photography to help compensate for wide differences in brightness between sky and land.

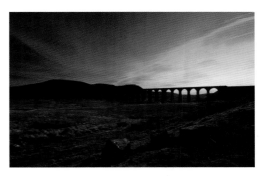

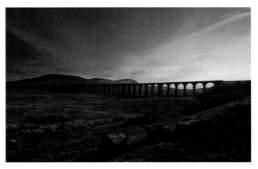

**RIBBLEHEAD VIADUCT
NORTH YORKSHIRE, UK**
There was a massive difference in brightness between sky and foreground. A graduated filter could have helped, but the line of transition cut across the peak (top). Instead two separate exposures were combined using Photoshop Layer Masks (bottom).

Special effects filters

Soft-focus filters and starburst filters are two of the most common special-effects filters. The soft-focus filter is sometimes still used in portraiture to soften skin blemishes, but its effects can now be replicated and extended in digital post-processing.

The same is true of the starburst and most other special-effects filters. There was an explosion of such images in the 1970s, but they can now look rather dated. In the digital age, you can always capture the original image 'straight' and apply effects later.

Alternatively, the Filter effects section of the the D90's Retouch menu (see page 106) mimics the effects of several common filters, including Skylight and Warm filter. The Cross screen option offers a range of effects, equivalent to a bagful of different starburst filters.

Red Intense filter effect

Starburst filter effect

Camera performance

Essential accessories

A wide range of add-ons is available to improve or modify the performance of the D90. Nikon include several items with the camera, but perhaps these should all be considered as essentials rather than add-ons.

EN-EL3e Battery

An exhausted battery turns your fabulous D90 into useless dead weight. While the D90 is fairly economical with batteries, it's always advisable to have a fully charged spare on hand. This is especially true in cold conditions, or when making extensive use of the monitor (e.g. in Live View mode or shooting movies).

MH-18a Charger

Vital to keep the EN-EL3e battery charged and ready for action.

BM-10 LCD monitor cover

It's advisable to keep the monitor cover attached at all times. If it does become scratched, the cover is easy and inexpensive to replace, whereas replacing the monitor itself would be a complex and very expensive business.

BF-1A body cap

The body cap keeps the camera interior free of dust and dirt when no lens is attached.

Optional accessories

A selection from Nikon's extensive range is listed below.

Multi-Power Battery Pack MB-D80

The MB-D80 has two main functions – providing extra power for the camera and improving its handling when used in portrait orientation. It provides an extra shutter-release button, Main command dial, Sub-command dial and AF-ON button. It can be loaded with one or two EN-EL3e batteries or with six AA cells.

AC Adaptor EH-5/EH-5a

Either of these adaptors can be used to power the camera directly from the AC mains supply, allowing uninterrupted shooting in, for example, long studio sessions.

Infra-red Remote Control ML-L3

This inexpensive remote control unit allows the camera to be triggered from a distance of up to 16ft (5m). Nikon state that it should be fired from in front of the camera, but users report that the beam can be bounced off walls and ceilings, allowing operation from a wide range of positions.

Remote Cord MC-DC2

This remote shutter release cable, approximately 3ft (1m) in length, plugs into the D90's accessory terminal. Releasing the shutter without touching the camera body minimizes camera shake and is particularly useful when shooting long exposures, especially at B (bulb) setting. The D90 is not compatible with earlier Nikon remote cords.

GPS Unit GP-1

Dedicated Global Positioning System device (see page 243).

Magnifying Eyepiece DK-21M

Magnifies the viewfinder view by about 17%, which may help some users with framing.

Tip

Many photographers choose to wear contact lenses or glasses instead of adjusting the dioptre. My own prescription is -5 m-1 and I've never had any problem using the D90 while wearing contacts.

Dioptre Adjustment

The D90's viewfinder has built-in dioptric adjustment between -2 and +1 m-1. If your eyesight is outside this range, Nikon produces a series of viewfinder lenses between –5 and +3 m-1, with the designation DK-20C.

Magnifier DG-2 and Eyepiece Adapter DK-22

In combination, these provide a 2x magnified view of the central portion of the viewfinder image. This can be useful for critical focusing in close-up photography in particular, but has been at least partly superseded by the absolute focusing accuracy of the D90's Live View mode.

Right-Angle Magnifying Viewing Attachment DR-6

Allows the viewfinder image to be seen from above, useful when the camera is in an awkward position. To some extent it has also been superseded by Live View mode.

Storage

Memory cards

The D90 stores images on Secure Digital (SD) cards, which are found in capacities up to 2GB. The newer Secure Digital High Capacity (SDHC) can also be used, offering capacities up to 32GB. On long trips it's easy to fill up even large-capacity memory cards and they are now remarkably cheap, so it's advisable to carry a spare or two. Nikon particularly recommend SanDisk and Lexar cards for reliability.

> **Tip**
> SD cards are very small and easily mislaid. Although they are robust, there's no guarantee they will survive being trodden on or dropped into water, so handle with care. Spare cards, especially those loaded with irreplaceable images, should be stored in a secure container and kept in the safest possible place.

Portable storage devices

SD cards are generally secure but it's always worth backing up valuable images as soon as possible. On longer trips, with no regular access to a computer, many photographers use some sort of mobile device for this purpose. There are various dedicated photo storage devices available, usually comprising a compact hard drive along with a screen. Examples include the Vosonic VP5500 and Epson P-5000. However, many of us already own something that will also store images, in the shape of an iPod. Not all iPod models are suitable, so investigate carefully. The iPad (but not the iPhone) also works well for this: you'll need an Apple iPad Connector.

Camera support

There's much more to camera support than tripods, but these still remain the staple for most serious photographers.

Tripods

The D90's great quality at high ISO settings does facilitate hand-holding, but there are still many occasions where nothing replaces a tripod. A good tripod is also an investment, and should last for many years. Tripods come in all manner of sizes, weights, and materials; the best combination of low weight with good rigidity comes – at a price – in materials like titanium and carbon fibre. Carbon-fibre tripods are made by Manfrotto and Gitzo, among others. The unusual design

Tip
Many hikers will already be aware that some walking/trekking poles incorporate a camera mount, thereby doubling as a 'walking stick' and a lightweight monopod.

of the Benbo range gives them great flexibility and they are much favoured by nature photographers who need to shoot in awkward positions.

A tripod is essential to achieve the best results when shooting movies, and there are many tripods on the market that are designed specifically for this purpose.

Monopods

Monopods cannot offer the ultimate stability of a tripod, but are lighter, easier to carry and quicker to set up. They are much favoured by sports photographers in particular, who often have to react quickly while using long, hefty telephoto lenses.

NEAR GORDALE SCAR, NORTH YORKSHIRE, UK
The extra effort in carrying a tripod to a remote location is usually well-rewarded.

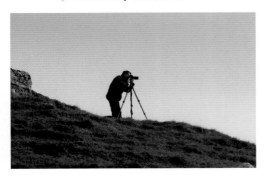

Other camera supports

There are many other solutions for camera support, both proprietary products and improvised alternatives. There's still much to be said for the humble beanbag; many people make their own to suit their exact needs, but they can also be bought from various suppliers. An interesting development of the simple beanbag is the Pod Camera Platform (below), which incorporates a tripod mount.

Tip
Those tramping long distances and wishing to save weight can make a workable 'beanbag' by cramming spare hats, gloves, etc into a simple mesh sack of the sort that's readily available from any outdoor shop.

(Right) The Pod camera platform is a good solution in awkward places or where space is limited.

(Above) A simple home-made bean-bag that has served me well for many years.

(Right) Using a stuff-sack as an improvised bean-bag.

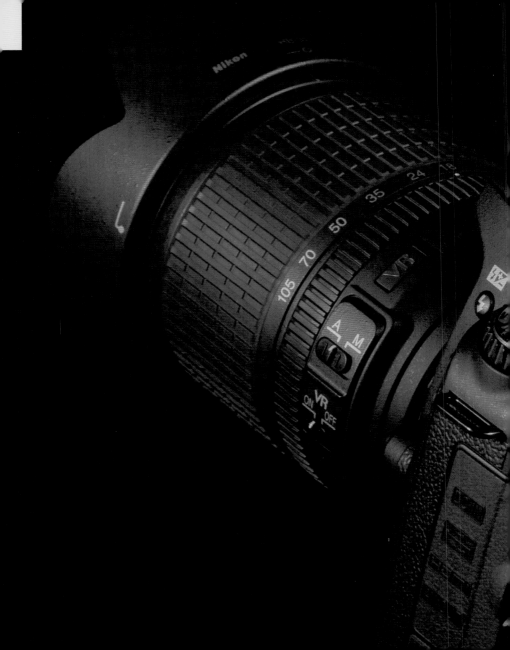

Chapter **9**

Connection

Connecting to external devices is not merely an adjunct to digital photography: it's an essential part of the process. It's through external devices that you store, organize, view and print your images. Fortunately, the D90 is designed to facilitate every aspect of this process and the necessary cables are included with the camera.

Connecting to a TV

The EG-D100 cable supplied with the camera is used to connect the D90 to a normal TV or VCR. You can also connect the camera to a HDMI (High Definition Multimedia Interface) TV but you'll need an HDMI cable (not supplied). In other respects, the process is the same.

1) Check the camera is set to the correct mode in the Setup menu (**PAL** or **NTSC** for standard TVs and VCRs, or **HDMI**).

2) Turn the camera **OFF**.

Note
Use of the EH-6 mains adaptor is recommended for lengthy playback sessions. No harm should result if the battery becomes exhausted during playback, but it is annoying.

3) Open the cover on the left side of the camera and insert the cable into the appropriate slot (AV-out or HDMI).

4) Tune the TV to either the Video or HDMI channel.

5) Turn the camera on and press the playback button. Images remain visible on the camera monitor as well as on the TV and you navigate through images using the Multi selector in the usual way. The D90's Pictmotion or Slide show facilities (see pages 82–3) can be used to automate playback.

The D90 connected to a standard TV.

Connecting to a printer

Images from the D90 can be printed in numerous ways. The most flexible and powerful method is to transfer pictures to a computer, and this is the only option where NEF (RAW) files are concerned. The memory card can also be used in a compatible printer or taken to a high-street photo printing outlet. The D90 can be connected to any printer that supports the PictBridge standard, allowing JPEG images to be printed directly.

1) Make sure the camera is switched **OFF**.

2) Turn the printer on and connect the supplied USB cable. Open the cover on the left side of the camera and insert the the smaller end of the cable into the USB slot.

3) Turn the camera on. You should now see a welcome screen, followed by a PictBridge playback display. There's now a choice between **Printing pictures one at a time** or **Printing multiple pictures**.

Printing pictures one at a time

This process is very straightforward, particularly if you are already familiar with navigating the D90's playback screens.

1) If the photo displayed is the one you wish to print, press **OK**. This brings up a menu of printing options (see page 234). Use the Multi selector to navigate through the menu and highlight specific options. Press **OK** to select the highlighted option.

2) When the required options have been set, select **Start printing** and press **OK**. To cancel at any time, press **OK** again.

Tip
NEF (RAW) images can not be printed directly from the camera, but you can use the Retouch menu to create a JPEG copy of a NEF image you'd like to print in this way.

Note
To avoid potential damage to image data, always ensure that the camera is switched **OFF** before connecting or disconnecting USB or other interface cables.

CONNECTION

Printing options

Option name	Options available	Notes
Page size	Printer default 3.5 × 5in 5 × 7in A4	Options will be limited by the maximum size the printer can print.
No. of copies	1–99	Use ▲ or ▼ to choose number, then press **OK** to select.
Border	Printer default Print with border No border	If **Print with border** is selected, borders will be white.
Time stamp	Printer default Print time stamp No time stamp	Prints time and date when image was taken.
Crop	Crop No cropping	Prints selected area only to size selected under **Page size** (see opposite page).

Image cropping

If **Crop** is selected, the image is displayed again with a border delineating the crop area. Use the ⊖✖ and ⊕ buttons to change the size of the crop area and the Multi selector to reposition it if you don't want it centred. When satisfied, press **OK**.

Printing multiple pictures

You can print multiple pictures, and also create an index print of all the JPEG images (up to a maximum of 256) stored on the memory card. With the PictBridge menu displayed, press **MENU**. The following options are displayed:

Print Select	Use the Multi selector to scroll through pictures on the memory card (displayed as six thumbnails at a time). To see an image full screen, press the ⊕ button. To choose the currently selected image for printing, hold the ⊙— button and press ▲. The picture is marked with a 凸 and the number of prints set to 1. Keep the ⊙— button depressed and use ▲ to change the number of prints. Repeat the process to select further images and choose the number of prints required from each. Press **OK** to display the PictBridge menu and select printing options, as shown in the table on page 234 (only **Page size**, **Border** and **Time stamp** will be available). Select **Start printing** and press **OK**.
Select date	Prints one copy of each image taken on a selected date.
Print (DPOF)	Prints images already selected using the **Print set (DPOF)** option in the Playback menu (see page 83).
Index Print	Prints all JPEG images (up to a maximum of 256) on the memory card. If more than 256 images exist, only the first 256 will be printed. Options for **Page size**, **Border** and **Time stamp** can be set as already described. If the selected page size is too small for the number of images, a warning will be displayed.

Connecting to a computer

Connecting to a Macintosh or PC unleashes more of the D90's power, including the ability to optimize NEF (RAW) files. The supplied Nikon Transfer software enables you to store and back up your images, while Nikon View NX offers basic editing and image enhancement. The optional Nikon Capture NX has much greater capabilities, especially when working with NEF (RAW) files. The optional Nikon Camera Control Pro allows the D90 to be controlled directly from the computer.

Computer requirements

Most modern computers will meet the minimum basic requirements: a USB port for connecting the camera (or USB card reader) and a CD drive for installation of the software. Nikon Transfer and Nikon View NX require one of the following operating systems: 32-bit Windows Vista; Windows XP with Service Pack 2; Mac OS X (Version 10.3.9 or later). Mac OS 9 and earlier versions of Windows are not supported.

Those with older computers will still be able to transfer and view images using third-party software, but older systems may run very slowly when dealing with the large files created by the D90, and there may be particular difficulty in opening NEF (RAW) files.

External card reader

Built-in card-reader slots

Note

The D90 is supplied with a USB cable for direct connection to a computer. However, you may find it more convenient to transfer photos by inserting the memory card into a card reader. Some 'multimedia' PCs have built-in card-reader slots, but separate card-readers are widely available and inexpensive.

236

Backing up

Remember that until they are backed up, your precious images exist only as data on the camera's memory card. SD cards are robust but they are not indestructible, and in any case you will surely wish to format and reuse your card or cards. If your images are transferred to the computer and the card is formatted, those images will still only exist in a single location. If anything happens to your hard drive – be it fire, theft or hardware failure – you could lose thousands of irreplaceable images. The simplest form of backup is to a second hard drive.

Colour calibration

A major headache for many digital camera users is that images look one way on the camera monitor, different on the computer screen, and different again when you email or print them. To ensure that images look consistent across different devices, all these devices need to be calibrated – first and foremost your main computer screen.

This may seem complex but in the long run it will save a huge amount of time. Detailed advice is beyond the scope of this book but try searching System Help for 'monitor calibration' (in Mac OS X, use the Display Calibrator Assistant). There's also some useful advice at www. northlight-images.co.uk/viewing.html.

MONITOR CALIBRATION
A screenshot of the Display Calibrator Assistant in Mac OS X. Various third-party calibration options are available for users of other operating systems.

Connecting the camera

This description assumes that you have installed the Nikon Transfer software from the CD supplied with the camera.

1) Turn the computer on and allow it to complete its startup squence. Open the cover on the left side of the camera and insert the smaller end of the supplied USB cable into the USB slot; insert the other end into a USB port on the computer. It is recommended that you do not connect to a USB hub or to a port on the keyboard.

Note
Nikon View NX, Nikon Capture NX or a third-party application can be set to open automatically when the D90 is connected. See the software manual or Help menu for details.

2) Turn the camera on. Nikon Transfer will start automatically (unless you have configured its Preferences not to do so), and a window like the one shown below will be displayed on the computer screen.

3) The Nikon Transfer window offers various options; see the Help menu in Nikon Transfer itself for full details. The following are among the most important.

4) If you don't want to transfer all images, use the check box below each thumbnail to deselect it as required.

5) Click the **Primary Destination** tab to choose where the photos will be stored. You can create a new subfolder for each transfer, rename images as they are transferred, and so on.

6) Click the **Backup Destination** tab if you want Nikon Transfer to backup photos automatically during transfer.

NIKON TRANSFER
This screenshot shows the main window of the Nikon Transfer software included with the camera. The software will open automatically when you connect the D90 to your computer.

238

Disconnecting the camera

Switch off the camera when transfer is complete, and disconnect the cable. Nikon Transfer will close automatically. If you transfer images using a card-reader, you must remove the card from the system as if it were any other external drive. For instance, in Windows XP or Vista, use the **Safely Remove Hardware** option; in Mac OS X, use **Command + E** or drag the D90 icon to the Trash.

Nikon software

The Nikon D90 is bundled with Nikon Transfer and Nikon View NX software. Nikon Transfer is a simple application that does one job simply and effectively. Nikon View NX is a more sophisticated package for many of the main digital photography tasks you will need to perform. It allows you to transfer images, view them individually or browse through them, save them in other formats and print them. However, Nikon View NX has only limited abilities to edit and enhance images. For full functionality in this respect, you need Nikon Capture NX or a third-party application such as Adobe Photoshop.

NIKON VIEW NX
The Nikon View software supplied with the camera has a range of image-management options, but its image-editing capabilities are limited.

Using Nikon View NX

1) From a browser view such as the thumbnail grid (choose the view mode from the **View** menu), click on an image to highlight it. **Image Viewer** shows the image in more detail, plus a histogram, and **Full Screen** shows the image at full size.

2) Click the **Camera Settings** tab on the left side of the screen. This reveals detailed info about the image, and also the **Quick Adjustment** palette, which allows basic adjustments to exposure and white balance. It also has access to Nikon Picture Controls (see pages 76–7).

3) Click **Apply** to commit the adjustments. These will be saved and you do not need to export or convert the file immediately.

4) To export the file as a TIFF or JPEG file that can be viewed, edited and printed by most other applications, choose **Convert Files** from the **File** menu. Here you can set a new size for the image if required, and also change its name.

5) The **File Format** drop-down menu in the **Convert Files** dialogue offers three main options: JPEG, TIFF (8-bit) and TIFF (16-bit).

Nikon View NX file format options

JPEG	Choose compression ratio: Excellent Quality; Good Quality; Good Balance; Good Compression Ratio; Highest Compression Ratio	Suitable if extensive further editing is not envisaged. It's recommended to choose Excellent Quality unless storage space is at a premium, or you know the image will only be used as an email attachment or similar.
TIFF (8-bit)		Creates larger file sizes than JPEG (Excellent Quality) and is a better choice if subsequent editing is envisaged; however, 16-bit is advised for extensive retouching work.
TIFF (16-bit)		The best choice when further editing is anticipated. Images can be converted to 8-bit after editing, halving file size.

240

NIKON CAPTURE NX
More advanced than Nikon View, Nikon Capture does not come as standard with the D90.

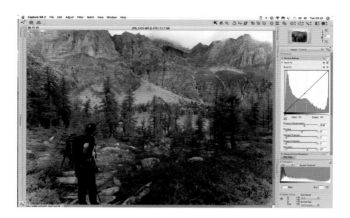

Nikon Capture NX

Nikon Capture NX is a far more complete editing package than Nikon View NX. For those who wish to explore the full range of editing options, especially in relation to NEF (RAW) files, Nikon Capture NX or one of its third-party rivals is essential. Before purchase, when comparing against competitors such as Adobe Photoshop, one important point to consider is that Capture NX will not open RAW files created by non-Nikon cameras. Photoshop does have a much wider feature set but it costs around four times as much. (If you own an older version of Photoshop, the upgrade price may be significantly lower.)

Nikon Capture NX2 was not released in time for evaluation in this book. It incorporates a significant number of new features.

Camera Control Pro 2

In the studio and other controlled settings, Camera Control Pro 2 allows almost all the functions and settings of the D90 to be operated directly from a Mac or PC.

Camera Control Pro 2 integrates with Live View mode, allowing detailed examination of the image on the computer screen for the ultimate in critical focus control.

CONNECTION

Third-party software

The industry standard in image-editing and manipulation software is, indisputably, Adobe Photoshop, the most recent version being Adobe Photoshop CS4. Its power is enormous and it's the subject of many dedicated books and websites. Some photographers will prefer the much more affordable Photoshop Elements, which still has sophisticated editing features, including the ability to open NEF (RAW) files from the D90.

Photoshop Elements also includes something that Adobe Photoshop itself does not, in the form of its Organizer module, which allows photos to be sorted into 'Albums' and also 'tagged' in different ways. This enables easy retrieval of photos under all sorts of criteria. Some sort of cataloguing software will become essential as you begin to amass hundreds or thousands of images.

Mac users have another excellent choice in the form of iPhoto, which comes pre-loaded on new Macs. There's no easier imaging software to grasp, and in the latest version the Adjust palette provides quick and flexible image editing too. iPhoto can open NEF (RAW) files from the D90, but – unlike Photoshop Elements – cannot edit in 16-bit depth, which is recommended for best results.

Finally, for photographers who work with NEF (RAW) format images, the future almost certainly lies in two applications: Apple's Aperture (Mac only) and Adobe Lightroom (Mac and PC). These programs both combine powerful organizing and cataloguing features with sophisticated, non-destructive image editing. This means that edit settings are stored alongside the original NEF (RAW) (or DNG) file. TIFF or JPEG versions, incorporating all the edits, can be exported as and when required. Lightroom 2, recently released, includes enhanced editing features.

LIGHTROOM 2
Adobe Lightroom's Develop module offers a wide spectrum of RAW adjustments.

242

Note

Versions of Adobe Photoshop prior to CS3 will not recognize the NEF (RAW) files created by the D90. These require the Camera Raw plug-in, version 5.1, which is not compatible with versions prior to Photoshop CS3. One way to work around this without a costly upgrade is to use the free Adobe DNG Converter to convert D90 files to the standard DNG format. These can then be opened with Photoshop CS or CS2. Similar limitations apply to older versions of Photoshop Elements, but an upgrade is much less costly.

Connecting to a GPS unit

Almost simultaneously with the release of the D90, Nikon introduced the GP-1 GPS (Global Positioning System) Unit (see page 226). This allows information on latitude, longitude, altitude, heading, and Coordinated Universal Time to be incorporated into image metadata. The same information is displayed as an extra page of photo info on playback. The GP-1 can be directly connected to the camera's accessory terminal or, alternatively, clipped to the camera strap, in which case it links to the accessory terminal using the supplied cable. When the camera has established a connection and is receiving data from the GPS, a GPS icon will be displayed in the camera's control panel. If this flashes, the GPS is searching for a signal, and data will not be recorded for shots taken in this condition.

GPS options

The GPS item in the Setup menu has two sections:

Auto meter off

If enabled, exposure meters turn off automatically after a set period (see Custom setting c2). This reduces battery drain. Ensure that meters are turned on by half-pressure on the shutter release before taking shots, otherwise GPS data may not be recorded. If this option is disabled, the meters will not turn off while a GPS unit is attached and GPS data will always be recorded.

Position

Displays the current information as reported by the GPS device.

CONNECTION

Chapter **10**

Care

The Nikon D90 is a rugged and well-made camera, but it is still packed with highly complex electronic and optical technology. A few simple common-sense precautions, outlined in the following pages, should ensure that it keeps functioning perfectly for many years to come.

Basic care

Keeping the camera clean is one of the most basic aspects of care. The camera body can be cleaned by removing dust and dirt with a blower, then wiping it with a soft, dry cloth. After exposure to sand and salt at the beach, wipe the camera off carefully with a cloth dampened with distilled water, then dry it thoroughly. As prevention is better than cure, keep the camera in a case when not in use.

Lenses require particular care. Glass elements and coatings are easily scratched and this will degrade your images. Remove dust and dirt with a blower. Fingerprints and other marks should be removed using a dedicated lens cleaner and soft cloth, preferably one of optical grade. Again, prevention is better than cure, so the use of a skylight or UV filter to protect the lens is advisable, and lens caps should be replaced when the lens is not in use.

Keep the cover on the playback monitor as much as possible. If the cover needs cleaning, use a blower to remove loose dirt, then wipe the surface with a soft cloth. Do not apply pressure. To clean the monitor itself, follow the same procedure but take extra care.

Tip
Never use household cleaning products anywhere near the D90 or any other camera.

Storage

If the camera will be unused for any length of time, remove the battery, close the battery compartment cover and store in a cool dry place. Avoid extremes of temperature, high humidity, and strong electromagnetic fields such as those produced by TVs and computers.

246

Cleaning the sensor

To speak of sensor cleaning is slightly misleading as the sensor itself is protected by a low-pass filter. Specks of dust and dirt settling on this will appear as dark spots or smears in the image.

The D90's self-cleaning facility does a good job of keeping dust at bay. Choose options for this facility under the **Clean image sensor** option in the Setup menu (see page 101). Occasionally, however, stubborn spots may still appear on the low-pass filter, and it may be necessary to clean the filter by hand. This is best done in a clean, draught-free area with good light, using a desk lamp or similar that can be directed into the camera's interior.

Tips

Before performing a manual clean, ensure the battery is fully charged. Better still, use a mains adaptor.

If spots do appear on your images, they can be removed with the Clone Tool or Healing Brush in Adobe Photoshop. In Nikon Capture NX, this process can be automated by creating a Dust-off reference image (see page 103). Spot removal can also be applied across batches of images in Adobe Lightroom 2.

To clean the low-pass filter, remove the lens, switch the camera on and select **Lock mirror up for cleaning** from the Setup menu. Press the shutter-release button to lock up the mirror. First, try to remove dust using a hand-blower (not compressed air or other aerosol). If this is ineffective, consider using a dedicated sensor-cleaning swab, and carefully follow the instructions supplied with it.

Do not use other brushes or cloths and never touch the low-pass filter with your finger. The filter is very delicate and the sensor itself even more so. When cleaning is complete, turn the camera off and the mirror will return to rest.

WADI RUM, JORDAN
A magical location, but very sandy. Sand, dust and dirt are all potentially harmful to the camera. Prevention is better than cure, so minimizing its exposure is advisable.

CARE

Weather

Coping with cold

Nikon specify an operating temperature range for the D90 of 32–104°F (0–40°C). This does not mean that the camera cannot be used when ambient temperatures are below freezing but, as far as possible, the camera itself should be kept within the stated range. Keeping the camera in an insulated case or under outer layers of clothing between shots will help to keep it warmer than the surroundings, but don't put it too near your skin as condensation may become a problem. If it does become chilled, battery life is likely to be severely reduced. In extreme cold, the LCD displays may become erratic or disappear completely and ultimately the camera may cease to function. If allowed to warm up gently, no permanent harm should result.

Heat and humidity

Extremes of heat and humidity (Nikon stipulate over 85%) can be even more problematic for the camera, as they are more likely to lead to long-term damage. In particular, rapid transfers from cool environments (an aircraft cabin, say) to hot and humid ones (the streets of Bangkok) can lead to condensation within the lens and camera. If such conditions are anticipated, pack the camera and lens(es) in airtight containers with sachets of silica gel, which will absorb any moisture. Allow the equipment to reach the ambient temperature before unpacking, let alone using it.

Water protection

The Nikon D90 has reasonable weatherproofing and can be used with confidence in light rain, though it should be exposed no more than absolutely necessary, and wiped regularly with a microfibre cloth. A cloth of this kind is always handy to wipe off any accidental splashes. Nikon advise that the moisture seal is compromised if the built-in flash is raised, so it is prudent to avoid using this in wet weather.

Salt water is much more hostile to electronic components than fresh. If contact occurs, clean it immediately with a cloth lightly dampened with fresh water, preferably distilled.

Ideally, avoid exposure in the first place by protecting the camera with a waterproof cover. A simple plastic bag will provide reasonable protection, but there are various purpose-made rain-guards and waterproof cases on the market. Some are intended for smaller DSLRs, so make sure the D90 fits into the case before buying.

Dust protection

To minimize the ingress of dust into the camera, take great care when changing lenses. Hold the camera pointing downwards and stand with your back to the wind. In really bad conditions, such as sandstorms, it's advisable to avoid changing lenses completely, and to protect the camera with a waterproof, and therefore also dustproof, case.

Dust that settles on the outside of the camera is easy to remove. The safest way is with a hand-operated or compressed-air blower.

Camera cases

In any conditions, some sort of case is highly advisable to protect the camera when not in use. The traditional 'ever-ready' case is a criminally misnamed item; many photographers prefer the term 'never-ready'. Much better is a simple drop-in pouch that can be worn on a belt. Excellent examples come from makers such as Camera Care Systems and LowePro.

CLIMBING STICKLE GILL, LAKE DISTRICT, UK
Definitely no place for an unprotected camera!

Tip

In adverse conditions, double-check that all access covers on the camera are properly closed, including the connector cover on the left of the camera body. The hotshoe cover should also be in place (this is one of the easiest things to lose).

Note

There seems to be no evidence that modern airport X-ray machines have any harmful effect on either digital cameras or memory cards.

Glossary

8-bit, 12-bit, 16-bit see Bit depth

Accessory shoe see Hotshoe

Aperture The lens opening, of variable size, which admits light. Relative aperture sizes are expressed in f-numbers (see f-number).

Artefact Occurs when data produced by the sensor is interpreted incorrectly, resulting in visible flaws in the image.

Bit depth The amount of information recorded for each colour channel. 8-bit means that 2^8 or 256 levels of brightness are recorded for each channel. 16-bit images recognize over 65,000 levels per channel. The D90 records RAW images in 12-bit depth and they are converted to 16-bit on import to the computer.

Bracketing Taking a number of otherwise identical shots in which just one parameter (e.g. exposure) is varied.

Buffer On-board memory which holds images until they can be written to the memory card.

Burst A number of images shot in quick succession. The maximum burst size is limited by buffer capacity.

Channel The D90, like other digital devices, records data for three separate colour channels (see RGB).

CCD (Charge-coupled device) A type of image sensor used in many digital cameras.

Clipping Complete loss of detail in highlight or shadow areas of the image (sometimes both), leaving them as blank white or black.

CMOS (Complementary Metal Oxide Semiconductor) A type of image sensor used in many digital cameras, including the Nikon D90.

Colour temperature The colour of light, expressed in degrees Kelvin (K). Confusingly, 'cool' (bluer) light has a higher colour temperature than 'warm' (red) light.

Compression The process by which digital files are reduced in size.

Contrast The range between the highlight and shadow areas of an image, or a marked difference in illumination or colours between adjacent areas.

CPU (Central Processing Unit) A computer in the camera (also found in many lenses) that controls the unit's functions.

Crop factor see Focal length multiplication factor

Depth of field The amount of an image that appears acceptably sharp. The smaller the aperture, the greater the depth of field.

Dioptre Unit expressing the power of a lens.

dpi (Dots per inch) A measure of resolution: should strictly be applied only to printers (see ppi).

Dynamic range The range of brightness from shadows to highlights within which the camera can record detail.

Ev Exposure value. A standardized unit of exposure, 1 Ev is equivalent to 1 stop in traditional photographic parlance.

250

Evaluative metering A metering system whereby light reflected from several subject areas is calculated based on algorithms.

Exposure Refers to the amount of light hitting the image sensor, and to systems of measuring this. Also 'making an exposure' (taking a picture).See also Overexposure, Underexposure

Exposure compensation A control that allows intentional over- or underexposure.

Extension rings/Extension tubes Hollow tubes that fit between the camera tube and lens, used to allow greater magnifications.

f-number Lens aperture expressed as a fraction of focal length; f/2 is a wide aperture and f/16 is narrow.

Fast (lens) Lens with a wide maximum aperture, for example f/1.8. f/4 would be considered relatively fast for long telephotos.

Fill-in flash Flash used in combination with daylight. Used with naturally backlit or harshly side-lit subjects to prevent shadows.

Filter A piece of glass or plastic in front of, within or behind the lens to modify light.

Firmware Software which controls the camera. Upgrades can be transferred onto the camera using a memory card.

Focal length The distance (in mm) from the optical centre of a lens to the point at which light is focused.

Focal length multiplication factor
Because the D90's sensor is smaller than a frame of 35mm film, the effective focal length of all lenses is multiplied by 1.5.

fps (frames per second) The number of exposures (photographs) that a camera can take in a second. The Nikon D90's maximum rate is 4.5 fps.

Highlights The brightest areas of the scene and/or the image.

Histogram A graph representing the distribution of tones in an image, ranging from pure black to pure white.

Hotshoe An accessory shoe with electrical contacts that allows synchronization between the camera and a flashgun.

Hotspot A loss of detail in the highlight areas of an image. This is a common problem in flash photography.

Incident light metering Measuring the light falling on to a subject, usually with a separate light meter. An alternative to the in-camera meter, which measures reflected light.

ISO (International Organization for Standardization) ISO ratings express film speed and the sensitivity of digital sensors is quoted as ISO-equivalent.

JPEG (Joint Photographic Experts Group) A compressed image file standard. High levels of JPEG compression can reduce files to about 5% of their original size, but there may be some loss of quality.

LCD (Liquid crystal display) A flat screen such as the D90's control panel.

Macro A term used to describe close focusing and close-focusing ability of a lens. A true macro lens has a reproduction ratio of 1:1 or better.

Megapixel (see pixel)

Memory card A removable storage device for digital cameras.

Noise Image interference manifested as random variations in pixel brightness and/or colour.

Pixel Short for 'picture element'. The individual coloured dots (usually square) that make up a digital image. One million pixels = 1 megapixel.

ppi (Pixels per inch) Should be applied to digital files rather than the commonly used dpi (see dpi).

Red-eye reduction A system that causes the pupils of a subject to shrink by shining a light prior to taking the flash picture.

Reproduction ratio The ratio between the real size of an object and the size of its image on the sensor.

RAW The image file format in which the raw data from the sensor is stored without in-camera processing.

Resolution The number of pixels for a given dimension, for example 300 pixels per inch. Resolution is often confused with image size. The native size of an image from the D90 is 4288 × 2848 pixels; this could make a large but coarse print at 100 dpi or a smaller but finer one at 300 dpi.

RGB (Red, Green, Blue) Digital devices, including the D90, record colour in terms of brightness levels of the three primary colours.

Sensor The light-sensitive chip at the heart of every digital camera.

Shutter The mechanism that controls the amount of light reaching the sensor by opening and closing to expose the sensor when the shutter-release button is pushed.

Speedlight Nikon's range of dedicated external flashguns.

Spot metering A metering system that meters the intensity of light reflected by a very small portion of the scene.

Telephoto lens A lens with a large focal length and a narrow angle of view.

TIFF (Tagged-image File Format) A universal file format supported by virtually all image-editing applications.

TTL Through The Lens, like the viewing and metering of SLR cameras such as the D90.

USB (Universal Serial Bus) A data transfer standard, used to connect to a computer.

Viewfinder An optical system used for framing the image; on an SLR like the D90 it shows the view as seen through the lens.

White balance A function that compensates for different colour temperatures so that images may be recorded with the correct colour balance.

Wide-angle lens A lens with a short focal length and a wide angle of view.

Zoom A lens with variable focal length, giving a range of viewing angles. To zoom in is to change focal length to give a narrower view; to zoom out is the converse. 'Optical zoom' refers to the genuine zoom ability of a lens; 'digital zoom' is the cropping of part of an image to produce an illusion of the same effect.

252

Useful websites

NIKON

Nikon Worldwide
Home page for the Nikon Corporation
www.nikon.com

Nikon UK
Home page for Nikon UK
www.nikon.co.uk

Nikon USA
Home page for Nikon USA
www.nikonusa.com

Nikon User Support
European Technical Support Gateway
www.europe-nikon.comsupport

Nikon Info
User forum, gallery, news and reviews
www.nikoninfo.com

Nikon Historical Society
Worldwide site for the study of
Nikon products
www.nikonhs.org

Nikon Imaging Corporation
Official Worldwide imaging site
www.nikonimaging.com/global

Nikon Links
Links to many Nikon-related sites
www.nikonlinks.com

Grays of Westminster
Revered Nikon-only London dealer
www.graysofwestminster.co.uk

GENERAL

Digital Photography Review
Independent news and reviews
www.dpreview.com

Thom Hogan
Real-world reviews and advice
www.bythom.com/nikon.htm

Jon Sparks
Landscape and outdoor pursuits
photography
www.jon-sparks.co.uk

EQUIPMENT

Lastolite
Reflectors, light tents, ePhotomaker
www.lastolite.com

Sigma
Independent lenses and flash units
www.sigma-imaging-uk.com

Adobe
Photoshop, Photoshop Elements, Lightroom
www.adobe.com/uk

Apple
Aperture and iPhoto
www.apple.com/uk

PHOTOGRAPHY PUBLICATIONS

Photography books
www.ae-publications.com

***Black & White Photography* magazine,
Outdoor Photography magazine**
www.pipress.com

Index

Contact us for a complete catalogue or visit our website:
Ammonite Press, 166 High Street, Lewes, East Sussex, BN7 1XU, United Kingdom
Tel: +44 (0)1273 488006 Fax: +44 (0)1273 472418
www.ammonitepress.com

NIKON D90
THE EXPANDED GUIDE

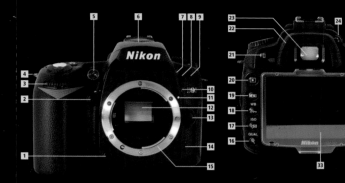

FRONT OF CAMERA BACK OF CAMERA

1 Depth-of-field preview button
2 Function button
3 Sub-command dial
4 Camera strap eyelet
5 AF-assist/Self-timer/Red-eye
reduction lamp
6 Built-in flash
7 Flash mode/Flash compensation button
8 Microphone
9 Infra-red receiver
10 Bracketing button
11 Lens mount index
12 Reflex mirror
13 Lens-release button
14 Focus mode selector
15 Lens mount

16 Playback zoom in/QUAL button
17 Thumbnail/playback zoom out/
ISO button
18 Protect button/Help/WB button
19 Menu button
20 Playback button
21 Delete/Format button
22 Viewfinder eyepiece
23 Viewfinder
24 Dioptre adjustment control
25 AE/AF-lock button
26 Main command dial
27 Live view button
28 Multi selector
29 OK button
30 Focus selector lock
31 Memory card access lamp
32 INFO display/Quick settings
display button
33 Playback and menu monitor

AMMONITE
PRESS

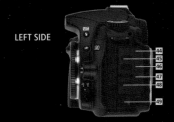

LEFT SIDE

BOTTOM OF CAMERA

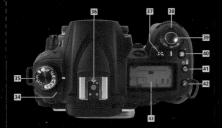

TOP OF CAMERA

RIGHT SIDE

34 Focal plane indicator
35 Mode dial
36 Accessory hotshoe
37 Metering/Format button
38 Power switch
39 Shutter-release button
40 Exposure compensation button/reset
41 Release mode button
42 AF mode button/reset
43 LCD control panel
44 Connector cover
45 DC connector
46 USB connector
47 HDMI connector
48 Video connector
49 Accessory terminal

50 Battery compartment
51 Battery compartment lock release
52 Camera serial number
53 Tripod socket (¼in)
54 Camera strap eyelet
55 SD card cover

AMMONITE
PRESS